PAINTERS
on
PAINTING

Selected and Edited with an
Introduction by

Eric Protter

D1252913

DOVER PUBLICATIONS, INC.
Mineola, New York

Published in Canada by General Publishing Company, Ltd., 30 Lesmill Road, Don Mills, Toronto, Ontario.

Bibliographical Note

This Dover edition, first published in 1997, is an unabridged and unaltered republication of the revised edition of *Painters on Painting* as published by Grosset & Dunlap/Universal Library, New York, in 1971.

Library of Congress Cataloging-in-Publication Data

Painters on painting / selected and edited with an introduction by Eric Protter.
 p. cm.
 Originally published: Rev. ed. New York : Grosset & Dunlap, 1971.
 Includes bibliographical references and index.
 ISBN 0-486-29941-4 (pbk.)
 1. Painting. I. Protter, Eric.
ND1140.P25 1997
750'.1—dc21
 97-34498
 CIP

Manufactured in the United States of America
Dover Publications, Inc., 31 East 2nd Street, Mineola, N.Y. 11501

Preface

ALTHOUGH many great painters have written specifically on the subject of painting in one form or another (journals, treatises, notebooks, letters, etc.), there are others whose literary legacy, if indeed it ever did exist, has been lost.

To avoid omission of these painters we have turned to writings about them and their theories by other painters. Hence the excerpts by Vasari, Pacheco, Ridolfi, etc. But obviously even these inclusions cannot make this book all inclusive. Some omissions are inevitable since it is impossible to encompass the world of painting in a single volume.

Another significant consideration in the preparation of this book was the fact that, in many cases, the writings of painters consist only of personal letters, often not directly concerned with theoretical matters as such. However, we considered letters which dealt with the mood of the artist or indicated the artistic climate in which he found himself important in providing unique insight into the artist's world. Similarly, we have occasionally included anecdotes, for they too give a more personal impression of the artist.

The selection of twentieth-century painters—particularly the young contemporary painters—was extremely difficult and is to some extent controversial. We want to stress that our primary consideration was the inclusion of artists holding many different points of view.

The task of compiling an anthology of this sort necessarily involves the assistance and cooperation of numerous people and organizations.

To the best of our knowledge, many of the selections in this volume have not appeared in English before. It is with deep gratitude that we acknowledge translations by Salvator Attanasio, Karen Jare, Barbara Kennedy, Nora McGrath, and Michaela Murphy.

We also wish to thank those artists who have written statements especially for this book.

Grateful acknowledgment for assistance must go to the staffs of the New York Public Library, the Library of Congress, and the New York University Library. Mr. Len Fox of the New York University

Library must be singled out for his knowledgeable and invaluable help.

The editor and the publishers wish to thank the Albertina Bibliothek, Vienna; the Bonnat Collection, Bayonne; the Frick Collection, New York; the Collection of V. W. Van Gogh, Amsterdam; Hamburger Kunsthalle, Hamburg; the Metropolitan Museum of Art, New York; the National Gallery, Washington, D.C.; the National Gallery, London; the Ossolinski National Institute, Lwow; the Phillips Collection, Washington, D.C.; the Rhode Island School of Design, Providence; the Museum of Modern Art, New York; the Yale University Art Gallery; the Uffizi Gallery, Florence; the Terry Dintenfass Gallery, New York; the Lee Nordness Gallery, New York; Mr. Armand G. Erpf; Mr. and Mrs. A. M. Fiering; Mr. and Mrs. William B. Jaffe; and all others, from whose collections material here appears in print.

Finally, the editor wishes to thank Mr. George Mandel for help received in working out certain parts of this book.

CONTENTS

xi

Introduction

THROUGHOUT THE HISTORY OF PAINTING the art critic, in one form or another, has always made himself felt by his consistent and conspicuous presence as well as by his ability to write clever and biting prose. This middleman of the art world has attained a position of influence and power with the general public and with collectors that is completely out of line with his function.

Because art criticism is historically a part of the art world and because it is, today, an especially influential factor, it may be both informative and useful to examine its actual significance, for a moment, within another framework—that of the painter and his work.

For August 3, 1855, we find this entry in Delacroix's journal: "I went to see the Courbet exhibition; he has reduced admission to ten cents. I stay there alone for nearly an hour and discover that the picture which they refused is a masterpiece; I simply could not tear myself away from the sight of it. . . . They have refused one of the most singular works of the period, but a strapping lad like Courbet is not going to be discouraged for so small a thing as that."

Today, *The Atelier*—the painting Delacroix was referring to—is almost unanimously acclaimed as a great painting. Of course, there is nothing unique about this situation: one need only think of Cézanne, who in his lifetime was consistently refused exhibition in Paris and is today hailed not only as a "master" but as "the painter who exerted the greatest influence on all of modern art."

But though such delayed recognition seems to be one of the facts of the world of painting, the interested observer cannot help but wonder why so many important works of art are at first dismissed out of hand while a great many inferior works achieve an immediate acclaim that, with the passage of time, is dissipated.

One answer is provided by Sir Joshua Reynolds in his discourse to the students at the Royal Academy on December 10, 1772. He said: "Be as select in those whom you endeavour to please, as in those whom you endeavour to imitate. . . . It is certain that the lowest style will be the most popular, as it falls within the compass of ignorance itself; and the Vulgar will always be pleased with what is natural, in the confined and misunderstood sense of the word. . . .

"Our Exhibitions, while they produce such admirable effects by nourishing emulation and calling out genius, have also a mischievous tendency, by seducing the Painter to an ambition of pleasing indiscriminately the mixed multitude of people who resort to them."

On March 15, 1855, Delacroix made a similar observation about the taste of the general populace, perceptively adding: ". . . but men in the profession, artists or practically that, who are looked on as superior men, are inexplicable when they are so cowardly as to lend themselves to all this silliness."

In studying the history of art, it becomes clear that official standards and tastes, in one form or another—standards based on academics, religion, governmental or personal politics—have always predominated. One might conclude that a painter's work is never examined in the light that it must if its real value and its meaning are to be recognized.

That even a clearly defined, academically honest attempt at judging artists is doomed to failure is shown by the chart by which the eminent seventeenth-century French art historian Roger de Piles attempted to compare fifty-seven outstanding painters.

In a most logical way de Piles divided painting into four distinct areas: *composition, drawing, color,* and *expression.* He defined *expression* as "general thought or understanding" and not just "the character of any particular object." He explained *composition* as consisting of two equally important elements—invention and disposition; a painter might be a marvelous inventor and yet lack the

ability to execute these inventions in a first-rate manner. By assigning 20 points to each category de Piles contrived this interesting table of comparisons:

65: Raphael, Rubens	45: Andrea del Sarto, Barocci
58: The Carracci, Domenichino	44: Albani, Sebastiano del Piombo,
56: Le Brun	C. Veronese, P. Veronese,
55: Van Dyck, Vanius	Perino del Vega, Pordenone,
53: Poussin, Correggio	Fra Salviata
51: Titian	42: Guercino, Lanfranco,
50: Rembrandt	P. da Caravaggio
49: Tintoretto, Leonardo da Vinci,	41: Diepenbeeck, G. Palma
G. Romano, Le Sueur	40: Daniele da Volterra,
48: Holbein, Pietro da Cortona	J. Jordaens, L. Jordaens
47: Vanius	39: Giorgione, F. Zuccaro
46: T. Zuccaro, Teniers, Primaticcio	37: G. da Udine, Parmignianino
36: Dürer	30: Bourdon, P. Perugino
34: Reni	28: Josepin, Caravaggio
33: Michelangelo, Murillo	27: V. Palma
32: P. Testa	24: Bellini, Lucas van Leyden
31: Bassano, Pourbus	23: Fra Penni

Were we to make up such a list today, unquestionably Giorgione, Dürer, Michelangelo, Caravaggio, Lucas van Leyden, and others would be ranked much differently. In fact, for us it is inconceivable and amusing to think of Dürer, Michelangelo, and Lucas van Leyden scoring 36, 33, and 24 points, respectively, while Le Brun and Vanius achieve 56 and 55 points.

This is not to ridicule Roger de Piles. He was a fine and able art historian. We have included this chart* to make the point that it is virtually impossible at any given time to appraise accurately or conclusively artists who have not been dead for roughly a century.

In general the most a critic may honestly hope to do is to enlighten his audience as to what an individual artist may be trying to do, and how his art relates to the world. In a more specific way, a critic may point out the structural failures and successes of individual paintings. But to assign any contemporary painter his place (high or low) in history is to betray both speciousness and arrogance.

Unfortunately, such unenlightened criticism is, in our time, not

merely prevalent but rampant. Perhaps because our world has grown small and our psyche has been shattered by an explosive age, perhaps because our inner motifs and emotions have been examined and re-examined and we don't like what we see in ourselves and in other men—perhaps it is because of the twentieth-century condition that the critic has become confused in his role and has altogether lost his dignity. Paradoxically, he has subverted his obligation to resist his prejudices in a time of such complex and far-reaching artistic experimentation that an even greater objectivity is required of him. He has lost the facility to expose himself to the expression of a painting, and instead approaches it with personal demands, understanding only that which he wants to understand. To be favorably received, a painter must paint as the critic wishes him to paint, or at least offer the critic some private emotional identification. In this semi-paranoiac state the critic strips himself entirely of his responsibility to artist and audience alike.

In the last sixty years the art world has been flooded with such diverse ways of painting—so rapidly succeeding one another—as impressionism, post-impressionism, cubism, futurism, expressionism, construction painting, dada, surrealism, social realism, magic realism, abstract expressionism, and pop art. As each of these manifestations emerges, the confused critic either fights a last-ditch battle on behalf of the prevailing art, or jumps on the band wagon and proclaims loudly that he has just recognized, or even "discovered," *the new art*. The real trouble occurs, however, when an even "newer" art appears before the previous one has run its course. One can well imagine the editorial meetings at the influential art magazines, which must resemble the platform-writing sessions of our national political conventions. Uneasy compromises are undoubtedly worked out with at least as much sincerity as is invoked in drafting a civil rights plank on which both the southern and the northern politician can stand for a while.

But this commercial game is utterly unimportant to art itself. The critic will continue to label the painter for purposes of his own, and the painter will continue to ignore the critic in order to create. Courbet's words "There can be no schools: there are only painters" have as much validity today as they had in the past and will have in the future.

<div align="right">

Rockland, Maine
July, 1963

</div>

* Based on the compilation of Roger de Piles as given in Elizabeth G. Holt, *A Documentary History of Art* (Princeton, 1957).

....*I am fifty years old and I have always lived as a free man; let me be free for the rest of my days; for when I am dead let it be said of me: "He never belonged to any school, to any church, to any institution, to any academy — least of all to any regime, lest it be the regime of liberty."*

GUSTAVE COURBET (1870)

....*One must very clearly take one's position and not care what the critics say. What they say is completely unimportant. Despite all their wishes they cannot hold up the process of things. A painter is never understood, at best he is accepted.*

GEORGES BRAQUE (1954)

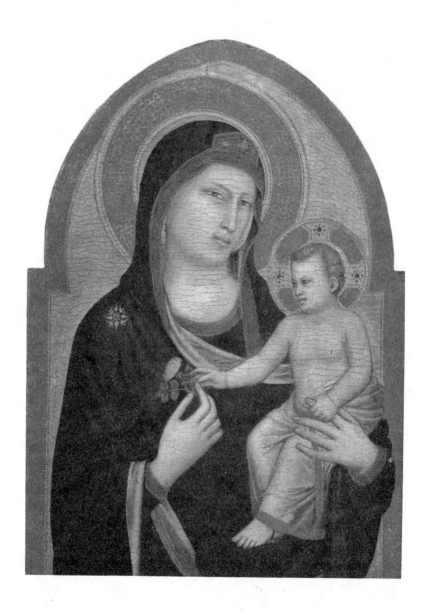

GIOTTO: *Madonna and Child.* National Gallery of Art, Washington, D.C., Samuel H. Kress Collection.

Giotto Di Bondone

(c. 1266–c. 1337)

Giotto introduced the new painting. He gave up the crudeness of the Greeks and became the greatest painter in Etruria. . . . Giotto recognized that in art which others had not attained. He brought nature and grace to art; but he did not disobey the rules.

LORENZO GHIBERTI

HOW GIOTTO BECAME THE STUDENT OF CIMABUE

In the year 1276, in the country of Florence, about fourteen miles from the city, in the village of Vespignano, there was born to a simple peasant named Bondone, a son, whom he named Giotto, and whom he brought up according to his station. And when he reached the age of ten, showing in all his ways, though still childish, an extraordinary vivacity and quickness of mind, which made him beloved not only by his father but by all who knew him, Bondone gave him the care of some sheep. And when Giotto led them to the pasture he was constantly driven by his natural inclination to draw on the stones or the ground some object in nature, or for that matter something that came to his mind. One day, Cimabue, going on business from Florence to Vespignano, found Giotto drawing a sheep from nature upon a smooth and solid rock with a pointed stone. And quite obviously Giotto had never learned from anyone but nature. Cimabue marveled at the child and asked him whether he would go and be with him. And the boy replied that if his father were content, then he would gladly go. When Cimabue asked Bondone for the child, the old man gave his son to him, pleased that Giotto would grow up in Florence.

There, in a little time, with the aid of nature and the teaching of Cimabue, Giotto not only equaled his master, but he freed himself from the rude manner of the Greeks, and brought back to life the true art of painting, introducing the drawing from nature of living persons—something that had not been practiced for two hundred years. Or, if some had tried it, they certainly did not succeed in a happy way.

From *The Lives of the Painters,* by Vasari

Cennino Cennini

(c. 1365–c. 1440)

For the first time since antiquity, artistic fantasy is recognized; this, Cennino says, when it accompanies technical skill, enables an artist to represent as reality that which is an imitation of nature.

ELIZABETH G. HOLT

BASIC REQUIREMENTS FOR BECOMING AN ARTIST

Now then, you of noble mind, who love this profession, come at once to art and accept these precepts: enthusiasm (love), reverence, obedience, and perseverance. As soon as you can, place yourself under the guidance of a master, and remain with him as long as possible.

HOW THE ART OF PAINTING
SHOULD BE LEARNED

Know that painting cannot be learned in less time than thus. First of all, you must study drawing on tablets for at least one year.* Then you must remain with a master at the workshop—a master who understands working in all parts of art. You must begin with the grinding of colors; learn how to boil down glues; acquire the technique of laying grounds on panels, and to work in relief upon them; you must learn how to rub them smooth, and how to gild; and how to engrave well. This will take you six years. Next, you must practice coloring; to adorn with mordants; to make cloths of gold; and to gain the facility of painting on walls. This will take at least six more years. But throughout this time, you must always keep drawing without intermission, either on holidays or on work days. In this way through long habit, good practice becomes second nature. If you adopt other habits do not ever hope to attain great perfection. There are many who say that they have learned the art without ever having been with a master. Do not believe them. If you do not see practice with some master, you will never be fit for anything, even if you study day and night.

* During those times, the first year was merely a trial period. If a master was satisfied with his apprentice at the end of the year, the student was then bound to him for at least twelve years.

ONE SHOULD CONTINUALLY DRAW FROM NATURE

Remember that the most perfect guide available to you, and the best helm, is the triumphal gateway of drawing from nature. It is a better model than any other; and, with a bold heart, you may always trust it, especially when you begin to have some judgment in design. And without fail draw something every day; for even if you draw just a little it will stand you in good stead.

WHAT ARE NATURAL COLORS,
AND HOW TO GRIND BLACK

Know there are seven natural colors of which black, red, yellow, and green are of the nature of earths, whereas white, ultramarine blue or della magna blue, and Naples yellow are also natural colors, but require artificial assistance.

To grind the black pigment properly use a slab of porphyry which is hard and strong. Such other grinding stones as serpentine and marble are too soft. A very pale-colored slab of porphyry, and one which is not polished highly, will best suit the purpose. It should be about half a braccio square.* Next take another stone of porphyry which is about half the size of the first one. It should be flat underneath and raised above in the shape of a porringer, and feel comfortable in your hand so that you can easily control its movement. Then take some of the black (or of any other color), about the size of a walnut, place it on the slab, and with the stone which you hold in your hand break the pigment into small pieces. Put some clean water, either from a river, a fountain, or a well, to the color and grind it well for half an hour, an hour, or as long as you please. But know, were you to grind it for a year, the color would become blacker and better. When you have finished grinding, take a flat piece of fine-grained wood, three fingers wide and part of which is shaped like the blade of a knife. With this blade scrape the stone and collect the color neatly. Keep it liquid and not too dry so that it may flow well on the stone, and also so that you can grind it thoroughly and collect all of it. Then put it into a small vase and pour clean water on it until the vase is full. In this manner keep it always soft, and well covered from dust and from all other harm.

HOW TO COLOR A DEAD MAN

Next we shall speak of coloring a dead man, that is to say, his face and his body, or any naked part that may be visible. The procedure is the same for a panel or a wall except that on a wall you need not

* Half a braccio is less than one foot.

5

first lay a ground tint of *verda terra*. There it is sufficient to lay on the half tints between the lights and the shades. But on a panel you must lay it on the usual way as directed for coloring a living face, and also shade it in the same way with *verdaccio*. You must not use any rosy tints, because dead persons have no color. But take a little ochre for your three gradations of flesh color, mixed with white, and tempered in the usual manner, laying each tint in its place and softening them into each other, on the face as well as on the body. And in the same manner, when you have nearly covered your ground, make the lightest flesh tint still lighter, reducing it to pure white for the highest lights. Then mark the outlines with dark sinopia, mixed with a little black, which is called *sanguigno*. Paint the hair in the same manner, but not so that it shall appear to be alive, but dead, using several shades of *verdaccio*. On panels paint them the same way. And so paint the bones of Christians or rational creatures with this same flesh color.

From *Il libro dell'arte*, by Cennini

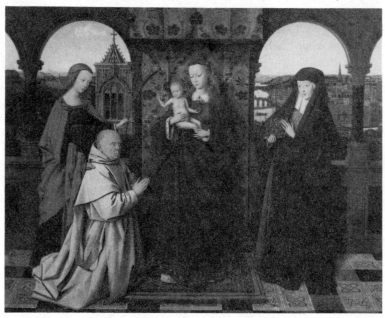

JAN VAN EYCK: *Virgin and Child, with Saints and a Carthusian Donor.* The Frick Collection.

Hubert van Eyck

(1370–1426)

Jan van Eyck

(1390–1441)

In twenty years the human mind, represented by these two men, had found, in painting, the most ideal expression of its beliefs, the most physiognomic expression of faces, not the noblest, certainly, but the first correct manifestation of bodies in their extract forms, the first picture of the sky, of the air, of clothes, of the country, of external richness by means of true colors; it had created a living art, invented or perfected its mechanism, determined its language and produced imperishable works. All that was to be done was done.

<div align="right">EUGÈNE FROMENTIN</div>

If the "representational" is not that which represents, but, rather, that which fulfills no other function in a picture than to represent, then the masterpiece of van Eyck is a perfect example of a painting that totally abstracts from the representational elements of reality.*

<div align="right">ETIENNE GILSON</div>

THE DISCOVERY OF PAINTING WITH OIL

Heaven generously bestowed upon us the highest glory of scholarship, while nature, in her benevolence, endowed us with a genius for painting. Neither the Greeks nor the Romans, nor any other people, despite their search, were privileged to find the method of painting discovered by Joannes van Eyck. . . .

It is supposed that the art of painting with a glue and egg medium was imported into the Netherlands from Italy, because as we have noted in the biography of Giovanni of Cimabue, this method was first used in Florence, in 1250.

* The Arnolfini portrait.

<div align="center">7</div>

The brothers, Jan and Hubert, made many paintings with a glue and egg medium, as no other method was known at that date, except one used in Italy by which painting was done on wet ground.*

In the time of the two van Eycks, the city of Bruges was enjoying an inundation of wealth from a great international trade which had centered there more extensively than anywhere else in the Netherlands. Art follows wealth for its rich rewards. Joannes went to live in Bruges because there were many wealthy merchants residing there. He painted many pictures there with glue and egg, on wood, and became famous for his noble art in the various countries to which his work was sent.

According to the people of Bruges, Joannes was a learned man, clever and inventive, who studied many subjects related to painting: he examined many kinds of pigment; he studied alchemy and distillation. At length, he worked out a method of varnishing his egg and glue paintings with oil, so that these shining and lustrous pictures exceedingly delighted all who saw them. In Italy, many artists had searched for this method in vain.

Now it happened in this way. Joannes had painted a panel on which he had spent much time, because he liked nicety and clarity of execution in his painting. He varnished the finished panel according to his new invention and placed it in the sunlight to dry. The parts of the panel may not have been joined or glued sufficiently, or the heat of the sun may have been too strong: the panel burst at the joints and fell apart. Joannes, much disappointed that his work was lost through the influence of the sun, took resolve that the sun should not damage his work ever again.

Accordingly, hostile to the egg and varnish method, he set himself to discover or invent some kind of varnish which would dry within the home, away from the sunlight. He had already examined many oils and other similar materials supplied by nature, and had found that linseed oil and nut oil had the best drying ability of them all. He boiled these oils with some other substances, and produced the finest varnish on earth.

Men with active and clear minds, such as possessed by Joannes, continued to study in order to attain higher perfection. So Joannes found, after many experiments, that colors mixed with these oils could be handled easily, that they dried well, became hard, and, once dry, could resist water. The oil made the color appear more alive, owing

* Other methods of painting were known long before. Theophilus' *Schedula diversarum artium* (12th cent.) mentions oil as a medium for painting. Detailed mention of earlier methods is made also by Sir C. L. Eastlake in his classic work, *Materials for a History of Oil Painting*.

to a lustre of its own, without varnish. And what surprised and pleased him most was that paint made with oil could be applied more easily and mixed more thoroughly than paint made with egg and glue. He no longer needed to apply color in streaks.

Joannes was greatly pleased by this invention of treating paint with oil, and he had every reason to be, because he had created a new type of painting, to the amazement of the world. . . . This noble discovery, of painting with oil, was the only thing the art of painting still needed to achieve naturalistic rendition. . . . As far as I can learn, Joannes invented the process of oil painting in the year 1410. Vasari, or his printer, made a mistake in dating this invention a hundred years later.

The van Eyck brothers kept their invention to themselves. Many beautiful paintings were made in collaboration by the two, and many were made by one alone. Although he was the younger, Joannes surpassed his brother in the art.

THE GHENT ALTARPIECE

The painting, marvelous for its time, is excellent in regard to drawing, action of figures, conception of the subject, and precision of workmanship. The draperies are well displayed in the style of Albrecht Dürer; the blue, red, and purple colors in these have not changed at all and are so fresh that they look as if they had been laid on just recently. These colors surpass in beauty those of any other painting.

The learned Joannes gave the greatest concentration to this work, as though to convince Pliny of the incorrectness of his statement that painters who have to paint a hundred faces, or even a smaller number, are unable to compete with nature, which scarcely produces two similar ones in a thousand, and generally make some resembling others. In this painting are about 330 faces, of which not one is similar to another. Moreover, different expressions can be observed on these faces, such as serenity, love, and divine faith. From the mouth of Mary, who is reading a book, words seem to come.

Many foreign trees are in the landscape painted on the double doors of the central panel; one can distinguish the various kinds of plants and grasses on the ground. They are rendered most beautifully. The hairs in the portraits, in the blazes and manes and tails of the horses, can almost be counted separately, so thinly and delicately are they painted. This striking work as a whole amazes every painter.

From *Dutch and Flemish Painters,* by Carel van Mander

Fra Giovanni Angelico da Fiesole
(Fra Angelico)
(1387–1455)

Fra Angelico's paintings are no mere religious pictographs. He was above all else an artist, an artist to his very fingertips, who carried about in one body two temperaments which are usually supposed to have but little in common, and which indeed are not often found inhabiting the same frame—the artistic and the saintly. But he was primarily an artist, an artist who happened to be a saint.

He was the first Italian artist of the Renaissance to represent an actual landscape from nature, as he was also the first to attempt to solve certain problems of aerial perspective.

<div align="right">LANGSTON DOUGLAS</div>

ON HIS WAY OF PAINTING

Fra Giovanni was kindly to all, and moderate in all his habits, living temperately, and holding himself entirely apart from the snares of the world. He used frequently to say that he who practiced the art of painting had need of quiet, and should live without cares or anxious thoughts; adding that he who would do the work of Christ should perpetually remain with Christ. He was never seen to display anger among the brethren of his order; a thing which appears to me most extraordinary, nay almost incredible; if he admonished his friends, it was with gentleness and a quiet smile; and to those who sought his works, he would reply, with the utmost cordiality, that they had but to obtain the assent of the prior, then he would assuredly not fail to do what they desired. In fine, this never sufficiently to be lauded father was most humble, modest, and excellent in all his words and works; in his painting he gave evidence of piety and devotion, as well as of ability, and the saints that he painted have more of the air and expression of sanctity than have those of any other master.

It was the custom of Fra Giovanni to abstain from retouching or improving any painting once finished. He altered nothing, but left

all as it was done the first time, believing, as he said, that such was the will of God. It is also affirmed that he would never take the pencil in hand until he had first offered a prayer. He is said never to have painted a crucifix without tears streaming from his eyes, and in the countenances and attitudes of his figures it is easy to perceive proof of his sincerity, his goodness, and the depth of his devotion to the religion of Christ.* . . .

But superior to all the other works of Fra Giovanni, and one in which he surpassed himself, is a picture in the same church,† near the door on the left hand of the entrance: in this work he proves the high quality of his powers as well as the profound intelligence he possessed of the art which he practiced. The subject is the Coronation of the Virgin by Jesus Christ: the principal figures are surrounded by a choir of angels, among whom are vast numbers of saints and holy personages, male and female. These figures are so numerous, so well executed, in attitudes so varied, and with expressions of the head so richly diversified, that one feels infinite pleasure and delight in regarding them. Nay, one is convinced that those blessed spirits can look no otherwise in heaven itself, or, to speak under correction, could not, if they had forms, appear otherwise; for all saints, male and female, assembled here, have not only life and expression, most delicately and truly rendered, but the coloring also of the whole work would seem to have been given by the hand of a saint or of an angel like themselves. It is not without most sufficient reason, therefore, that this excellent ecclesiastic is always called Frate Giovanni Angelico. The stories from the life of our Lady of San Domenico which adorn the predella, moreover, are of the same divine manner, and I, for myself, can affirm with truth that I never see this work but it appears something new, nor can I ever satisfy myself with the sight of it, or have enough of beholding it.

From *The Lives of the Painters,* by Vasari

* Although there can be little question about the accuracy of Vasari's narrative, art historians and biographers have pointed out his "inadequacy" in relating, at times, only half the story and thereby giving a biased report.
† San Domenico di Fiesole. The picture is now in the Louvre.

Paolo Ucello

(1396–1475)

Ucello's affinities with the Gothic tradition are evident both in the delicacy and choice of his color schemes and in a propensity for those dreamlike effects in which he gave free reign to his imagination. . . .

It was his enthusiasm for perspective that led him to free himself from Gothic influences and made of him a true Renaissance—indeed a "modern" artist.

In his color harmonies he uses pigments in a manner that is quite arbitrary as regards truth to nature; thus he does not hesitate to paint earth pink and human beings green, when this suits his purpose, with a mind to some purely imaginative pattern he has visualized.

LIONELLO VENTURI

A CRITIQUE WITH REGARD TO FALSIFYING NATURE

Paolo Ucello would have been the cleverest and most original genius since the time of Giotto if he had studied figures and animals as much as he studied and wasted his time over perspective, though it is an ingenious and fine science. However, he who pursues it out of measure throws away his time, makes his manner dry, and often himself becomes solitary and strange, melancholy and poor, as Paolo did. . . . In San Miniato, outside of Florence, he painted the lives of the Fathers, in which pictures he made the field azure, the cities red, and the buildings varied, according to his own pleasure; and in this he did wrong, for things that we suppose to be of stone ought not to be painted of any other color.

He was the first who gained a name for landscapes, carrying them to more perfection than any other painter before him. In Santa Maria del Fiore he also made a monument to Sir John Hawkwood, the English captain of the Florentines, who died in the year 1393: a horse of extraordinary size, with the captain upon it. The work was considered and really is very fine for pictures of that sort, and if Paolo had not made the horse moving his legs on one side only, which horses do not naturally do or they would fall, the work would be perfect. Perhaps he made the mistake because he was not used to ride or study horses; but the foreshortening of the horse is very fine.

From *The Lives of the Painters,* by Vasari

12

Leon Battista Alberti

(c. 1404–1472)

Theory, when separated from practice, is, for the most part, found to avail very little; but when theory and practice chance to be happily united in the same person, nothing can be more suitable to the life and vocation of artists. . . . That this is true is seen clearly in the instance of Leon Battista Alberti.

<div align="right">VASARI</div>

ON COLORS

It seems obvious that colors vary according to lights, because when any color is placed in the shade, it appears to be different from the same color which is located in light. Shade makes color dark; whereas light makes color bright where it strikes. Philosophers say that nothing can be seen that is neither illuminated nor colored.

Hence they argue, it follows that there is a close relationship between colors and lights with respect to making anything visible to the eye. To realize how true this is, one must only consider a situation when light is lacking—then the colors are lacking also; and when light returns, the colors return. For this reason I shall discuss colors first; then I shall investigate how they vary in light. I shall speak as a painter.*

I say that through the mixture of colors an infinite number of other colors is created; but just as there are four elements, there are only four true colors from which many other subtypes are produced. The color of fire is red, of air, blue, of water, green, of earth, gray and ashen. The other colors, such as jasper and porphyry, are mixtures of these. Thus there are four types of colors and these produce their subtypes according to whether light or dark, white or black, is added, and these are almost numberless. We see green leaves lose their greenness from patch to patch until they become pale. Similarly, the air is frequently a white vapor around the horizon which disappears little by little. In some roses we recognize a lot of purple, while some others have the color of young girls' cheeks, while still others are like ivory. And the same way with white or black, the earth produces its subtypes of color. The admixture or addition of white, then, does not alter the types of the colors, but rather produces subtypes. So also the color black has the same power to make

* That is, not going into philosophical arguments.

<div align="center">13</div>

almost infinite subtypes of color by being mixed. The colors may be seen filled with shadow, or when the light is increased the colors become more open and bright. For this reason one may persuade the painter that white and black are not true colors, but an alteration of other colors, because the painter finds nothing but white with which to show the shades. We may add that you will never find either white or black that is not attached to one of those four colors.

ON THE THREE PARTS THAT MAKE UP PAINTING

Painting is divided into three parts. This division we have taken from nature. Because painting tries to represent things, let us observe in what way objects are seen. In the first place, when we see an object we say it is a thing that occupies a place. The painter describing this space will call this "marking of the edge with a line" *circumscription* or outline. Then, looking it over, we observe that many surfaces in the seen object connect, and here the artist, setting them down in their proper places, will say that he is making the *composition*. Lastly, we determine more clearly the colors and the qualities of the surfaces. Since every difference in representing these arises from light, we may call it precisely the *reception of light* or illumination. Thus painting is composed of *circumscription, composition,* and the *reception of light*. In the following each will be briefly discussed.

First we shall discuss the circumscription or outline. Outline will be that which describes the going around the edge in painting. It is said that Parrhasius, the painter who talks with Socrates and Xenophon, was very expert in this and had studied these lines a great deal. I say this, that in circumscription close attention must be given to its being made with very fine lines, almost such that they are not seen. In this the painter Apelles would always practice and compete with Protogenes.

Since outline or circumscription is nothing else but the drawing of the edge, which if it is done with too visible a line will not show that there is a surface edge there, but a break, I should wish that nothing be attended to in circumscribing but the going along the edge. I assure you that in this regard the greatest care must be used. No composition and no illumination deserve praise unless there is, additionally, good circumscription. And a good drawing—that is, a good circumscription—is often very pleasing by itself. . . .

It remains to us to speak of composition. It is necessary to repeat what composition is. Composition is that method in painting by which parts of the things that are seen are put together so as to fit in the picture. A painter's biggest work is a colossus, but an *istoria*

(narrative) evokes greater praise than any colossus. Therefore, let him paint narrative pictures. The narrative is reducible into bodies, bodies into limbs, limbs into surfaces. Thus the prime divisions of painting are surfaces. There arises from the composition of the surface that grace of bodies which is called beauty. Therefore in this composition of the surfaces, the grace and beauty of things is much to be sought after. To ensure this, I think there is no more appropriate and sure way than to follow nature, recalling in what way nature, the marvelous maker of things, has composed the surfaces well in beautiful bodies. To imitate her in this, it is necessary to take great thought and pains about it constantly. . . . When we wish to put into practice what we have learned from nature, we will always first note the limits to which we shall draw our lines.

Up to here I have discussed the composition of surfaces; there follows the composition of limbs. First of all, one must make sure that they go well together. They will do so if they correspond to a single beauty with respect to size and function and kind and color and other such things. For if there were in one painting a very large head and a small breast, a heavy foot, a normal hand, and a puffed-up body—this composition would surely be ugly to look at.

So therefore take one limb, and let every other limb be accommodated to it in such a way that all of them will fit the others in length and breadth. . . . Then let each limb follow its own function in whatever is going on. It is correct that a runner should fling his hands no less than his feet, whereas I would have a philosopher, while he is talking, show modesty much more than an ability in fencing. . . .

The reception of light remains to be treated. First let us study light and shade and remember how one surface is brighter than another where the rays of light strike, and how, where the force of light is lacking, the same color becomes dusky. It should be noted that the shadow will always correspond to the light in another part, so that no part of the body is lighter without another being dark.

As for imitating the bright with white and the shadow with black, I admonish you to take great care to know the distinct surfaces as each one is covered with light or shadow. This will be well enough understood by you from nature. When you know it well, with great restraint commence to place the white where you need it, and at the same time oppose it with black. With this balancing of white and black the amount of relief in objects is clearly recognized. . . .

The mirror is a good judge for you to know. It is marvelous how every weakness in a painting is so manifestly deformed in the mirror.

From *De pictura*, by Alberti

Piero della Francesca

(1416–1492)

*Piero attains his plastic effect by the use of colors,
put on in zones, one color representing light, and the
other shade. This was a wholly new conception; it is
the basic principle of the chromatic form of painting.
With Piero light both surrounds and creates form.
. . . All light vibrates, and natural light is fully ren-
dered in painting only when free play is given to its
vibrations, the dance of molecules. Piero's light, how-
ever, does not move; it illuminates and creates its own
world, a world other than ours, august, serene, over
which time flows unavailing, for it is founded in eter-
nity.*

LIONELLO VENTURI

ON PERSPECTIVE

Painting comprises three principal parts which we call draw-
ing, measurement, and coloring. By drawing we mean the outlines
and profiles actually contained in the objects. By measurement we
refer to these same outlines and profiles when they are placed pro-
portionately in their proper places. By coloring we think of the way
colors show up on the various things, that is, light and dark and how
they change according to the light. Of these three principal parts
which make up painting, I intend to deal only with measurement—
which we call perspective—although I will also have to bring in
drawing, because without this part of painting it is impossible to
demonstrate how perspective works. We shall eliminate coloring,
and deal here only with that which can be demonstrated by lines,
angles, and proportions, because we are speaking of points, lines, sur-
faces, and objects. Five different divisions make up this part. The
first is seeing, that is, the eye; the second is the form of the things
that are seen; the third is the distance between the eye and the things
that are seen; the fourth is the lines that go from the extremity of the
object to the eye; the fifth is the plane that exists between the eye and
things that are seen. And it is on this plane that one intends to repre-
sent the objects. The first part, as I have said, is the eye. I intend to

16

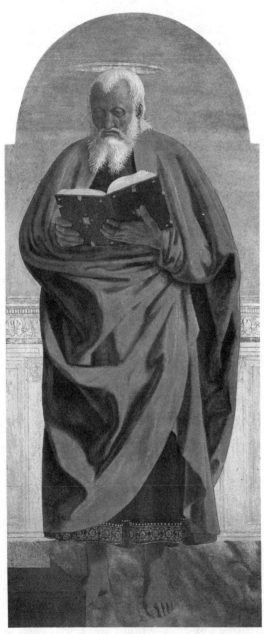

PIERO DELLA FRANCESCA: *St. John the Evangelist*. The Frick Collection.

speak of it only to the degree that it affects painting. I say that the eye is the first part because it is within it that all objects seen from different angles are represented; that is, when the objects that are seen are equidistant from the eye, the larger object will be represented within a larger angle than will be the smaller one. In the same way, when objects are of the same size but are not located at an equal distance from the eye, the object that is closer to the eye will be represented within a larger angle than will the object that is further from the eye. The foreshortening of objects is understood by these differences. The second part is the form of the object, because without form the mind could not judge the object nor could the eye comprehend it. The third part relates to the distance from the eye to the object, for if there were no distance between the eye and object, the object would be next to, or touch, the eye. And if the object were larger than the eye, the eye would be unable to perceive it. The fourth part deals with the lines which start at the extremities of the object and terminate in the eye: by receiving these lines the eye discerns the object. The fifth part is the plane on which the eye describes objects proportionately by means of its rays. On this plane the eye is able to judge the size of the objects. If no plane would exist, it would be impossible to know to what extent the objects were foreshortened, and hence it would become impossible to represent them. But aside from all this, it is necessary for an artist to be able to draw on a plane, in their true form, all the objects he intends to represent.

A point is that which has no parts. According to geometers, it exists only in the imagination. And according to these same mathematicians, a line has length but no width. But since I claim to treat perspective with illustrations that can be understood by the eye, I cannot use definitions that are comprehensible only by the mind. Hence, I must give another definition. I say that a point is the smallest thing that the eye can recognize. And I will call a line the extension of one point to another, and whose width is of the same size as is a point. A surface, I will define as being width and length enclosed by lines. There are many different kinds of surfaces, such as triangles, squares, tetragons, pentagons, hexagons, octagons, and others having more and different sides.

HEADS AND CAPITALS, BASES, AND OTHER OBJECTS

Many painters underestimate the importance of perspective, because they do not understand the importance of the lines and angles that are produced by it, while in effect they permit the correct proportionate description of every contour and line. Therefore, I feel I must explain how necessary this science is to painting. I say that the

word "perspective" means things that are seen from a distance and are represented within certain given planes. Further, these things are proportionately reduced, depending upon the distances. Without perspective, it would be impossible to correctly foreshorten any object. And as painting is nothing but a representation of surfaces and solids that are either enlarged or foreshortened and placed upon a picture plane, according to how the real objects seen by the eye within different angles appear on the aforementioned plane; and since in everything that is seen one part is always closer to the eye than another, the nearer one always appearing within a larger angle than the farther one, on the given plane; and since intellect alone cannot judge their size, that is, the size of the nearer object and the size of the object that is farther away—I say that perspective is a necessity because, as a real science, it differentiates the proportionate degrees of size and it concretely shows both foreshortenings and enlargements by means of lines.

Through the use of perspective, many ancient painters, such as Aristomenes of Thasos, Polycles, Apelles Andramides; Nitheusm Zeuxis and many others, earned everlasting praise. And although there were many painters who did not employ perspective, and who were also praised, it must be said that they were praised by people who used poor judgment and who were ignorant of what could have been accomplished by means of perspective. And since I am ambitious for the glory of art in this age, I have had the courage and the presumption to write this small piece on perspective in painting.

From *De prospectiva pigendi,* by Piero della Francesca

Sandro Botticelli

(1444–1510)

*His art has both a feminine and a virile side; in it
melancholy, tenderness, and manly forthrightness are
wedded, blend together, and become one, in the same
way as form and content are at one in a successful
work of art.*

<div align="right">LIONELLO VENTURI</div>

CONFLICTS WITH CHURCH IDEOLOGY

For the monks of Cestello this master painted a picture of the
Annunciation in one of their chapels, and in the church of San
Pietro he executed one for Matteo Palmieri, with a very large number
of figures. The subject of this work, which is near the side door, is
the Assumption of Our Lady, and the zones or circles of heaven are
there painted in their order. The patriarchs, the prophets, the apos-
tles, the evangelists, the martyrs, the confessors, the doctors, the vir-
gins, and the hierarchies: all of which was executed by Sandro ac-
cording to the design furnished to him by Matteo, who was a very
learned and able man. The whole work was conducted and finished
with the most admirable skill and care: at the foot of it was the por-
trait of Matteo kneeling, with that of his wife. But although this
picture is exceedingly beautiful and ought to have put envy to
shame, yet there were found certain malevolent and censorious
persons who, not being able to affix any other blame to the work,
declared that Matteo and Sandro had erred gravely in that matter,
and had fallen into grievous heresy.*

Now, whether this be true or not, let none expect the judgment of
that question from me: it shall suffice me to note that the figures
executed by Sandro in that work are entirely worthy of praise, and
that the pains he took in depicting those circles of the heavens must
have been very great, to say nothing of the angels mingled with
the other figures, or of the various foreshortenings, all of which are
designed in a very good manner. About this time Sandro received
a commission to paint a small picture with figures three parts of a
braccio† high, the subject being an Adoration of the Magi: the
work was placed between the two doors of the principal façade of

* Apparently the altar was interdicted, and the picture covered from view.
† A braccio is nearly two feet.

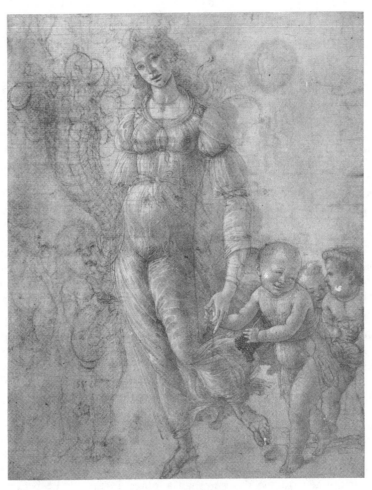

BOTTICELLI: *Abundance.*

Santa Maria Novella, and is on the left as you enter by the central door. In the face of the oldest of the kings, the one who first approaches, there is the most lively expression of tenderness as he kisses the foot of the Saviour, and a look of satisfaction also at having attained the purpose for which he had undertaken his long journey. This figure is the portrait of Cosimo de' Medici, the most faithful and animated likeness of all now known to exist of him.

The second of the kings is the portrait of Giuliano de' Medici, father of Pope Clement VII. He offers adoration to the divine Child, presenting his gift at the same time, with an expression of the most devout sincerity. The third, who is likewise kneeling, seems to be offering thanksgiving as well as adoration, and to confess that Christ is indeed the true Messiah: this is the likeness of Giovanni, the son of Cosimo. The beauty which Sandro has imparted to these heads cannot be adequately described, and all the figures in the work are represented in different attitudes: of some one sees the full face, of others the profile, some are turning the head almost entirely from the spectator, others are bent down; and to all, the artist has given an appropriate and varied expression, whether old or young, exhibiting numerous peculiarities also, which prove the mastery he possessed over his art. He has even distinguished the followers of each king in such a manner that it is easy to see which belongs to one court and which to another; it is indeed a most admirable work: the composition, the design, and the coloring are so beautiful that every artist who examines it is astonished, and at the time it obtained so great a name in Florence and other places for the master that Pope Sixtus IV, having erected a chapel in his palace at Rome, and desiring to have it adorned with paintings, commanded that Sandro Botticelli be appointed superintendent of the work.

A PERIOD OF DISRUPTION

Having completed the work for Pope Sixtus IV, he returned at once to Florence, where, being whimsical and eccentric, he occupied himself with commenting on a certain part of Dante, illustrating the *Inferno,* and executing prints, over which he wasted much time, and neglected his proper occupation. He engraved many of the designs he had executed, but in a very inferior manner. The best attempt of this kind from his hand is the Triumph of Faith, of Fra Girolamo Savonarola, of Ferrara, of whose sect our artist was so zealous a partisan that he totally abandoned painting, and not having any other means of living, he fell into very great difficulties. But his attachment to the party he had adopted increased; he became what was then called a *Piagnone** and abandoned all labor insomuch that, finding himself at length become old, being also very poor, he would surely have died of hunger had he not been supported by Lorenzo de' Medici, for whom he had worked at the small hospital of Volterra and other places. De' Medici assisted him while he lived, as did other friends and admirers of his talents.

From *The Lives of the Painters,* by Vasari

* The name given to Savonarola's followers.

Leonardo da Vinci

(1452–1519)

If one goes back to the time when The Last Supper *was executed, one can do no less than wonder at the immense progress that Leonardo caused his art to make. . . . He freed himself with one blow from the traditional painting of the fifteenth century; without errors, without weakening, without exaggerations, and as if with a single bound, he arrives at that judicious and learned naturalism, equally separated from servile imitation and from an empty chimerical ideal. How singular it is that the most methodical of men, the one among the masters of this time who was most occupied with the processes of execution and who taught them with such precision that the works of his best pupils are confused with his own every day—this man, whose* manner *is so strongly characterized, is* without rhetoric.

EUGÈNE DELACROIX

If you would take the full measure of his genius, remember that he worked after no set pattern or model; that each of his productions was an exploration along a new line. He did not, like other painters, multiply his works; but once having attained the special goal at which he aimed, once the especial ideal was realized, he abandoned that pursuit forever.

THÉOPHILE GAUTIER

WHAT PAINTING IS CONCERNED WITH

Painting is concerned with all the ten attributes of sight: darkness and light, solidity and color, form and position, distance and nearness, motion and rest.

From Leonardo's *Literary Works*

THE YOUNG STUDENT OF PAINTING

In the first place, the young student should acquire a knowledge of perspective so that he will be able to give every object its proper dimensions. The next requisite is that he be under the care of an able master so that he will gradually acquire a good style of drawing the different parts of the body. Next, he must study nature, in or-

23

der to confirm and fix in his mind the reason for the different precepts he has learned. He must also spend time viewing the works of the various old masters so as to form his eye and his judgment, so that he may be able to put into practice all that he has been taught.

OF PAINTING AND ITS DIVISIONS

Painting is divided into two principal parts. The first is the figure, that is, the lines that distinguish the forms of bodies and their component parts. The second is the color contained within those limits.

DIVISION OF THE FIGURE

The form of the bodies is divided into two parts, that is, the proportion that the different members have to each other (and which must always correspond to the whole), and the motion, which is expressive of what passes in the mind of the living figure.

OF DRAWING FROM NATURE

When you draw from nature, the distance between you and the object that you are painting must be equal to three times the height of the object. And when you begin to draw, form in your own mind a certain principal line (suppose a perpendicular). Observe well the relationship of the parts to that line, that is, whether they intersect it, are parallel to it, or are oblique to it.

A PRECEPT FOR THE PAINTER

It reflects no great honor on a painter to be able to execute only one thing well—such as a head, an academy figure, or draperies, animals, landscapes, or the like—in other words, confining himself to some particular object of study. This is so because there is scarcely a person so devoid of genius as to fail of success if he applies himself earnestly to one branch of study and practices it continually.

A NOTE ON ANATOMY

Note which muscles and tendons are brought into action by the motion of any member, and also when these muscles and tendons are hidden. Remember that these remarks are of the greatest importance to painters and sculptors who profess to study anatomy and the science of the muscles. Observe the human body from birth to decrepitude. Describe the changes which the members, and particularly the joints, undergo. Notice which grow fat and which grow lean.

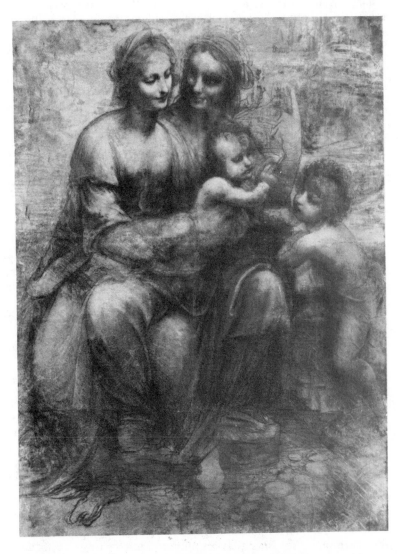

LEONARDO DA VINCI: *The Virgin and the Child with SS. Anne and John the Baptist.* Reproduced by courtesy of the Trustees, The National Gallery, London.

A PRECEPT ON BALANCE

The navel is always in the central or middle line of the body. It passes through the pit of the stomach to that of the neck. There must be as much weight—either accidentally or naturally—on one side of the human figure as on the other. This is demonstrated by extending the arm. The wrist then performs the function of a weight at the end of the steelyard, causing some weight to be thrown to the other side of the navel so as to counterbalance that of the wrist. It is for this reason that the heel is often raised.

A PRECEPT FOR AVOIDING A BAD CHOICE IN THE STYLE OF FIGURES

The painter ought to form his style upon the most proportionate model in nature. And after having observed that, he should also observe himself and be perfectly acquainted with his own defects and deficiencies. And after acquiring this knowledge, his constant care should be to avoid conveying into his own work those defects which he has found in his own person. For these defects, having become habitual to his observation, will mislead his judgment, as he will not be able to perceive them any more. We should, therefore, struggle against such a prejudice which grows up within us; for the mind, being fond of its own habitation, is apt to represent this prejudice to our imagination as something beautiful. The same motive may be the reason why there is not a woman, however plain in her person, who may not find her admirer, lest she be a monster. Against this bent of the mind you should, very cautiously, be on your guard.

A PRECEPT IN PAINTING

The painter should notice those quick motions which men are apt to make without thinking, when impelled by strong and powerful affections of the mind. He should note them down and make sketches of them, so that he will be able to use them in the future when they may answer a particular purpose. He should then put a living model in the same position, so that he may observe the quality and aspect of the muscles which are in action.

ADVICE TO PAINTERS

Be very careful, in painting, to observe that among the shadows there are other shadows that are almost imperceptible as to darkness and shape. This is proved by the third proposition, which says that the surfaces of globular or convex bodies have as great a variety of lights and shadows as have the bodies that surround them.

OF BACKGROUNDS

To give figures a great effect, a light figure must be opposed with a dark ground, and a dark figure with a light ground, contrasting white with black, and black with white. In general, all contraries—because of their opposition—give a particular force and brilliancy of effect.

OF VERDIGRIS

This green, which is made of copper, though it be mixed with oil, will lose its beauty, if it is not varnished immediately.* It not only fades, but if washed with a sponge and pure water only, it will detach from the ground upon which it is painted, particularly in damp weather.

HOW TO PAINT A PICTURE THAT WILL LAST ALMOST FOREVER

After you have made a drawing of your intended picture, prepare a good and thick priming with pitch and brick-dust that has been well pounded. Next, give it a second coat of white lead and Naples yellow. Then, having traced your drawing upon it, and having painted your picture, varnish it with clear and thick old oil, and with a clear varnish stick it to a flat glass or crystal. Another method, which may be even better, is the following: Instead of the good priming of pitch and brick-dust, take a flat tile that is well vitrified. Then apply the coat of white and Naples yellow, and do everything as before. But before the glass is applied to it, the painting must be perfectly dried in a stove, and varnished with nut oil and amber, or only with purified nut oil which has thickened in the sun.

IN WHAT PART A COLOR WILL APPEAR IN ITS GREATEST BEAUTY

We are to consider here in what part any color will show itself in its most perfect purity; whether it will be in the strongest light or in the deepest shadow, in a half-tint, or in the reflex. First of all, it is necessary to determine which color we intend to discuss, because different colors differ materially in that respect. Black is the most beautiful in the shade; white in the strongest light; blue and green in the half-tint; yellow and red in the principal light; gold in the reflexes; and lake in the half-tint.

* Verdigris and other blue and green copper colors, such as mountain blue and mountain green, had to be used by the old masters because of a lack of other pigments. They were well aware of the dangerous nature and incompatibility of these pigments and took the precaution of placing them between coats of varnish. From *The Materials of the Artist*, by Max Doerner.

COLORS IN REGARD TO LIGHT AND SHADE

Where the shadows terminate upon the lights, observe well what parts of them are lighter than others, and where they are more or less softened and blended. But above all, remember that young people have no sharp shadings: their flesh is transparent, something like we observe when we put our hand between the sun and our eyes; it seems reddish and of transparent brightness. If you wish to know what kind of shadow will suit the flesh color you are painting, place one of your fingers close to your picture, so that it will cast a shadow upon it. You can then obtain the intensity of the shadow which you desire, by moving your finger nearer or farther from the picture.

HOW TO REPRESENT THE WIND

In representing the effect of the wind, aside from the bending of trees and leaves twisted the wrong side up, you will also express the small dust which whirls upwards until it mixes with the air in a confused manner.

THE BRILLIANCE OF A LANDSCAPE

The vivacity and brightness of colors in a landscape will never bear any comparison with a landscape in nature when it is illumined by the sun, unless the painting is placed in such a position that it will receive the same light from the sun as does the landscape.

HOW TO MAKE AN IMAGINARY ANIMAL
APPEAR NATURAL

It is evident that it will be impossible to invent any animal without giving it members, and these members must individually resemble those of some known animal. Therefore, if you wish to make a sea serpent, for example, appear natural, take the head of a mastiff, the eyes of a cat, the ears of a porcupine, the mouth of a hare, the brows of a lion, the temples of an old cock, and the neck of a sea tortoise.

A PRECEPT FOR PAINTERS

The painter who has no doubt about his own ability will attain very little. When his work succeeds beyond his judgment, the artist acquires nothing. But when his judgment is superior to his work, he will never cease to improve, unless his love of gain interferes and retards his progress.

From *A Treatise on Painting,* by Leonardo

Vittore Carpaccio

(1455–1526/27)

He devoted himself to painting the life of ease and luxury he saw around him. But he was a poet too, and there is an unforgettable charm in the directness, precision and, often, unexpectedness of the impressions he sets down. . . . A happy intuition guides him to enchanting harmonies of tones, put on boldly and without nuances.

LIONELLO VENTURI

RIDOLFI ON CARPACCIO'S PAINTING

At the beginning of his career he had a rather hard style, but in time it softened, and earned him the title of master. It is in his paintings of historical events—in the grace he imparted to facial expressions as well as in his careful attention to detail—that he departed from the hard and dry style of antiquity. It is this quality which renders his pictures pleasing and agreeable.

The paintings he made for the Convent of St. Ursula* brought him no little fame. Indeed, they are still admired by professors today, for they are extremely delightful works, full of perspective and different kinds of costumes. They are executed with painstaking care, and although this meticulousness is not the painter's chief merit, it is nonetheless worthy of praise when it is accompanied by a sensible style. When it is overdone it deserves to be blamed, for it renders the figures hard and displeasing. But Carpaccio's paintings in this style met all the requirements of delicacy and finish.

From *Delle maraviglie dell'arte,* by Ridolfi

* This St. Ursula sequence, located at the Venice Academy, is generally considered to be his masterpiece.

Hieronymus Bosch

(1460–1516)

He is not content to paint familiar legends and themes of a common heritage. As he paints, Bosch holds intimate conversation with himself, and gradually he sinks into the depths of his own unconscious. For him, to paint is to liberate his own demon.

RENÉ HUYGHE

ON HIS METHOD OF PAINTING

He had a firm, rapid, and very agreeable execution, often finishing his works at the first painting; yet those works have stood perfectly well, and without changing. Like other old masters, he had a mode of drawing and tracing his subjects on the white panel; he then passed a transparent flesh-colored priming over the design, often using the ground to contribute to the effect of his work.

From *Dutch and Flemish Painters*, by Carel van Mander

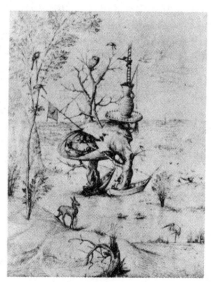

BOSCH: *The Alchemist.* Drawing. Graphische Sammlung, Albertina, Vienna.

Albrecht Dürer

(1471–1528)

Dürer demanded of painting the most painstakingly definite drawing of every detail, and insisted that there should be no compromise with this demand.

MAX DOERNER

Like his predecessors in Germany, Dürer endeavored to work from life, without being too eager to select the most beautiful from the beautiful. . . . It is amazing how many new, characteristic things Dürer discovered in nature and in himself, and how he applied these to painting, in the poses as well as in the general composition and arrangements. . . . A great star, rising very high, was destined to light the world for centuries. This star was an artist who had learned everything to be known in the field of drawing. Yet he had not lit his torch in Italy, nor in Greece, where the antique marbles of illustrious Greek sculptors enlightened the earth. This artist was Albrecht Dürer.

CAREL VAN MANDER

ABOUT PAINTING

He that would be a painter must have a natural turn thereto.

Love and delight therein are better teachers of the Art of Painting than compulsion is.

If a man is to become a really great painter he must be educated thereto from his very earliest years.

He must copy much of the work of good artists until he attain a free hand.

To paint is to be able to portray upon a flat surface any visible thing whatsoever that may be chosen.

It is well for anyone first to learn how to divide and reduce to measure the human figure, before learning anything else.

ABOUT PERSPECTIVE

Perspective is a Latin word meaning "to look through." Five things belong to "looking through."

1. The eye that sees.
2. The object that is seen.
3. The distance between the eye and the object.
4. One sees everything by means of straight lines: that is to say, the shortest lines.
5. The dividing from one another the things that are seen.

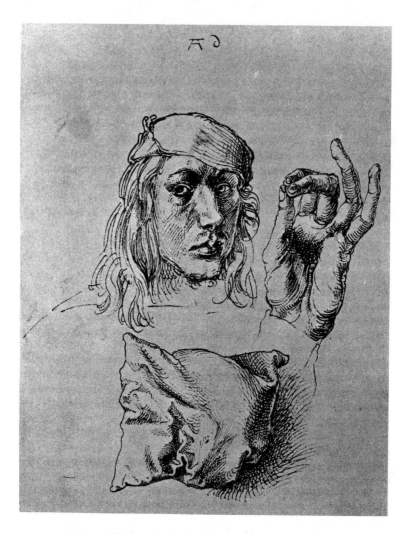

DÜRER: *Self-Portrait*. Ossolinski National Institute, Lwow.

SOME ELABORATIONS ON PERSPECTIVE

One can only see those things to which the sight can reach.

Where the sight cannot reach by means of straight lines (as stated above under the fourth heading), things cannot be seen, because sight is not effected through crooked lines.

All things seen by radii which open out widely look large.

All things contained between narrow radii look small.

All things seen by similar radii (that is to say, lines of sight inclined to one another at the same angle), whether they be large or small, far off or near, look the same size.
All things seen by high radii look high.
All things seen by low radii look low.

EXTRACT FROM THE THIRD OF THE
FOUR BOOKS ON HUMAN PROPORTIONS

Great pains and close attention are needed to make something that is praiseworthy to look at. For first of all let a man consider the head and realize how strangely it is rounded. The same is true of the other parts: such strange lines are involved that no rules can be laid down, but must be drawn only from point to point. The forehead, cheeks, nose, eyes, mouth, and chin, with their curvings in and out and their peculiar forms, must be carefully drawn, so that not the very smallest thing be passed over, but that all be drawn with well-considered and particular care. Moreover, just as each part should be drawn correctly, so should it harmonize well in respect of the whole. Thus the neck should agree aright with the head, being neither too short nor too long, too thick nor too thin. Then let a man take care that he put together correctly the breast and the back, the belly, and hinder parts, the legs, feet, arms, and hands, with all their details, so that the very smallest points be made correctly and in the best way. Moreover, these things should be wrought in the work to the clearest and most careful finish, and even the tiniest wrinkles and details should not be omitted insofar as it is possible, although it is useless to overdo and overload a thing. If indeed a man has to paint a figure in haste, he must be content with few details; but even so, evidence must be given therein of a true judgment, and—all haste notwithstanding—a just intention must be discoverable and the same quality of form must be retained throughout the whole body.

And so in all figures, be they hard or soft, fleshy or thin, one part must not be fat, and another bony. It is as if you were to make a leg fat and an arm thin, or a figure fat in front and lean behind. For all things must agree together in symmetry and not be falsely mingled. Things that agree together in symmetry are considered beautiful. That is also why in all parts throughout, in every figure, the limbs should be represented uniformly in point of age. The head must not be copied from a youth, the chest from an old man, and hands and feet from one of middle age. Neither must the figure be made youthful before and old behind, or contrariwise; for that which is opposed to nature is bad. Hence, it follows that each figure

33

should be of one kind alone throughout, either young, or old, or middle-aged, lean or fat, soft or hard. For example, you will find the grown lad to be smooth, hairless, and plump, whereas old age is rugged, bony, wrinkled, and its flesh is wasted.

In order to make such things, it is well for a man first of all to draw the outlines of his picture as he intends it to be, that is, before he sets about his work, so that he may see whether there isn't something in the figures that might be improved. If you do this carefully and with attention you shall not afterwards lightly repent what you have done. Therefore, it is necessary for every artist to learn to draw well, for this is incalculably useful in many arts, and much depends upon it. For if a man who does not know how to draw were to set the description of a good canon before him and to attempt to follow it, faring with his unskilled hand through the length, thickness, and breadth of the figure, he would very soon spoil what he is desiring to make. But when a man who well understands how to draw sets a well-described figure before him, he can improve it so much when he outlines it that it becomes even better.

<div align="right">From The Dürer Manuscripts</div>

CORRESPONDENCE WITH JACOB HELLER

<div align="right">Nuremberg, August 24, 1508</div>

Dear Herr Jacob:

I have safely received your letter, that is to say the last but one, and I gather from it that you wish me to make you a good picture, which is just what I myself have in mind to do. You must know how far it has got on; the wings have been painted in stone colors on the outside, but they are not yet varnished; inside the whole of the ground has been laid, so that it is ready to paint on.

The middle panel I have outlined with the greatest care and at cost of much time; it is also laid over with two very good colors upon which I can begin to paint the ground. For I intend, as soon as I hear that you approve, to paint the ground dome four, five, or six times over, for clearness' and durability's sake, using for the purpose the very best ultramarine that I can get. And no one shall paint a stroke on it except myself.

I want therefore to spend much time on it and I would like to assure myself beforehand that I shall not exhaust your patience. Therefore I have determined to write you about my plan, and to tell you that I cannot without loss carry out such a work for the 130 Rhenish florins we bargained for; for I must spend much money and lose time over it. However, whatever I have promised you I

will honorably perform. If you don't want the picture to cost more than the price we agreed upon, I will still paint it in such a way that it will always be worth much more than you paid for it. If, however, you will give me 200 florins I will follow out my plan. Although, if hereafter somebody were to offer me 400 florins I would not paint another, for I shall not gain a penny over it, as a long time must still be spent on it. So, let me know your intention and then I will go to the Imhofs for 50 florins, for I have not as yet received any money on the work.

Now I commend myself to you. I want you also to know that in all my days I have never begun any work that pleased me better than this picture of yours which I am painting. Till I finish it I will not do any other work; I am only sorry that the winter will so soon come upon me. The days grow so short that one cannot do much.

I have still one thing to ask you; it is about the Madonna that you saw at my house; if you know of anyone near you who wants a picture, pray, offer it to him. If a proper frame were put on it, it would be a beautiful painting, and you know that it is nicely done. I will let you have it cheap. I would not take less than 50 florins to paint one like it. As it stands finished in the house it might get damaged; therefore I would give you full power to sell it for me for as cheaply as 30 florins—indeed, I would even let it go for 25 florins, rather than not having it sold. I certainly have lost much food over it.

NUREMBERG, November 4, 1508

Dear Herr Jacob Heller:

In my last letter I wrote you my candid and sincere opinion and you have angrily complained of it to my cousin, declaring that I twist my words. I have likewise since received your letter from Hans Imhof. I am justly surprised at what you say in it about my last letter; seeing that you accuse me of not keeping my promises to you. From such a slander each and every one exempts me, for I bear myself in such a manner, I trust, that I can always take my place among other straightforward men. Besides, I know well what I have written and promised you, and you know that in my cousin's house I refused to promise you to make a good thing, because I cannot. But I did pledge that I would make something for you that not many men can. Now I have given such exceeding pains to your picture that I was led to send you the aforesaid letter. I know that when the picture is finished all artists will be well pleased with it. It will not be valued at less than 300 florins. I would not paint another like it

35

for three times the price agreed, for, for it I neglect myself, suffer loss, and earn anything but thanks from you.

I am using, let me tell you, quite the finest colors I can get. Of ultramarine I shall want 20 ducats' worth alone, and that does not include the other expenses. Once the picture is finished, I am quite sure that you yourself will say that you have never seen anything more beautiful; but I dare not expect from beginning to end to finish the painting of the middle panel in less than thirteen months. I shall not begin any other work until it is finished, although this will be to my detriment. Then what do you suppose my expenses will be while I am working at it? You would not undertake to keep me for that time for 200 florins. Only think what you have repeatedly written about the materials. If you wanted to buy a pound of ultramarine you would hardly get it for 100 florins, since I cannot buy a good ounce of it for less than 10 to 12 ducats.

And so, dear Herr Jacob Heller, my writing is not so utterly crooked as you think, and I have not broken my promise in this matter.

Further, you reproach me with having promised you that I would paint your picture with the greatest possible care at my command. Certainly, I have never said that, or if I did, I was out of my senses because I would hardly be able to finish it in my lifetime. With such extraordinary care I can hardly finish a face in half a year; your picture contains fully 100 faces, not including the drapery and landscape and other things that are also a part of it. Besides, who ever heard of making such a work for an altarpiece? No one could see it. I think it was thus that I wrote you—that I would paint the picture with great or more than ordinary pains because of the time which you waited for me. . . .

<p align="right">NUREMBERG, July 24, 1509</p>

Dear Herr Heller:

I have read the letter which you addressed to me. You write that you did not mean to decline taking the picture from me. To that I can only say that I don't understand what you do mean. When you write that if you had not ordered the picture you would not make the bargain again and that I may keep it as long as I like and so on—I can only think that you have repented of the entire business, and to this I gave you my answer in my last letter.

But, at Hans Imhof's persuasion, and having regard for the fact that you commissioned me to paint the picture, and also because I prefer that it should find a place in Frankfurt rather than any-

where else, I have consented to send it to you for 100 florins less than it might well have brought me. Although you bargained with me to begin with for "about 130 florins," you must remember what I wrote to you and you to me in the sequel that followed. I only wish that I had painted it just in the way you bargained for—I should have finished it in half a year. But considering what you promised, and being desirous of pleasing you with it, I have now worked at the picture for more than a year, and I have painted over 25 florins' worth of ultramarine upon it. And I can tell you with perfect truth that I shall probably be out of pocket with what you pay me for this painting, for earning one and spending three is not the way to get very far. . . .

NUREMBERG, August 26, 1509

First my willing service to you, dear Herr Jacob Heller. . . . I have painted it with great care as you will see, using none but the best colors I could obtain. It is painted with good ultramarine under, and over, and over that again, some five or six times; and then, after it was finished I painted it again twice over so that it may last a long time. If it is kept clean I know it will remain bright and fresh 500 years, for it is not done as men are wont to paint. So have it kept clean and don't let it be touched or sprinkled with holy water. I feel sure that it will not be criticized, or only for the purpose of annoying me. . . .

I may tell you also that at my own expense I have had a new frame made for the middle panel which has cost me more than 6 florins. I have broken off the old one, for the joiner had made it roughly. I have not had the other fastened on, for you did not wish it. It would be a very good thing to have the rims screwed on so that the picture may not be shaken.

If anyone wants to see it, let it hang forward two or three finger breadths, for then the light is good to see it by. And when I come over to you, say in one, two, or three years' time, if the picture is properly dry, it must then be taken down and I will varnish it over anew with some excellent varnish, which no one else can make. It will then last 100 years longer. But don't let anybody else varnish it, for all other varnishes are yellow, and the picture would be ruined for you. And if a thing on which I have spent more than a year's work were ruined, it would be grief to me. When you have it set up, be present yourself, so that you can see that it will not be damaged. Deal carefully with it, for you will hear from your own and from foreign painters how it is done. . . .

Michelangelo Buonarroti

(1475–1564)

*Michelangelo, who, from a certain point of view, is
the inventor of the ideal among the moderns, is the
only man to have possessed the "graphic" imagination
in its supreme degree without being a colorist.*

CHARLES BAUDELAIRE

ON THE PAINTING OF
THE SISTINE CHAPEL

I've grown a goiter by dwelling in this den—
as cats from stagnant streams in Lombardy,
or in what other land they hap to be—
which drives the belly close beneath the chin:

my beard turns up to heaven; my nape falls in,
fixed on my spine: my breastbone visibly
grows like a harp: a rich embroidery
bedews my face from brush-drops thick and thin.

My loins into my paunch like levers grind:
my buttock like a crupper bears my weight;
my feet unguided wander to and fro;
in front my skin grows loose and long; behind,
by bending it becomes more taut and strait;
crosswise I strain me like a Syrian bow:

whence false and quaint, I know,
must be the fruit of squinting brain and eye;
for ill can aim the gun that bends awry.

Come then, Giovanni, try
to succor my dead pictures and my fame;
since foul I fare and painting is my shame.

38

ON PAINTING

Good painting is noble and devout in itself, for among the wise nothing tends more to elevate the soul or to raise it toward devotion than the difficulty of that perfection which approaches God and becomes one with Him. Good painting is but a copy of this perfection, a shadow of his pencil, a music, a melody, and only a very keen intelligence can feel the difficulty of it. That is why it is so rare and why so few people can attain to it or know how to produce it. Painting is the music of God, the inner reflection of his luminous perfection.

THREE LETTERS

JANUARY 27, 1509

Dearest father:

. . . I myself am quite concerned, for this Pope hasn't given me a single grosso for a whole year, and I am not asking for any, for my work is not progressing in such a way as to make me think that I deserve anything. This is due to the difficulty of the work, and also to the fact that *this is not my profession.** Yet I am wasting my time fruitlessly. God help me. If you need money, go to the Spedalingo and have him give you up to fifteen ducats; also, let me know how much you have left. During the last few days Jacopo,† the painter whom I called here, left Rome. Since he complained about me here, I imagine that he will complain about me in Florence also. I want you to lend a deaf ear. That's all. He is a thousand times wrong.

1549

Messer Benedetto:‡

So that it may be evident that I have received your little book, I shall reply to what you ask me, even if ignorantly. I say that painting is to be considered the better, the more it approaches relief, and relief is to be considered the worse, the more it approaches painting. And so I used to be of the opinion that sculpture is the lamp of painting, and between them there is the same difference that there is between the sun and the moon. Now that I have read your essay, in which you say that, philosophically speaking, those things which

* He is referring to painting.
† Jacopo dell' Indaco, a fellow apprentice at Ghirlandaio's studio, brought to Rome to help with the Sistine frescoes.
‡ Messer Benedetto Varchi, consul of the Florentine Academy. He solicited the opinions of many artists on the relative merits of the arts, for inclusion in a book of his lectures.

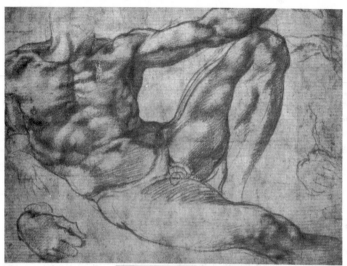

MICHELANGELO: *Studies for the Libyan Sibyl* (chalk drawings). The Metropolitan Museum of Art (Purchase, 1924, Joseph Pulitzer Bequest).

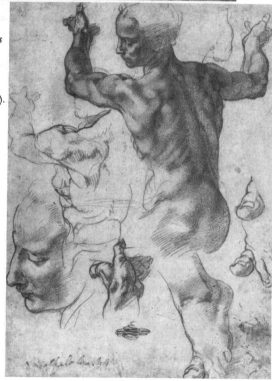

MICHELANGELO: *Study for the Sibyls* (chalk drawing).

have an identical goal are one and the same thing, I have changed my mind. And so I say that if greater judgment and difficulty, impediment and labor, do not constitute higher nobility, then painting and sculpture are essentially the same. And in order that this be upheld, every painter should think no less of painting than of sculpture. By sculpture I understand that art which operates by taking away. That art which operates by laying on is similar to painting. Suffice it to say that, since both emanate from one and the same intelligence, sculpture and painting can be made to live in harmony together, and give up so many lengthy arguments, for these arguments take up more time than the actual practice of both arts. The man who wrote that painting was more noble than sculpture did not know what he was writing about, and if he understood the other things about which he was writing no better, I am sure that my housemaid would have written more intelligently about them. There are infinite points not yet expressed which could be voiced on similar sciences; but, as I said, it would require too much time, and I have but little of it, for, not only am I old, but I am almost to be numbered among the dead. Therefore, I beg you to forgive me. Finally, I thank you from the bottom of my heart for the too great honor you have done me, which is more than I deserve.

APRIL 25, 1560

Most illustrious Duke of Florence:

I saw the designs of the rooms painted by Messer Giorgio,* and the model of the large hall† with Messer Bartolommeo's design of the fountain‡ which is to go in the said place. As for the paintings, I thought I saw some marvelous things, which is typical of all those which are or will be made under the patronage of your Excellency. As regards the model of the hall, as it is now it seems low to me. Since so much money is going to be spent, it should be raised at least twenty-four feet. Concerning the restoration of the palace, judging by the design I saw, I am of the opinion that it could not be carried out any better. As for the fountain of Messer Bartolommeo, I think it is a beautiful fantasy which will turn out an admirable thing. As regards the fabric of the Florentines** here, it grieves me that I am too old and near death to gratify your desire in full.

* *The Genealogy of the Gods,* by Vasari, in the old Palazzo della Signoria, which Cosimo was remodeling.
† Hall of the Five Hundred, in the Palazzo.
‡ Ammannati had entered the contest for the Fountain of Neptune in the Piazza della Signoria, and sent his designs to Michelangelo for his opinion.
** Church of the Florentines in Rome.

Titian Vecellio

(1477–1576)

The sensualist will find sensuality in Titian; the thinker will find thought; the saint, sanctity; the colorist, color; the anatomist, form; and yet the picture will never be a popular one in the full sense, for none of these narrower people will find their special taste so alone consulted, as that the qualities which would ensure their gratification shall be sifted or separated from others; they are checked by the presence of other qualities which ensure the gratification of other men.

JOHN RUSKIN

ON PAINTING

Titian used to say that not every painter had a gift for painting, and that many painters were disappointed when they met with difficulties in art, and that painting done under pressure by artists without the necessary talent, could only give rise to formlessness, because painting was a profession that required peace of mind. Furthermore, the painter must always seek the essence in things, always represent the essential characteristics and emotions of the person he is painting. . . . And finally, Titian related that it was good drawing and not color that made a painting beautiful.

RIDOLFI ON TITIAN

And even when he was very old and practically blind, not a day passed when he did not do something in either charcoal or chalk, these being the media he mostly used in drawing. . . .

He was a tireless worker who usually worked slowly and carefully from nature. He also copied famous statues* but he was clever enough to work over what he had done, altering it so that it did not appear to be an imitation. In painting clothes on figures he liked to use those reds and blues that always look well on figures. When possible he kept his paintings at home for some time, covering them up as soon as he had finished them, and then, after some time had elapsed, he would re-examine them, and change them several times until they reached perfection.

From *Delle maraviglie dell'arte,* by Ridolfi

* The figure of David and others.

Giorgione (Castelfranco Veneto)

(1478–1510)

The first master of the Venetian High Renaissance was Giorgione. . . . He is ranked among the greatest painters in history, for it was he who brought to Venetian painting most of the special qualities that set it apart from all the other styles of the sixteenth century. . . .
Michelangelo and Raphael had created an ideal world through their mastery of form; Giorgione created his ideal world—a warmer and more human one than theirs—out of light and color.

H. W. AND DORA JANE JANSON

RIDOLFI ON GIORGIONE

By mixing nature and art, he created such a beautiful world of color that I do not know whether to say that a new nature was produced by art or a new art discovered by nature to compete with the art that seeks to imitate her. . . .

It was certainly marvelous to see how that lad was able to add grace and tenderness to Bellini's color; it was as if he shared nature's ability to create human flesh through a mixture of the elements. Giorgione blended shadow and light with consummate delicacy, gently reddening those parts of the body where most blood flows. All his he did in the most pleasing manner that was ever seen. He well deserved the reputation of being the most talented painter of modern times, having invented such a beautiful style of painting.

Giorgione succeeded in finding an easy, unlabored style with which he concealed the difficulties encountered in his work. In imitating nature, he used only the few colors that were suitable to his subject matter.

From *Delle maraviglie dell'arte,* by Ridolfi

WHY PAINTING IS SUPERIOR TO SCULPTURE

It is related that Giorgione, in a conversation with certain sculptors, at the time when Andrea del Verrocchio was working on his bronze horse, was told that since sculpture was capable of exhibit-

43

ing the various aspects in one sole figure (since the spectator can walk around it), it must on this account be acknowledged as being the greater art, as painting could do no more than display a given figure in one particular aspect. Giorgione disagreed, stating that he was of the opinion that in one picture the painter could display the various aspects, with the additional advantage of making it unnecessary for a spectator to walk around the figure. He even argued that a painting could display, at one glance, all the different aspects that could be presented by the figure of a man, even though the latter should assume several attitudes, a thing that could not be accomplished by sculpture without forcing the observer to change his place, with the result that the work is not presented in one view, but in several. He declared further that he could execute a single figure in painting in such a manner as to show the front, the back, and the profiles of both sides, all at the same time. This assertion surprised his listeners beyond description. But Giorgione accomplished his purpose in the following way. He painted a nude figure with its back turned to the spectator, and at the feet of the figure was a limpid stream, wherein the reflection of the front was painted with utmost exactitude. On one side was a highly burnished corselet, of which the figure had divested itself: the left side of the figure being perfectly reflected, that is, every part being clearly recognizable. On the other side was a mirror in which the right side of the nude was clearly exhibited. By this beautiful and admirable invention, Giorgione desired to prove that painting is in effect the superior art, requiring more talent and demanding greater effort. He also demonstrated that a painting is capable of showing more from one view than a sculpture can. The work was greatly commended as being both ingenious and beautiful.

From *The Lives of the Painters,* by Vasari

Raphael Sanzio

(1483–1520)

Cold, insipid, complacent, academic—all these words are on our tongues, as they are when we read certain passages of Racine, and with as little justification. What saves him? First of all his supreme skill. . . . And then there is in Raphael, as in Racine and Mozart, an inner rhythm which is perceptible in every touch, and allows great precision without loss of grace or vitality. With Raphael all the weapons of academic technique become as sensitive and springy as a rapier.

KENNETH CLARK

ON HIS EDUCATION AS A PAINTER

Raphael—one of those possessed of such rare gifts that it is impossible to call them simple men, but rather, if it is permissible so to speak, mortal gods—was born in the city of Urbino. He was the son of Giovanni de' Santi, a painter but not a very excellent one, a man of good understanding, and capable of directing his son in that good way which unfortunately had not been shown to him in his youth. . . . And as soon as he was grown, he began to teach him painting, so that it was not long before he was able to help his father in many of his works. But at last, the good father, knowing that his son could learn little from him, determined to put him with Pietro Perugino, and going to Perugia, told him his desire. And Pietro, who was very courteous, and a lover of men of talent, accepted Raphael.

It is a well-known fact that while studying the manner of Pietro, Raphael imitated it so exactly at all points that his copies cannot be distinguished from the original works of the master. And as he became more skilled, he improved upon his master, in design, coloring, and invention. Having done this, it appeared to him that he had done enough; but as he grew older he realized clearly that he was still too far from the truth of nature. On becoming acquainted with the works of Leonardo da Vinci, who in the expression he gave to his heads had no equal, and who surpassed all others in the grace and movement which he imparted to his figures, Raphael was dumbstruck with astonishment and admiration. The manner of Leonardo pleased him more than any other he had ever seen, and he zealously set himself to studying it. By degrees, and with great difficulty, he abandoned the manner of Pietro, and he tried as much as possible to imitate Leonardo. But no matter how hard he

45

tried, there were certain artistic points in which he could never surpass Leonardo. There are many who do not doubt that Raphael surpassed Leonardo in tenderness and in a certain natural facility, but certainly he was by no means superior with regard to force of conception and grandeur, which is such a noble foundation in art. Nonetheless, Raphael approached Leonardo more closely than any other painter, and particularly in the area of coloring.

In the course of time, Raphael found a very serious impediment in the manner he had learned from Pietro and had so readily adopted.* He could not completely rid himself of the dry, minute, and even defective design. This caused him extreme difficulty in learning to treat worthily the beauties of the nude form, and to master the methods of those difficult foreshortenings which Michelangelo had executed in his Cartoon for the Hall of the Council in Florence. Now, any artist who lost courage in the belief that he had been wasting his time previously, would never, no matter how fine his genius, have been able to accomplish what Raphael did in his later years. For Raphael, having decided to acquire the manner of Michelangelo, which was indeed filled with difficulties, changed his position from master to that of disciple. Through an incredible effort he achieved in a few months that which a man in his youth—when learning comes easy—would have taken years to achieve.

At the time when Raphael decided to change his manner, he had never given his attention to the nude form with the degree of care and study which this subject demands. Previously he had drawn it from life only in the manner of Pietro, but naturally endowing it with the grace that had been imparted to him by nature. But thenceforth he devoted himself to the anatomical study of the nude figure; and he investigated the muscles in dead and excoriated bodies as well as those of the living. In the living, the muscles are not as easily recognized, because they are covered by skin. It was in this way that Raphael learned how the muscles become soft or tense; he learned their correct proportions; their location in the body; and finally, how through certain flexing of the muscles the perfection of grace may be attained in some attitudes. Thus he also became aware of the effects produced by the inflation of parts, and by the elevation or depression of any given portion or separate member of the body or of the whole frame. Through this research he also became acquainted with the articulations of the bones, with the distribution of the nerves, the course of the veins, etc.

* In a note to Vasari, the Cavalier Tommaso Puccini registered his dissent. He stated that he "could not agree with Vasari since it is certain that Raphael owes at least half of his success to Pietro."

And even though he made a profound study of the human body, he realized fully that painting certainly did not end with the delineation of the nude form, but that it was a much wider field. He perceived that those who possess the power of expressing their thoughts well and with facility, and of giving effective form to their conceptions, deserved equally to be counted among the great painters. And furthermore, he understood, that he, Raphael, who in the composition of his pictures would neither confuse them by too much, nor render them poor through too little, but rather give everything its rightful arrangement and just distribution, could also become a judicious and able master.

But additionally, Raphael correctly judged that art should be further enriched through new and varied inventions in perspective, with views of buildings, with landscapes, with a graceful manner of clothing figures, and by placing figures in shade and light. He also recognized the significance of giving beauty and animation to the heads of women and children, and of imparting to all, whether male or female, young or old, such an amount of spirit and movement as was warranted by the particular occasion. Likewise he gave the proper values to the attitudes of horses in battle scenes, to their movements in flight, and to the bold bearing of the warriors. The correct representation of animals in all their varied forms did not escape his consideration; neither did the portraying of men in such a way that they would appear alive and be recognized for those whom they were supposed to represent. Raphael also thought that the innumerable accessories of all kinds should be taken into account. For example, he carefully arranged draperies and vestments; he gave careful attention to helmets and other elements of armour; he made sure that his figures wore the appropriate clothing. He recognized that equal care should be given to the hair and the head of figures, to vases, trees, grottoes, rocks, fires, the air (either turbid or serene), to clouds, rain, storms, to the darkness of the night, to the moonlight, to sunshine, and to an infinite variety of objects. Thus it was his belief that painting required that the appropriate attention be given to a great diversity of items.

Thus Raphael resolved that since he could not attain the eminence of Michelangelo in one specific area, he would attempt to equal him or perhaps even surpass him in the areas that have just been enumerated. And he gave up his attempts to imitate Michelangelo, lest he should waste his time, and instead concentrated on attaining perfection in the area he had chosen.

From *The Lives of the Painters*, by Vasari

Hans Holbein, the Younger

(1497–1543)

If you will examine the matter closely, nothing in a portrait is a matter of indifference. Gesture, grimace, clothing, décor even—all must combine to realize a character. Great painters . . . Holbein, in all his portraits—have often aimed at expressing the character which they undertook to paint, with sobriety but with intensity.

CHARLES BAUDELAIRE

AT THE COURT OF KING HENRY VIII

. . . It happened that an English Earl once came to visit Holbein. He wished to see the painter's pictures, and the work upon which he was engaged at that time. This did not please Holbein, who painted everyone from life, and who just then needed privacy for his work. For this reason, the artist declined to receive the Earl, and he did so with the greatest possible politeness. He asked the Earl again and again to pardon him for his refusal, for there was a reason why he could not accept the visit. And he asked the Earl to please call at another time. But no matter how politely and how humbly Holbein explained the matter, the Earl refused to give up, and tried to pass the artist on the stairway, showing forcefully that a person of His Grace's importance should be more feared, and treated with more deference, by a painter. Holbein warned the Earl not to carry out his intention. But the Earl persisted, whereupon Holbein grappled with him and threw him down the stairs. As he fell, the Earl exclaimed, "O Lord, have mercy on me."

The noblemen in attendance on the Earl had their hands full taking care of him. In the meantime, Holbein closed his door and secured it well, climbed out through a window that led to the roof, and hurried to the King to ask that he be pardoned, without telling what had happened. The King asked Holbein repeatedly what he had done, and was willing to pardon him if he would confess his crime. Holbein did so, openly and completely. The King responded as if it were most difficult for him to pardon Holbein, and told him not to act so boldly again. His Majesty ordered the artist not to leave, and to remain in one of the royal chambers, until more could be learned about the Earl's condition.

Very soon the Earl arrived. Carried on a royal litter, he was brought before the King, wounded and in bandages. He complained, in a very weak voice, about the painter who had treated him so badly; but the truth was only partly told, and the charge was made worse by lies, just for spite, all to the detriment of Holbein—as the King well understood.

The Earl, after finishing his complaint, asked the King to punish the culprit adequately and justly, as such injury to his personage demanded. In his temper, the Earl noticed that the King was not greatly impressed and not very eager to fulfill his wishes, had not asked much about the case, and had remained rather cool about the matter. It seemed to him that the King was not much inclined to punish Holbein sufficiently, so the Earl gave the King to understand that he wanted to take revenge himself.

The King became angry that the Earl should speak so impertinently in His Majesty's presence, as if the Earl wanted to place himself in the position of the King. His Majesty said, "Now you have no more dealings with Holbein, but with my royal self." He raised his voice and began to threaten the Earl, saying, "Do you imagine that I care so little for that man? I tell you, Earl, that if it pleased me to make seven dukes of seven peasants, I could do so, but I could not make of seven earls one Hans Holbein, or anyone as eminent as he."

THE PORTRAIT OF HENRY VIII

. . . Among the pictures which Holbein painted for Henry VIII, there is an excellent portrait of His Majesty. This portrait is full length, life-size, and so lifelike that everyone who sees it is frightened, it looks as if it were alive and the head and legs move naturally.

From *Dutch and Flemish Painters*, by Carel van Mander

Giorgio Vasari

(1511–1576)

Vasari's treatise contains a complete survey of the manual activities of the time, in connection with which Vasari gives us very important information on the condition of technique in the sixteenth century.

ERNST BERGER

ON FORESHORTENING

Our artists have had the greatest skill in foreshortening figures, that is, in making them appear larger than they really are; a foreshortening being to us a thing drawn in shortened view, which seeming to the eye to project forward has not the length or height that it appears to have; however, the mass, outlines, shadows, and

lights make it seem to come forward and for this reason it is called foreshortened. Never was there a painter or a draftsman that did better work of this sort than our Michelangelo Buonarroti, and even yet no one has been able to surpass him because he has so well succeeded in making his figures stand out so marvelously. For this work* he first made models in clay or wax, and from these, because they remain stationary, he took the outlines, the lights, and the shadows, rather than from the living model. These foreshortenings give the greatest trouble to him who does not understand them because his intelligence does not help him to reach the depth of such a difficulty, to overcome which is a more formidable task than any other in painting. Certainly our older painters, as lovers of the art, found the solution of the difficulty by using lines in perspective, a thing never done before, and made therein so much progress that today there is true mastery in the execution of foreshortenings.

ON COLORING

Unity in painting is produced when a variety of different colors are harmonized together, when these colors in all the diversity of many designs show the parts of the figures distinct the one from the other, as the flesh from the hair, and one garment different in color from another. When these colors are laid on flashing and vivid in a disagreeable discordance, so that they are like stains and loaded with body, as was formerly the wont with some painters, the design becomes marred in such a manner that the figures are left painted by the patches of color rather than by the brush, which distributes the light and shade over the figures and makes them appear natural and in relief. All pictures, then, whether in oil, in fresco, or in tempera, ought to be so blended in their colors that the principal figures in the groups are brought out with the utmost clearness, the draperies of those in front being kept so light that the figures which stand behind are darker than the first, and so little by little as the figures retire inwards, they become also in equal measure gradually lower in tone in the color both of the flesh tints and of the vestments. And especially let there be great care always in putting the most attractive, the most charming, and the most beautiful colors on the principal figures, and above all on those that are complete and not cut off by others, because these are always the most conspicuous and are more looked at than others which serve as the background to the coloring of the former. A sallow color makes another which is placed beside it appear more

* The figure of Jonah on the end wall of the Sistine Chapel.

lively, and melancholy and pallid colors make those near them very cheerful and almost of a certain flaming beauty.

PAINTING IN TEMPERA

Before the time of Cimabue and from that time onwards, works done by the Greeks in tempera on panel and occasionally on the wall have always been seen. And these old masters, when they laid the gesso ground on their panels, fearing lest they should open at the joints, were accustomed to cover them all over with linen cloth attached with glue of parchment shreds, and then above that they put on the gesso to make their working ground. They then mixed the colors they were going to use with the yolk of an egg and shredded into it a tender branch of a fig tree, in order that the milk of this with the egg should make the tempera of the colors, which after being mixed with this medium, was then ready for use. They chose mineral colors for these panels. Some of the colors were prepared by chemists, whereas others were found in mines. For this kind of work all pigments are good, except the white used for work on walls made with lime, for that is too strong. It is in this manner that their works and their pictures are executed, and this method is called coloring in tempera.

PAINTING ON CANVAS

Unless canvases intended for oil painting are to remain stationary, they are not covered with gesso because it would interfere with their flexibility. The gesso would crack if the canvases were rolled up. However, there is a paste, made of flour and walnut oil mixed with two or three measures of white lead, which is spread on the canvas with a knife, after the canvas has been covered from one side to the other with three or four coats of smooth size. With this paste the artist fills in all the holes that are on the canvas. When this is done, the artist applies one or two more coats of soft size followed by the composition or priming. . . . Because painting on canvas has seemed easy and convenient it has been adopted not only for small pictures that can be carried about, but also for altarpieces and other important compositions, such as are seen in the halls of the palace of San Marco at Venice and elsewhere. Consequently, where the panels are not sufficiently large, they are replaced by canvases on account of the size and convenience of the latter.

From *On Technique,* by Vasari

Jacopo Robusti Tintoretto

(1518–1594)

In fact, only two of the great mannerists produced landscapes of any significance. They are Tintoretto and El Greco. With Tintoretto nature was caught up in the rushing wind of his genius and made to serve the purpose of his colossal invention.

KENNETH CLARK

ON PAINTING

Tintoretto used to say that the study of painting was hard work, and most difficulties appeared to that painter who had most profoundly advanced into it. He said that young students, if they wished to profit, should never depart from the paths of the greatest painters, especially from Michelangelo and Titian, one being marvelous in drawing and the other in color. He also related that since nature was always the same, one should not capriciously change the muscles of figures.

He also said that in judging a painting one should observe whether at first viewing the eye was gratified and whether the artist had observed the rules of art; as for the rest, he felt that everyone makes mistakes in small things.

When asked which were the most beautiful colors, he said black and white because one gives force to the figures by deepening the shadows, and the other relief.

He further stated that only skilled artists should draw from live models because they usually lacked both grace and fine form. And he said that whereas beautiful colors were sold in the shops of the Rialto, drawing was only to be obtained from the box of talent and that it required long study, often late into the night, and hence, drawing was practiced and understood by only a few men.

RIDOLFI ON TINTORETTO

At great expense, he began to collect from many places plaster casts of antique statues; from Florence he obtained Daniello Volteranno's miniature copies of the statues in the Medici Chapel: Aurora (Dawn), Crepuscolo (Twilight), Notte (Night), and Giorno (Day). He studied all of these statues with particular care,

making thousands of drawings of them by lamplight, in order to acquire, by means of the deep shadows cast by that kind of a light, a strong style of drawing in relief. He continuously copied the various parts of these statues (hands, arms, torsos, etc.), drawing them in charcoal or water colors on colored paper, drawing in the highlights with chalk or white lead.

His acute intellect made him aware of the fact that in order to become a great painter one had to become skilled in copying reliefs, and that strict imitation of nature was not enough. For nature produces mostly imperfect things, and only rarely links together parts of equal beauty. He believed that it was the intention of excellent artists to take from nature an extract of the beautiful and then add what was lacking, thereby making nature appear entirely perfect. He never ceased to copy the paintings of Titian, and it is from these paintings that he learned the art of good coloring.

He also worked from live models. From them he made a great many studies in foreshortening. He tried to connect with nature that which he observed in reliefs, learning harmony from one and correct form from the other. Sometimes he dissected corpses so as to see how the muscles worked.

He also learned by making little models out of wax or clay and dressing them in scraps of cloth and carefully draping them so that the folds emphasized the shape of the limbs. These small models he placed in little houses and perspective boxes. He would place little lights in the windows so that light and shade would be produced. Still other models he suspended from the beams of his ceiling. This enabled him to observe the effect they made when seen from below, from which he learned how to make foreshortenings for ceiling frescoes.

One of Tintoretto's attributes, praised by many an artist, was his ability to imagine the effect that a painting would make when hung in a particular place.* This meant that he understood how much finish would be required of a particular painting. But at all times his masterly brushwork was "free."

From *Delle maraviglie dell'arte*, by Ridolfi

* Ridolfi explains that it is not always praiseworthy for a painter to use delicacy and finish. It is especially unnecessary in the case of paintings that are to be hung at a distance from the spectator, since the space that exists between him and the painting will harmonize the vigorous brush strokes and make them appear soft and agreeable.

Paolo Veronese

(1528–1588)

Those painters who have best understood the art of producing a good effect, have adopted one principle that seems perfectly conformable to reason; that a part may be sacrificed for the good of the whole. Thus, whether the masses consist of light or shadow, it is necessary that they should be compact and of a pleasing shape; to this end, some parts may be made darker and some lighter, and reflections stronger than nature would warrant. Paul Veronese took great liberties of this kind. It is said, that being once asked, why certain figures were painted in the shade, as no cause was seen in the picture itself, he turned off the enquiry by answering, "una nuevola che passa," a cloud is passing which has overshadowed them.

<div align="right">SIR JOSHUA REYNOLDS</div>

THE TRIAL OF PAOLO VERONESE

<div align="right">SATURDAY, July 18, 1573</div>

Having been summoned by the Holy Office to appear before the Sacred Tribunal, Paolo Caliari of Verona, domiciled in the Parish of San Samuel, when questioned about his name and surname, answered as above.

When questioned about his profession he replied:

I paint and make figures.

Question: Do you know the reason why you have been summoned here?

Answer: No, my lords.

Question: Can you imagine it?

Answer: I can well imagine it.

Question: Tell us what you can imagine.

Answer: According to what the Reverend Father, that is, the Prior of SS. Giovanni e Paolo, whose name is unknown to me, told me, Your Illustrious Lordships ordered him, when he was here, to have me paint a Magdalen in place of a dog, in my painting.* I told him that I would gladly have done this and for that matter anything else, for both my honor and that of my painting, had I felt that such a figure would be suitable. However, I did not

* Now known as *The Feast in the House of Levi.*

<div align="center">55</div>

feel, and for many reasons which I shall state provided that I am given the opportunity, that a Magdalen belonged in the painting.

Question: What picture are you referring to?

Answer: This picture is of the Last Supper that Jesus Christ took with his Apostles in the House of Simon.

Question: Where is this picture?

Answer: In the Refectory of the Friars of SS. Giovanni e Paolo.

Question: Is it on the wall, on a panel, or on a canvas?

Answer: On canvas.

Question: How high is it?

Answer: It is about seventeen feet high.

Question: How wide is it?

Answer: About thirty-nine feet.

Question: Did you paint any attendants in this painting of the Supper of Our Lord.

Answer: Yes, my lords.

Question: Tell us how many attendants there are, and what each one is doing.

Answer: There is Simon, the owner of the inn. Next to this figure I painted a steward who I supposed had come there for his own pleasure, to see how things were going. There are also many other figures I do not remember because a long time has gone by since I painted the picture.

Question: Aside from this one, have you painted other Suppers?

Answer: Yes, my lords.

Question: How many have you painted, and where are they?

Answer: In Verona I painted one for the reverend monks of San Nazzaro. It is to be found in their refectory. I also painted one here in Venice, for the reverend fathers of San Giorgio. It is located in their refectory.

He was told that this was not a Supper.

Question: We are asking about Our Lord's Supper.

Answer: I painted one in the refectory of the Servi of Venice, another one in the refectory of San Sebastian here in Venice. I also painted one in Padua for the fathers of Santa Maddalena. Aside from these, I do not remember having painted any others.

Question: In the Supper which you painted for SS. Giovanni e Paolo, what is the meaning of the figure of the man with the bleeding nose?

Answer: I intended to show a servant whose nose was bleeding due to some accident.

Question: What is the significance of the armed men who are dressed as Germans, and who hold halberds in their hands?

Answer: To answer this properly, I must say a few words on the subject.

Question: Say them.

Answer: We painters take the same liberties that poets and madmen take, and I have showed the two halberdiers—one drinking and one eating near a staircase. They are there to be of service, because it seemed fitting to me that the master of the house, who was great and rich according to what I was told, should have such servants.

Question: And why did you place the man dressed as a buffoon with the parrot on his wrist, on that canvas?

Answer: For ornamental reasons, as is customary.

Question: Who is sitting at Our Lord's table?

Answer: The Twelve Apostles.

Question: What is St. Peter, the first one, doing?

Answer: He is carving the lamb so as to pass it to the other end of the table.

Question: What is the one next to him doing?

Answer: He is holding a plate so that he may receive what St. Peter will serve him.

Question: Tell us what the next one is doing?

Answer: He has a toothpick; he is cleaning his teeth.

Question: Who do you believe really was at that Last Supper?

Answer: I believe that Christ was there with His Apostles; but if there is extra space in a painting, I adorn it with figures according to my fancy.

Questioned if he had been commissioned to paint Germans, buffoons, and other such things in the picture, Veronese replied: No, my lords, but I was commissioned to decorate the picture in any way I wished. It is a large painting and it seemed to me that there was room for many figures.

Asked next whether the decorations which he as a painter was accustomed to add to paintings or pictures were usually placed there because they were proper and fitting to both the subject matter and the principal figures, or whether they were really invented according to his pleasure, that is, things that came into his head without his exercising any judgment or discretion, Veronese replied: I paint pictures as best as I am able, bearing in mind what is fitting.

Then asked if it seemed fitting to him to paint buffoons, drunkards, Germans, dwarfs, and similar obscenities in a picture depicting the Last Supper of Our Lord, he replied: No, my lords.

Question: Is it not known to you that in Germany and other places diseased with heresy it is usual by means of scurrilous pictures

and other such inventions to mock at, abuse, and sneer at the things of the Holy Catholic Church, in order to teach false doctrines to stupid and ignorant people?

Answer: Yes, my lord, that is wrong. But I repeat what I have said before, namely, that I must do what my betters have done before me.

Question: What did your betters do? Did they perhaps do similar things?

Answer: In the Pontifical Chapel in Rome, Michelangelo painted Our Lord Jesus Christ, His Mother, St. John, St. Peter, and the Heavenly Host all in the nude—even the Virgin Mary. And they are shown in different poses, with not much reverence.

Question: Are you not aware of the fact that no clothes are necessary in a painting of the Last Judgment because no clothes or similar things are presumed, and also that there is nothing in those figures that is not spiritual? There are no weapons, jesters, dogs, or similar buffooneries. And do you assume simply because of this or because of any other example that you were right in painting the picture the way you did? And do you intend to defend the painting and insist that it is good and not obscene?

Answer: My illustrious lords, no, I do not want to defend the picture, but I did believe that I was doing right. I did not consider many things, for I did not believe that anyone would be disturbed, particularly since the figures of the buffoons are placed outside of the hall where Our Lord is seated.

*As a result of this session of the Tribunal, the judges decreed that Veronese, at his own expense, would have three months in which to execute the necessary changes. It was further stated that should he refuse to make the changes, he would be liable to penalties that the Sacred Tribunal would wish to impose.**

From the records of Veronese's examination

* Veronese did not make all the ordered changes. However, he did change the title of the painting, thereby granting that he was not painting The Last Supper. Apparently this satisfied the judges of the Inquisitional Tribunal.

Peter Bruegel, the Elder

(1529–1569)

In Bruegel's work there is no borrowing from Italian art, so usual in the Netherlands in the first half of the century; no classic balance; none of the formal beauty of the High Renaissance; no suggestion of Mannerism; no prelude to the coming Baroque style of Rubens in the next century. Bruegel, the greatest Flemish artist of his century, is the exception to the general rule. What he does anticipate is the realistic rendering of peasant scenes, the genre and landscape art of seventeenth century Holland.

<div align="right">PAUL J. SACHS</div>

HOW BRUEGEL WENT ON TRIPS AMONG THE PEASANTS

Peter painted many pictures from life on his journey, so that it was said of him that while he visited the Alps, he had swallowed all the mountains and cliffs, and, upon coming home, had spit them forth upon his canvas and panels; so remarkably was he able to follow these and other works of nature.

. . . With his friend the merchant Franckert, Bruegel often went on trips among the peasants, to their weddings and fairs. The two dressed like peasants, brought presents like the other guests, and acted as if they belonged to the families or were acquaintances of the bride or groom. Here Bruegel delighted in observing the manners of the peasants, in eating, drinking, dancing, jumping, making love, and engaging in various drolleries, all of which he knew how to copy in color very comically and skillfully, and equally well with water color and oils; for he was exceptionally skilled in both processes.* He knew well the characteristics of the

* Van Eyck, Dürer, L. van Leyden, Bruegel were in the habit of spreading the white ground over panels more thickly than we do: they then scraped the surface as smooth as possible. They also used cartoons, which they laid on the smooth fair white ground, and then sat down and traced them, first rubbing any dark (powder) over the back of the drawing. They then drew in the design, beautifully with black chalk or pencil. But an excellent method, which some adopted, was to grind coal black finely in water; with this they drew in and shaded their designs with all possible care. They then delicately spread over the outline a thin priming through which every form was seen, the operation being calculated accordingly, and this priming was flesh-colored (Van Mander).

peasant men and women of the Kampine and elsewhere. He knew
how to dress them naturally and how to portray their rural, un-
couth bearing while dancing, walking, standing, or moving in dif-
ferent ways. He was astonishingly sure of his composition and drew
most ably and beautifully with the pen. He made many sketches
from nature. From *Dutch and Flemish Painters,* by Carel van Mander

BRUEGEL: *Die Mäher.* Hamburger Kunsthalle.

Giovanni Paolo Lomazzo

(1538–1600)

Lomazzo's treatise was widely read and used until the nineteenth century and is of great importance for an understanding of Mannerism.

<div align="right">ELIZABETH G. HOLT</div>

OF THE DIVISIONS OF PAINTING

Painting is either contemplative or practical. The contemplative establishes general precepts which must be learned by everyone who wishes to become famous in the art. The practical offers observations of discretion and judgment, by teaching how to put that into practice which is generally conceived. . . . The contemplative part has five divisions. The first deals with *proportion;* the second with the *motions, actions,* and *situations* of figures; the third with *color;* the fourth with *light;* the fifth with *perspective.*

There are two aspects to proportion. Either it is direct—expressing the exact and true proportion of the thing to be represented (i.e., if a man's stature consists of nine or ten faces in length, then his face should be a ninth or a tenth part thereof)—or else the proportion is in perspective in respect to the eye. This proportion differs very much from the other. For in this case the proportion of the head or face to the whole body depends upon the distance the object is from the eye.

From *A Tracte Containing the Arts of Curious Painting,* by Lomazzo

El Greco (Domenico Theotocopoulos)

(1541–1614)

Mannerism—and El Greco may be regarded by those who enjoy a paradox as the greatest Italian mannerist—allowed a distortion of form never again contemplated until about 1910. . . .

<div align="right">KENNETH CLARK</div>

ON HIS WAY OF PAINTING

Domenico Greco, in the year 1611, showed me an entire cupboard filled with earthenware models he had made to be used for his works. And what exceeds admiration, he had originals of all his pictures, painted in oil in a small scale. . . .

Who could believe that Domenico Greco often went back to his paintings and retouched them again and again, only to leave the colors distinct and unblended and to give them the look of brutal sketches, like an affectation of vigor? . . .

I was much amazed when I asked Domenico Greco in the year 1611 which was the most difficult, the color or the drawing, and he replied, the color. And still more amazing was to hear him speak with so little respect of Michelangelo—the father of painting—saying that he was a worthy man, but that he never learnt how to paint. Furthermore, for anyone who knows the man, it will not come as a surprise that he had sentiments different from the common sentiments of artists, for he was as unique in all else, as he was in his painting.

HIS MANNER OF LIVING

About the same time there came from Italy a painter called Domenico Greco, said to have been a pupil of Titian. He made his home in the very ancient and illustrious city of Toledo, where he introduced a manner so extravagant that to this day nothing so fanciful has been seen. And the greatest connoisseurs would be hard put to imagine his extravagance, for such is the discordance between his works that they do not look to be by the same hand. He came to this city with a great reputation, so great that it was given to be understood that nothing in the world was superior to his works. And, in very truth, some are worthy of the highest esteem and capable of ranking him among the most famous painters. His character is as extravagant as his painting. It has never been heard said that he ever made a contract for any of his works, for to his mind no price was high enough to pay for them. . . . He earned much money, but he spent it lavishly in maintaining a style of living luxurious in the extreme. Indeed, he went so far as to keep musicians in his hire to soothe and distract him while he took his meals. He worked a great deal and the sole wealth he bequeathed at his death amounted to two hundred unfinished pictures. He reached an advanced age, ever enjoying the same esteem and repute. He was a famous architect and very eloquent of speech. He had few pupils, for few were minded to follow his doctrines, so fanciful and extravagant that they were suited only to himself.

From *Arte de la pintura,* by Pacheco

Francisco Pacheco

(1564–1654)

His painting academy was one of the cultural centers of the city and attracted not only literati but such outstanding pupils as Velazquez, Alonso Cano, and possibly also Zurbarán. . . . Belonging to the same transitional generation between Mannerism and Baroque as Carducho, Pacheco is, however, much more favorably inclined towards naturalism.*

ELIZABETH G. HOLT

ON PAINTING

Drawing is the life and soul of painting; drawing, especially outline, is the hardest; nay, the Art has, strictly speaking, no other difficulty. Here are needed courage and steadfastness; here giants themselves have a lifelong struggle, in which they can never for a moment lay aside their arms. . . .

In the works of the masters we see much draftsmanship, much consideration and tact, much depth, knowledge, and anatomy, much purposes and truth in the muscles, *much discrimination in the different kinds of clothes and silks,* much finish in the parts, in drawing and color, much beauty and *diversity in the features,* much Art in foreshortening and perspective, much ingenuity *in adapting the light effects* to the place—in short, much care and diligence in discovering and disclosing those points that are most difficult to master. . . .

I adhere in all things to Nature, and if I could have her uninterruptedly before my eyes for each detail, it would be all the better.

From *Arte de la Pintura,* by Pacheco

* Seville.

Peter Paul Rubens

(1577–1640)

*In his art, all the animal instincts of human nature
appear on the stage; those which convention had ex-
cluded as gross he reproduces as true, and mingles
them with other human emotions just as they are
intermingled in life.*

HIPPOLYTE TAINE

FIVE LETTERS

VALLADOLID, May 24, 1603

To Annibale Chieppio:

Malicious fate is jealous of my too great satisfaction: as usual, it
does not fail to sprinkle in some bitterness, sometimes conceiving a
way to cause damage which human precaution cannot foresee, still
less suspect. Thus the pictures which were packed with all possible
care by my own hand, in the presence of my Lord the Duke, then
inspected at Alicante, at the demand of the customs officials, and
found unharmed, were discovered today, in the house of Signor
Hannibal Iberti, to be so damaged and spoiled that I almost despair
of being able to restore them. . . . The colors have faded and,
through long exposure to extreme dampness, have swollen and
flaked off, so that in many places the only remedy is to scrape them
off with a knife and lay them on anew.

Such is the true extent of the damage. (Would it were not!) I
am in no way exaggerating, in order to praise the restoration later.
To this task I shall not fail to apply all my skill, since it has pleased
His Most Serene Highness to make me a guardian and bearer of the
works of others, without including a brush stroke of my own. I say
this not because I feel any resentment, but in reference to the sug-
gestion of Signor Hannibal, who wants me to do several pictures
in great haste, with the help of Spanish painters. I agreed to this,
but I am not inclined to approve of it, considering the short time
we have, as well as the extent of the damage to the ruined pictures;
not to mention the incredible incompetence and carelessness of the
painters here, whose style (and this is very important) is totally
different from mine. God keep me from resembling them in any

64

way! In short, *pergimus pugnantia secum; cornibus adversis componere.**

Moreover, the matter will never remain secret, because of the gossiping of these same assistants. They will either scorn my additions and retouches, or else take over the work and claim it as all their own, especially when they know it is in the service of the Duke of Lerma, which may easily mean that the paintings are destined for a public gallery. As for me, this matters little, and I willingly forgo this fame. But I am convinced that, by its freshness alone, the work must necessarily be discovered as done here (a thankless trick), whether by the hands of such men, or by mine, or by a mixture of theirs and mine (which I will never tolerate, for I have always guarded against being confused with anyone, however great a man). And I shall be disgraced unduly by an inferior production unworthy of my reputation, which is not unknown here.

ROME, February 2, 1608

To Annibale Chieppio:

You must know, then, that my painting for the high altar of the Chiesa Nuova turned out very well, to the extreme satisfaction of the Fathers and (which rarely happens) of all others who saw it. But the light falls so unfavorably on this altar that one can hardly discern the figures or enjoy the beauty of coloring, and the delicacy of the heads and draperies, which I executed with great care, from nature, and completely successfully, according to the judgment of all. Therefore, seeing that all the merit in the work is thrown away, and since I cannot obtain the honor due my efforts unless the results can be seen, I do not think I will unveil it. Instead I will take it down and seek some better place for it, even though the price has been set at 800 crowns (at 10 jules to the crown), that is, ducatoons. But the Fathers do not wish the picture to be removed unless I agree to make a copy of it by my own hand, for the same altar, to be painted on stone or some material which will absorb the colors so that they will not be reflected by this unfavorable light. I do not, however, consider it fitting to my reputation that there should be in Rome two identical pictures by my hand. . . .

In order that you may be well informed on everything, I will tell you that the composition is very beautiful because of the number, size, and variety of the figures of old men, young men, and ladies richly dressed. . . .

* We proceed to combine things that are hostile, with horns directed against each other.

65

To Sir Dudley Carleton:

. . . The third picture is painted on a panel about three and a half feet long by two and a half feet high. The subject is truly original—neither sacred nor profane, so to speak, although drawn from the Holy Scripture. It represents Sarah in the act of reproaching Hagar, who, pregnant, is leaving the house with an air of womanly dignity, at the intervention of the patriarch Abraham. I did not give the measurements of this one to your man* since it already has a little frame on it. It is done on a panel because small things are more successful on wood than on canvas; and being so small in size, it will be easy to transport. According to my custom, I have employed a man competent in his field to finish landscapes,† solely to augment Your Excellency's enjoyment. But as for the rest, you may be sure that I have not permitted a living soul to lay a hand on them. . . .

To William Trumbull:

I am quite willing that the picture done for my Lord Ambassador Carleton be returned to me and that I paint another Hunt less terrible than that of lions, with a rebate on the price, as is reasonable, for the amount already paid: and all to be done by my own hand, without a single admixture of anyone else's work. This I will maintain on my word as a gentleman. I am very sorry that there should have been any dissatisfaction in this affair on the part of my Lord Carleton, but he never let me understand clearly, although I asked him to state whether this picture was to be a true original one, or one merely retouched by my hand.

To Justus Sustermans:

. . . I am afraid that a fresh painting, after remaining so long packed in a case, might suffer a little in the colors, particularly in the flesh tones, and the whites might become somewhat yellowish. But since you are such a great man in our profession, you will easily remedy this by exposing it to the sun, and leaving it there at intervals. And if need be, you may, with my permission, put your hand to it and retouch it wherever damage or carelessness may render it necessary. And once more I kiss your hands.

* Carleton's man visited Rubens in order to obtain measurements of all the paintings Rubens was preparing for Carleton, so that frames could be prepared.
† Jan Wildens.

Frans Hals

(1580–1666)

. . . Like Rubens, Hals took from the Venetians both their color and their sweeping brushstrokes.

ANDRÉ MALRAUX

Hals went the way of nearly all Dutch artists who attached themselves to the Flemish traditions in their beginnings; that is to say, he passed from the love of showy and garish joyousness in color to the quietness of monochrome. . . .

His superb brushwork and his clear, almost dry handling of color, which brought out in such a vivid manner the structure of things, astonish us afresh every time we examine them.

M. J. BINDER

AN ANALYSIS OF HIS ART

He was not long in making up his mind; his judgment was rapid. Hals was only a practical painter, I warn you at once of that; but as a practical craftsman he is one of the most skillful and expert masters that ever existed anywhere, even in Flanders, in spite of Rubens and Van Dyck, even in Spain, in spite of Velazquez. . . .

Hals is forty-seven years of age. Here is his most masterly work in this dazzling kind, with its rich range of colors. *The Meeting of the Officers of the Cluveniersdoelen* is entirely beautiful, not the most piquant of his works, but the most lofty, the most exuberant, the most substantial, the most learned. In it there are no set purposes, no affectation of placing his figures outside the air rather than in it or of creating a void round about them. He evades none of the difficulties of an art which, if it is well understood, accepts them all and solves them.

Perhaps, taken individually, the heads are less perfect than in the *Banquet of the Officers of the St. Jorisdoelen in Haarlem,* less spiritually expressive. With the exception of this accident, which might be as much the fault of the models as of the painter, the picture as a whole is superlatively good. The background is dark, and consequently the values are reversed. The black of the velvets, the silks, the satins, has a more fantastic effect; the lights unfold, the colors

67

stand out with a breadth, a conviction, and in harmonies which Hals never surpassed. As beautiful, as accurately observed in their shades as in their lights, in their strength as in their softness, it is a delight to the eye to see their richness and simplicity, to examine their choice, their number, their infinite shades, and to admire their most perfect union. The left half, in full light, is astonishing. The pigment itself is of the rarest; thick flowing colors, firm and full, thickly or thinly laid on according to need; the execution is free, wise, supple, daring, never wild, never insignificant. Each thing is treated according to its interest, its true nature, and its worth. In certain details we can detect a painstaking care, while others have been merely skimmed over. The guipures are flat, the lace is light, the satins glistening, the silks heavy-looking, the velvets more absorbent—all this without minutiae or narrowness. The picture discloses in its author a spontaneous feeling for the substances of things, a sense of proportion without the least error, the art of being precise without explaining too much, of making you understand everything with half a word, of omitting nothing but taking the unnecessary for granted; the touch expeditious, prompt, and rigorous; the right word in the right place, and nothing but the right word, found at the first attempt and never overdone; there is no turbulence and nothing superfluous; as much taste as in Van Dyck, as much practical skill as in Velazquez, in spite of the hundredfold difficulties of an infinitely richer palette, for instead of being limited to three tones, it draws upon the entire repertoire of all the tones that are known—such are, at the height of his experience and his verve, the almost unique qualities of this fine painter. The central personage, with his blue satins and greenish-yellow close coat, is a masterpiece. Never has anyone painted better, nor ever will.

From *The Masters of Past Time,* by Eugène Fromentin

Nicolas Poussin

(1594–1665)

> *In Poussin's own mind, a "mode" is one of those laws, or methods, which artists establish in order to help them in executing the work. In a way, such sets of rules entail certain obligations; so they impose restrictions upon the freedom of the painter, but, on the other hand, they facilitate his task by defining a general course of action whose observance is sure to lead to certain results.*
>
> ETIENNE GILSON

FROM A LETTER TO M. DE CHAMBRAY

MARCH 7, 1665

. . . First of all, we must know what imitation is and define it. Definition—imitation is the making of lines and the use of color on a plane surface to represent any object under the sun. The end is delectation. . . . There can be no picture of merit brought forth on canvas without a knowledge of light, atmosphere, form, color, and perspective. Such learning belongs to the foundations or essentials of painting. First of all, then, it is necessary that the subject be in itself noble, and that it give scope for revealing the painter's mind and industry. It should be capable of receiving a good form.

FROM VARIOUS LETTERS

I never feel myself so stimulated [to be painstaking] than after having seen a beautiful object.

There are two ways of looking at things. One is simply looking at them, whereas the other involves considering them attentively. Merely to see is nothing else than receiving into the eye the form or likeness of the object that is looked at; but to consider a thing is more than this: it is to seek with special diligence after the means of knowing this object thoroughly.

They do not realize that it is contrary to order and nature to place very large and massive things in high places,* or to make very delicate or weak bodies carry heavy weights.

To judge well is very difficult. To do so requires both theory and practice. Reason, not appetite, should control the judgment.

*He is referring to the vault of the Grande Galerie.

I submit to you some important considerations which will show what must be observed in the representations treated by an artist. Our brave ancient Greeks, inventors of all beautiful things, have discovered several modes through which they produced marvelous effects. This word "mode," as used by them, signifies reason, measure, or the form which we use in creative work. Reason compels us not to go beyond certain limits, to study nature with moderation and intelligence, to keep in each work a definite order, and to preserve to each thing its essential characteristic. These modes of the ancients combined the like and the unlike. Constancy in the proportions and the arrangement gave to each mode its peculiar character; namely, power to inspire the soul with certain passions.

Taste in amateurs varies as much as talent in painters. There should be as much diversity in the judgments of the former as in the productions of the latter. History shows that each of the great painters of antiquity excelled in some direction. One may conclude that no one man possessed perfection.

But who knows what can succeed? Sometimes, if we lost nothing, we should lose. The greatest evils come from great prosperity. These are the secret ways which Nature uses to effect changes.

ABOUT THE LIMITS OF DRAWING AND OF COLOR

It is important to avoid both too much softness and too much severity in lines and colors. That kind of painting is elegant in which the foreground and background are well united by the middle field. It is in this manner that the harmony and discords of colors, as well as their limitations, may be explained.

ON THE IDEA OF BEAUTY

Beauty does not enter a subject without careful preparation. This preparation includes order, mode, extent or space, and form. Order signifies the distance of the parts; mode treats quantity and number; form relates to contours and colors. It is not enough that all the parts have a suitable order or space, and that all the figures be in their natural places. There must be also "mode" to keep them within their true limits. Form, when the features are treated with grace and finesse, adds to the harmony of light and shade. True beauty detaches itself from animalism and belongs to the body only when induced by preparatory measures that elevate the imagination and excite the mind, to give to outward things a higher value than they really possess. Agreeable painting of the beautiful is the *ne plus ultra* of art.

From *The Outline on a Treatise on Painting,* by Poussin

Carlo Ridolfi

(1594–1658)

Ridolfi, a Venetian painter, imitator of Veronese, is chiefly known for his lives of the painters of his city, entitled The Wonders of Art.

ROBERT GOLDWATER

TWO MAJOR ABUSES

There are two major abuses that do great harm to painting. The first is ignorance on the part of patrons, who often err in choosing a painter; the second is the large number of painters who have no talent, and who, because of poverty, force themselves to paint. The first abuse has the effect of depriving skilled artists, who have labored hard and long to perfect their art, from the opportunity of putting their talents to work. As a result of the second abuse, we find that both public and private places are filled with monstrous paintings.

ON PAINTERS

Painting does not, as many people believe, make a man eccentric; rather it renders him adroit and adaptable in every situation.

A DEFINITION OF PAINTING

Painting is that universal idea which includes in itself all the things of the universe. And since natural objects, due to the imperfection of their material, are full of defects, it is the unique aim of painting to bring them back to their first state, as they were when made by the immortal creator.

From *Delle maraviglie dell'arte,* by Ridolfi

Sir Anthony Van Dyck

(1599–1641)

. . . *The place which Van Dyck, all things considered, so justly holds as the first of the portrait painters.*
SIR JOSHUA REYNOLDS

. . . *a nature inflammable rather than burning; at bottom, more sensuality than real fire, less transport than unrestraint; less capable of grasping things than allowing himself to be seized by them and of abandoning himself to them; a man delightful in his own attractiveness and sensible to all other attractiveness, devoured by that which is most consuming in this world—the muse and women; having abused everything—his charms, his health, his dignity, his talent.*
EUGÈNE FROMENTIN

ON THE USE OF CERTAIN COLORS AND EXPERIMENTS WITH CERTAIN MATERIALS

Treatment of Yellow: Van Dyck makes use of orpiment, which is the finest yellow that is to be found; but it dries very slowly, and, when mixed with other colors, it destroys them. In order to make it dry, a little ground glass should be added to it. In making use of it, it should be applied by itself, the drapery (for which alone it is fit) having been prepared with other yellows. Upon these, when dry, the lights should be painted with orpiment: your work will then be in the highest degree beautiful.

He spoke to me of an exquisite white, compared with which the finest white lead appears gray, which, he says, is known to M. Rubens.

He also spoke of a man who dissolved amber without carbonizing it, so that the solution was pale, yellow, transparent.

LONDON, May 20, 1633
The ground, or priming, for pictures is of great consequence. Sir Anthony Van Dyck has made the experiment of priming with isinglass; but he told me that what is painted upon it cracks, and

Van Dyck: *Countess of Clanbrassil.* The Frick Collection.

that this glue causes the colors to fade in a very few days. Thus it is good for nothing.

I gave him some of my good (amber) varnish to work with the colors, by mixing with them on the palette in the same way that the varnish of Gentileschi is used, but he told me that it thickened too much, and that the colors, in consequence, became less flowing. Having replied that the addition of a little spirit of turpentine, or other fluid which evaporates, would remedy this, he answered that it would not: but that remains to be tried. See whether the oil of white poppy, spike oil, or other will answer.

Van Dyck has tried the white of Bismuth with oil, and says that the white prepared from lead—the material commonly used—provided it be well washed, is much whiter than that of Bismuth. The latter has not body enough, and is only good for the miniature painter.

Mytens, after trying the white of tin (or Bismuth), told me that it blackened on exposure to the sun, and that if mixed with white lead, it spoils the latter. Thus, it is good for nothing in oil, nor even in tempera if you expose it to the air: in a book it would do for illuminating.

From *The Mayerne Manuscript**

* Theodore de Mayerne was born in Geneva in 1573. He was a doctor at the court of Henry IV. Later, James I of England appointed him his first physician. He attained fame in chemistry. His knowledge of painting, and his remarkable predilection for investigating its technical processes and materials, were of great service to the artists with whom he was in touch. Dallaway, in his annotations on Walpole, remarks that "his application of chemistry to the composition of pigments, and which he liberally communicated to the painters who enjoyed the royal patronage, to Rubens, Van Dyck, and Petitot, tended most essentially to the promotion of art. From his experiments were discovered the principal colors to be used for enameling, and the means of vitrifying them."

Note: As Sir Charles L. Eastlake points out: "It seems that tin and bismuth were not very clearly distinguished at the period when the physician wrote. The allusion to the washing of white lead shows that Van Dyck, like other painters of his time, did not neglect this mode of improving the color. The trial by exposure to the sun also exemplifies the habits that were in practice at an earlier time."

Diego Velazquez

(1599–1660)

. . . Velazquez outdid himself in art, combining the energy of the Greeks, the diligence of the Romans, and the tenderness of the Venetians and Spaniards. He epitomizes the latter to such an extent that if we were without the vast number of Spanish paintings, we should know them through the small galaxy of his own works.

ANTONIO PALOMINO

KITCHEN SCENES AND OTHER SCENES OF HOME LIFE

Are we then to hold these *bodegones* as of no account? No, they are certainly to be valued—that is, when painted as Velazquez paints them—for in this branch he has attained such eminence that he has left room for no rival. They deserve high esteem, for with these elements and with portraiture he discovered the true imitation of Nature, and encouraged many by his powerful example. . . . The *figures* must be ably drawn and painted, and must appear as lifelike and inanimate Nature; then they will reflect the highest honor on their authors.

LIFE STUDIES

He kept a peasant lad as an apprentice, who for payment served him as a model in various attitudes and postures, weeping, laughing, in all imaginable difficult parts. After this model he drew many heads in charcoal and chalk on blue paper, and made similar studies after many other natives (*naturales*), thereby acquiring his sure hand in creating likenesses.

From *Arte de la Pintura*, by Pacheco

VELAZQUEZ: *The Infanta Maria Theresa.* The Metropolitan Museum of Art (Jules S. Bache Collection, 1949).

Claude Lorrain

(1600–1682)

*But for his finished pictures and etchings, he se-
lected only such motifs as he considered worthy of a
place in a dreamlike vision of the past, and he dipped
it all in a golden light or a silvery air which appears
to transfigure the whole scene. It was Claude who
first opened people's eyes to the sublime beauty of
nature.*

E. H. GOMBRICH

CONSTABLE ON LORRAIN'S LANDSCAPES

Claude Lorrain is a painter whose works had given unalloyed
pleasure for two centuries. In Claude's landscape all is lovely, all
amiable, all is amenity and repose—the calm sunshine of the
heart. He carried landscape, indeed, to perfection, that is, *human
perfection.* No doubt the greatest masters considered their best ef-
forts but as experiments, and perhaps as experiments that had
failed when compared with their hopes, their wishes, and what they
saw in nature. When we speak of perfection in art, we must recall
what the materials are with which a painter contends with nature.
For the light of the sun he has but patent yellow and white lead—
for the darkest shade, umber and soot. Brightness was the character-
istic excellence of Claude; brightness, independent of color. . . .

The *St. Ursula,* in the National Gallery, is probably the finest pic-
ture of *middle tint* in the world. The sun is rising through a
thin mist, which, like the effect of a gauze blind in a room, diffuses
the light equally. There are no large dark masses. The darks are
in the local colors of the foreground figures, and in small spots; yet,
as a whole, it is perfect in breadth. There is no evasion in any part
of this admirable work, every object is fairly painted in a firm style
of execution, yet in no other picture have I seen the evanescent
character of light so well expressed.

Claude, though one of the most isolated of all painters, was still
legitimately connected with the chain of art. Elsheimer and Paul Bril
opened the way to him, coming after the Caracci, with a softer and
richer style than theirs. Could the histories of all fine arts be com-
pared, we should find in them many striking analogies. Corelli was
to Handel what Elsheimer and Paul Bril were to Claude. Claude
could not have existed without them. He was, therefore, not a *self-
taught artist,* nor did there ever exist a great artist who was so. A

self-taught artist is one taught by a very ignorant person. . . .

But of Claude it may be proper to remark that his style and mode of execution, and even of thinking, varied much at different periods of life. Of his very early manner we know little; in middle age he appeared in the most perfect state, and from it he fast declined, so much so that the dates of his pictures (which can for the most part be ascertained) will serve as a criterion of their merit. Between the ages of forty and sixty he produced most of those works in which are seen his peculiar attribute, *brightness,* in its greatest perfection.

From *The Second Lecture on Landscape Painting, by* John Constable

Rembrandt van Rijn

(1606–1669)

His temperament was that of a Prophet—a God-
possessed man, brother to Dostoevski, and teeming
with the future, a future he bore within him as the
Hebrew prophets bore within them the coming of
the Messiah, and as he bore within himself the past.

ANDRÉ MALRAUX

LETTER TO HUYGENS

JANUARY 12, 1639

My Lord:

Because of the great zeal and devotion which I experienced in executing well the two pictures which His Highness commissioned me to make—the one being Christ's dead body being laid in the tomb* and the other Christ arising from the dead to the great consternation of the guards†—these same two pictures are now finished through studious application, so that I am now also disposed to deliver the same and so to afford pleasure to His Highness. For, in these two paintings the greatest and most natural movement (or most innate emotion)‡ has been expressed, which is also the main reason why they have taken so long to execute.

* *The Entombment.*
† *The Resurrection.*
‡ Until now, these words have been interpreted as "the greatest and most natural movement." H. E. van Gelder, however, pointed out that many 17th-century authors used the word *beweeglijkheid* to express emotion rather than physical movement. Hence Rembrandt's words should be interpreted as "with the greatest and most innate emotion." Rembrandt wished to convey that he had done his uttermost to express the emotions of the figures in accordance with their character. However, J. Rosenberg (*Rembrandt,* I, Cambridge, 1948, pp. 116, 226 note

78

REMBRANDT: *Portrait of Himself*. The Frick Collection.

29) and W. Stechow (*Art Bulletin*, 32, 1950, 253) do not accept this interpretation. They assert that "the interpretation as an inward emotion seems to be contradicted by the pictures themselves, in which the outer movement in the Baroque sense still dominates, and by the aesthetics of the period."

An unbiased observer will have to admit that the *Resurrection* is a "turbulent composition with frenzied Baroque movement," but that the *Entombment* is a composition fraught with inward feeling. Van Gelder has correctly drawn attention to the fact that the spectators—and also in the *Resurrection*—are moved by an inward emotion. New linguistic research supports van Gelder's theory (L. de Paauw-de Veer, *Oud Holland*, 74, 1959, 202).

Therefore, I request my Lord to be so kind as to inform His Highness of this, and whether it would please my Lord that the two pictures should first be delivered at your house as was done on the previous occasion. I shall first await a note in answer to this. And as my Lord has been troubled in these matters for the second time, a piece 10 feet long and 8 feet high shall also be added as a token of my appreciation, which will be worthy of my Lord's house. And wishing you all the happiness and heavenly blessings, Amen.

My lord, your humble and obedient servant,
REMBRANDT

(*Written in the margin was the following:* My Lord, I live on the Binnen Amstel. The house is called the sugar bakery.)

SANDRART ON REMBRANDT

1. Rembrandt, the son of a miller, a pupil of Lastman, attained to a high degree of excellence in art through industry and natural gifts, although he never visited Italy and was but imperfectly developed.

2. He sinned against the laws of anatomy, proportion, perspective, and the antique, as against Raphael's draftsmanship; and he warred also against academies and relied on nature.

3. Being incorrect in outline, he made his backgrounds dark and laid stress only on the general harmony of a picture, achieving excellent results in half lengths, heads, and small pictures.

4. His engravings bear witness to his industry, and by its means, he acquired affluence; his home was full of well-to-do pupils, each paying about 100 florins a year. In addition, he made between 2,000 and 2,500 florins a year by the sale of their works.

5. If he had been more prudent in his relations with others, he would have become still wealthier. But although he was no spendthrift, he cared little for social rank, and was addicted to the society of humble folks, who interfered a good deal with his work.

6. His color harmony.

7. His passion for collecting.

8. His concentration of light and his glowing color.

9. In his representation of old persons he came very close to nature. He painted few mythological or historical episodes, but rather simple and naturally picturesque subjects.

10. He died in Amsterdam; it is said that his son is also a good painter.

From Sandrart's Comments (1675)

Jacob van Ruisdael

(1628–1682)

Any second-rate painter of sea and sky may enchant us, while an artist as skillful as Hobbema grows tedious, because the elaborately described trees in his woodland scenes are not subordinated to a general principle of light. To this there is one great exception, Jacob van Ruisdael, who must be reckoned the greatest master of the natural vision before Constable. This grave, lonely man was evidently subject to fits of depression in which he worked without a spark of feeling or vitality. But when his emotions were rekindled he felt the grandeur and pathos of simple nature with a truly Wordsworthian force. This feeling he expressed, as all the greatest landscape painters have done, through the large disposition of light and dark, so that even before we approach his pictures we feel their dramatic significance: it is only upon looking more closely that we find them full of observed facts.

KENNETH CLARK

WHY RUISDAEL IS A UNIQUE LANDSCAPE PAINTER

Of all the Dutch painters Ruisdael is the one who bears the most noble resemblance to his country. He has its amplitude, its sadness, its rather gloomy placidity, and its monotonous and tranquil charm.

With tapering lines, a severe palette, in two great expressly physiognomic traits—gray limitless horizons, gray skies, which vie with infinity—he must have left us a portrait of Holland: I will not say a familiar one, but an intimate portrait, attractive, admirably faithful, and one which does not grow old. By other claims, too, Ruisdael is, I certainly think, the greatest figure of the school after Rembrandt; and that is no small glory for a painter of so-called landscape who never painted a living soul—at least not without the help of someone else.

When considered bit by bit and in detail, Ruisdael would seem perhaps inferior to a number of his fellow countrymen. In the

first place, he is not adroit at a time and in a class of painting in which skill was the current coin of talent, and perhaps it is to this want of dexterity that he owes the attitude and the ordinary burden of his thought. Neither is he very clever. He paints well, and does not affect any originality in his work. What he wishes to say he says clearly, with accuracy, but as if slowly, without hidden meanings, vivacity, or archness. His drawing has not always the sharp and incisive character, the eccentric accent, proper to certain pictures by Hobbema.

To consider his normal habits, he is simple, serious and robust, very calm and earnest, very much the same always, to such a degree that his qualities no longer strike us, so sustained are they; and before this style of expression, scarcely ever relaxed, before these pictures of almost equal merit, we are sometimes astounded by the beauty of the work, but seldom surprised. . . . In short, his color is monotonous, strong, harmonious, and not very rich. It varies only from green to brown; a bituminous background constitutes its ba-

RUISDAEL: *Grainfields*. The Metropolitan Museum of Art
(Michael Friedsam Collection, 1931).

sis. It has little brilliancy, it is not always pleasant, and in its primary essence it is not of very exquisite quality. A nice painter of interiors would have no difficulty in finding fault with him for the parsimony of his medium, and would often consider his palette too restricted.

With all this, in spite of all, Ruisdael is unique. . . . Wherever he appears he has his own way of comporting himself, obtruding himself, making you respect him, attracting your attention—he warns you that you have before you a noble soul, and that he has always something important to tell you.

This is the only reason for the superiority of Ruisdael, and this reason is sufficient: there is in the painter a man who thinks, and in each one of his works a conception. As learned in his own way as the most learned of his fellow countrymen, equally endowed by nature, more thoughtful and more moved—better than anyone else he adds to his gifts a balance that produces the unity and perfection of his works. You perceive in his pictures an air of plenitude, of conviction, of profound peace, which is the distinguishing characteristic of his personality, and which proves that harmony has not, for a single moment, ceased to reign over his fine natural faculties, his great experience, his ever-living sensibility, and his ever-present thought.

Ruisdael paints as he thinks—sanely, strongly, broadly. . . .

He felt things differently and established once and for all a much truer and audacious principle. He regarded the immense vault, which arches the country or the sea, as the actual, compact, and stable ceiling of his pictures. He curves and spreads it, measures it, determines its value in relation to the variations of light and terrestrial horizons: he shades its great surfaces, gives them form, executes them, in a word, as a piece of work of the highest importance. He discovers in it arabesques which carry on those of the subject, disposes dull masses in it, brings down light from it, and puts light in it only when necessary.

From *The Masters of Past Time,* by Eugène Fromentin

Jan Vermeer

(1632–1675)

Here, reality is not subordinated to painting, indeed painting seems the handmaid of reality, though we feel it tending towards a procedure which, while not at the mercy of appearances, is not as yet in conflict with them.

ANDRÉ MALRAUX

ACCEPTANCE INTO THE GUILD OF ST. LUKE

December 29, 1653. Painter Johannis Vermeer has had himself listed as a master painter—being a citizen—and has paid on account of his fee 1 gul. 10 stuyv. Rest, 4 gul. 10 stuyv.

July 24, 1656. Everything is settled.

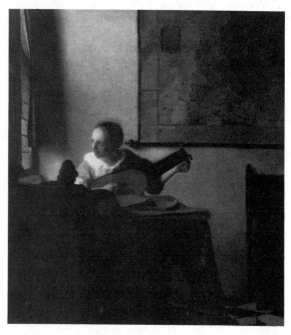

VERMEER: *Lady with a Lute.* The Metropolitan Museum of Art (Bequest of Collis P. Huntington, 1925).

84

HIS WIFE'S PETITION*

During the recent war against the King of France, the husband of the aforementioned was able to earn little or nothing. Moreover, in order to pay for the keep of his aforementioned children,† he was forced to part, at great loss, with the works of art he had purchased and in which he traded. Debts brought matters to such a pass that the aforementioned is not in a position to satisfy all her creditors.

From *Jan Vermeer van Delft*, by A. B. de Vries

Antoine Watteau

(1684–1721)

He was accustomed to gather together his loose designs in book form for ready reference and use. Very often he repeated the same outline with a variety of filling in. He was especially fond of drawing the backs of his figures that he might depict the various beautiful coiffures *of the period. . . . Watteau painted the color of the air, not merely objects. His richest effects are those of reflection and the gradation of flashes of light through breaks in thick foliage.*

EDGCUMBE STALEY

LETTERS TO M. DE JULIENNE ‡

Monsieur!

At my request, Marin, who brought me the venison you were good enough to send me this morning, is returning to you the canvas on which I painted the heads of a wild boar and a black fox, and you can dispatch them to M. de Losmenil, as I have for the moment finished with them. I cannot hide the fact that I am delighted with

* As far as is known, no original writings of Vermeer have been found or recorded. The first statement comes from the Guild in Delft; the second is a petition which Vermeer's wife filed after her husband's death. They do afford us some direct information about his life. Both the first and the second statements indicate financial troubles. The petition reveals the little-known fact that he had also been an art dealer.

† He had eleven children, three of which were of age at the time the petition was filed.

‡ The year of the letters is unknown, but their sequence is in order.

this large canvas and look forward to some corresponding satisfaction on your part and on that of Madame de Julienne, who is as inordinately fond of this hunting subject as I am. Gersaint had to secure me the services of that fellow La Serre, to enlarge the canvas on the right where I recomposed the horses under the trees, for I found that my space was congested after I had made all the agreed alterations in that part of the picture. I mean to begin work on it again after midday on Monday, because, during the morning, I shall be busy putting down ideas in *sanguine*. Do not forget to remember me to Madame de Julienne, to whom I send affectionate regards.

Monsieur!

Monsieur l'Abbé de Noirterre has been good enough to send me the picture by P. Rubens in which two angel's heads are represented and above them, on a cloud, the figure of a woman plunged in meditation. Nothing, certainly, could have given me greater happiness, were I not convinced that it was out of friendship for you and for your nephew that M. de Noirterre parted with such a valuable painting for my benefit. From the moment I received it, I have been unable to keep still; my eyes revert tirelessly to the desk on which, as on a tabernacle, I have placed it! I can hardly imagine that P. Rubens ever performed anything so accomplished as this work. Be so good, Monsieur, as to convey my sincerest gratitude to Monsieur l'Abbé de Noirterre, pending the moment when I can myself send him my thanks. I shall take advantage of the next messenger to Orléans to write him and send him the picture of the *Rest on the Flight*, which I mean to give him as an expression of my gratitude.

Your devoted friend and servant, Monsieur!

William Hogarth

(1697–1764)

*At the same time that the aristocracy of England
was finding expression in Sir Joshua Reynolds' por-
traits, the middle class was finding its voice in the art
of William Hogarth. Realistic, moralistic, and anec-
dotal, as befitted the class he represented, Hogarth
ranks among those pictorial creators who have dis-
covered the expressive force of the brush stroke as
well as of color and its harmonies. He makes his entry
into art as a reflection of Hals and Velazquez.*

RENÉ HUYGHE

OF COLORING

By the beauty of coloring, the painters mean that disposition of
colors on objects, together with their proper shades, which appear
at the same time both distinctly varied and artfully united, in com-
positions of any kind; but, by way of pre-eminence, it is generally
understood of flesh color, when no other composition is named. To
avoid confusion . . . I shall now only describe the nature and ef-
fect of the prime tint of the flesh; for the composition of this, when
rightly understood, comprehends everything that can be said of the
coloring of all other objects whatever.

And herein . . . the whole process will depend upon the art of
varying; i.e., upon an artful manner of varying every color belong-
ing to flesh. But before we proceed to show in what manner these
principles conduce to this design, we shall look at nature's curious
ways of producing all sorts of complexions, which may help to fur-
ther our conception of the principles of varying colors, so as to see
why they cause the effect of beauty.

It is well known, the fair young girl, the brown old man, and the
negro—nay, all mankind, have the same appearance, and are alike
disagreeable to the eye, when the upper skin is taken away: now to
conceal so disagreeable an object, and to produce that variety of
complexions seen in the world, nature has contrived a transparent
skin, called the cuticula, with a lining to it of a very extraordinary
kind, called the cutis; they are both so thin that any little scald will

make them blister and peel off. These adhering skins are more or less transparent in some parts of the body than in others, and likewise different in different persons. The cuticula alone is like goldbeaters' skin, a little wet, but somewhat thinner, especially in fair young people, which would show the fat, lean, and all the blood vessels, just as they lie under it, as through isinglass, were it not for its lining, the cutis, which is so curiously constructed as to exhibit those things beneath it which are necessary to life and motion, in pleasing arrangements and dispositions of beauty.

The cutis is composed of tender threads, like network, filled with different colored juices. The white juice serves to make the very fair complexion; yellow makes the brunette; brownish yellow, the ruddy brown; green yellow, the olive; dark brown, the mulatto; black, the negro. These different colored juices, together with the different meshes of the network, and the size of its threads in this part or that part, produces the variety of complexions. . . .

There are but three original colors in painting, besides black and white; viz., red, yellow, and blue. Green and purple are compounded; the first of blue and yellow, the latter of red and blue: however, these compounds being so distinctly different from the original colors, we will rank them as such. Let us assume that there are mixed up, as on a painter's palette, scales of these five original colors, divided into seven classes—1,2,3,4,5,6,7. Four is the medium, and most brilliant class, being that which will appear a firm red, when those of 5,6,7 would deviate into white, and those of 1,2,3 sink into black, either by twilight, or at a moderate distance from the eye, which shows 4 to be the brightest, and a more permanent color than the rest. But as white is nearest to the light, it may be said to be equal, if not superior, in value as to beauty, with class 4; therefore, the classes 5,6,7 have, also, almost equal beauty with it too, because what they lose of their brilliancy and permanency of color, they gain from the white or light; whereas 3,2,1 absolutely lose their beauty by degrees as they approach nearer to black, the representative of darkness.

Let us then, for the sake of distinction and pre-eminence, call class 4 of each color *bloom tints,* or, if you please, virgin tints, as the painters call them; and once more recollect that in the disposition of colors, as well as of forms, variety, simplicity, distinctness, intricacy, uniformity, and quantity are the guides to beauty in the coloring of the human frame, especially if we include the face, where uniformity and strong opposition of tints are required, as in the eyes and mouth, which call most for our attention. But for the gen-

eral hue of flesh now to be described, variety, intricacy, and simplicity are chiefly required.

The value of the degrees of color being thus considered, and ranged in order upon the palette let us next apply them to a bust of white marble, which may be supposed to let every tint sink into it, as a drop of ink sinks in and spreads itself upon coarse paper, whereby each tint will gradate all around.

If you would have the neck of the bust tinged with a very florid and lively complexion, the pencil must be dipped in the bloom tints of each color as they stand one above another at No. 4; if for a less florid, in those of No. 5; if for a very fair, from No. 6; and so on till the marble would scarcely be tinged at all; let No. 6, therefore, be our present choice, and let us begin with penciling on the red tint, the yellow tint, the blue tint, and the purple or lake tint.

These four tints thus laid on, proceed to covering the whole neck and breast, but still changing and varying the situations of the tints with one another, and also causing their shapes and sizes to differ as much as possible; red must be oftenest repeated, yellow next often, purple-red next, and blue but seldom, except in particular parts, such as the temples, backs of the hands, etc., where the larger veins show their branching shapes (sometimes too distinctly), still varying those appearances. But there are, no doubt, infinite variations in nature, from what may be called the most beautiful order and disposition of the colors in flesh, not only in different persons, but in different parts of the same, all subject to the same principles in some degree or other.

Now if we imagine this whole process to be made with the tender tints of class 7, as they are supposed to stand, red, yellow, blue, green, and purple, underneath each other, the general hue of the performance will be a seeming uniform prime tint, at any little distance— that is, a very fair, transparent and pearl-like complexion—but never quite uniform as snow, ivory, marble, or wax, like a poet's mistress, for either of these in living flesh would in truth be hideous.

As in nature, by the general yellowish hue of the cuticula, the gradating of one color into another appears to be more delicately softened and united together; so will the colors we are supposed to have been laying upon the bust appear to be more united and mellowed by the oil they are ground in, which takes a yellowish cast after a little time, but is apt to do more mischief hereby than good; for which reason care is taken to procure such oil as is clearest, and will best keep its color in oil painting.

Upon the whole of this account we find that the utmost beauty of

coloring depends on the great principle of varying by all the means of varying, and on the proper and artful union of that variety; which may be further proven by supposing the rules here laid down, all or any part of them, reversed.

I am apt to believe that ignorance of nature's artful and intricate method of uniting colors for the production of variegated composition, or prime tint of flesh, has made coloring, in the art of painting, a kind of mystery in all ages; insomuch, that it may fairly be said, out of the many thousands who have labored to attain it, not above ten or twelve painters have happily succeeded therein. Correggio (who lived in a country village, and had nothing but the life to study after) is said almost to have stood alone for this particular excellence. Guido, who made beauty his chief aim, was always at a loss about it. Poussin scarcely ever obtained a glimpse of it, as is manifest by his many different attempts: indeed France has not produced one remarkably good colorist.

Rubens boldly, and in a masterly manner, kept his bloom tints bright, separate, and distinct, but sometimes too much so for easel or cabinet pictures; however, this manner was admirably well calculated for great works, to be seen at considerable distance, such as his celebrated ceiling at Whitehall chapel: which, upon a nearer view, will illustrate what I have advanced with regard to the separate brightness of the tints; and show, what indeed is known to every painter, that had the colors there seen so bright and separate, been all smoothed and absolutely blended together, they would have produced a dirty gray instead of flesh color. The difficulty then lies in bringing *blue*, the third original color, into flesh, on account of the vast variety introduced thereby; and this omitted, all the difficulty ceases; and a common sign painter, that lays his colors smooth, instantly becomes, in point of coloring, a Rubens, a Titian, or a Correggio.

From *The Analysis of Beauty*, by Hogarth

Jean Baptiste Chardin

(1699–1779)

He painted still life and interior subjects from the lower middle class. He developed his own technique in which he aimed for broad masses and paid as much attention to design as to color. Often a subject was painted several times, so that subsequent versions show a matured, simplified interpretation. Chardin's paintings of orderly everyday existence were just as French as the boudoir paintings of the court.

ERWIN O. CHRISTENSEN

It is with the tranquil light of his own life that he illuminates his interiors.

EDMOND AND JULES GONCOURT

ON THE DIFFICULTIES OF BECOMING A PAINTER

Gentlemen, you should be indulgent. Among all the pictures here,* seek out the worst ones; and know that a thousand unhappy painters have broken their brushes between their teeth out of despair at never being able to do as well. Parrocel, whom you call a dauber—and indeed one of you compare him to Vernet—is nevertheless also an exceptional man, compared with those who have abandoned the career upon which they entered. Lemoine used to say that the ability to retain in the finished picture the qualities of the preliminary sketch required thirty years, and Lemoine was not a fool. If you will listen to what I have to say, you may learn, perhaps, to be indulgent. At the age of seven or eight we are set to work with the pencil-holder in our hands. We begin to draw from copy books —eyes, mouths, noses, ears, and then feet and hands. And our backs have been bent to the task for a seeming age by the time we are confronted with the Farnese Hercules or the Torso; and you have not witnessed the tears provoked by the Satyr, the Dying Gladiator, the Medici Venus, the Antaeus. Believe me when I tell you that these masterpieces of Greek art would no longer excite the jealousy of artists if they had been exposed to the resentment of students. And when we have exhausted our days and spent waking, lamp-lit

* Chardin's studio was crowded with works by his fellow artists (frequently either little known or unknown).

nights in the study of inanimate nature, then living nature is placed before us, and all at once the work of the preceding years is reduced to nothing; we were not more constrained on the first occasion on which we took up the pencil. The eye must be taught to look at Nature; and how many have never seen and will never see her! This is the anguish of the artist's life. We work for five or six years from the life and then we are thrown upon the mercy of our genius, if we have any. Talent is not established in a moment. It is not after the first attempt that a man has the honesty to confess his incapacity. And how many attempts are made, sometimes fortunate, sometimes unhappy! Precious years may slide away before the day arrives of weariness, of tedium, of disgust. The student may be nineteen or twenty when, the palette falling from his hands, he finds himself without a calling, without resources, without morals; for it is impossible to be both young and virtuous, if nature naked and unadorned is to be an object of constant study. What can he then do, what can he become? He must abandon himself to the inferior occupations that are open to the poor, or he must die of hunger. The first course is adopted; and, with the exception of an odd twenty who come here every two years and exhibit themselves to the foolish and ignorant, the others, unknown and perhaps less unhappy, carry a musket on their shoulders in some regiment, or the costume of the stage at some theater.

From a statement by Chardin, recorded by Diderot

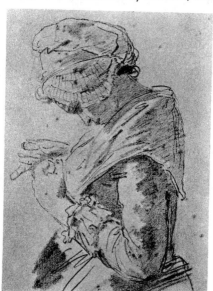

CHARDIN:
Drawing.

Sir Joshua Reynolds

(1723–1792)

*A man of superior intelligence and skill, Reynolds
had patiently studied the Venetians and Van Dyck.
He created a facile and dazzling style, a style of de-
pendable effects; it enabled him to arrange human
likenesses, in simplified, appetizing harmonies of
white, black, and red, against settings of autumnal
verdure. With this style Reynolds ushered in the great
era of English portrait painting.*

RENÉ HUYGHE

ON THE STUDY OF PAINTING

DECEMBER 11, 1769

. . . In speaking to you of the Theory of Art, I shall only con-
sider it as it has a relation to the *method* of your studies.

Dividing the study of painting into three distinct periods, I shall
address you as having passed through the first of them, which is
confined to the rudiments; including a facility of drawing any ob-
ject that presents itself, a tolerable readiness in the management of
colors, and an acquaintance with the most simple and obvious rules
of composition.

The first degree of proficiency is, in painting, what grammar is in
literature, a general preparation for whatever species of the art the
student may afterward choose for his more particular application.
The power of drawing, modeling, and using colors, is very properly
called the language of the art; and in this language, the honors
you have just received* prove you to have made no inconsiderable
progress.

When the artist is once enabled to express himself with some de-
gree of correctness, he must then endeavour to collect subjects for
expression; to amass a stock of ideas, to be combined and varied as
occasion may require. He is now in the second period of study, in
which his business is to learn all that has been known and done
before his own time. Having hitherto received instructions from a
particular master, he is now to consider the Art itself as his master.
He must extend his capacity to more sublime and general instruc-

* The excerpts from the two *Discourses* here quoted were made to the students
of the Royal Academy on the Distribution of Prizes.

93

tions. Those perfections which lie scattered among various masters, are now united in one general idea, which is henceforth to regulate his taste, and enlarge his imagination. With a variety of models thus before him, he will avoid that narrowness and poverty of conception which attends a bigoted admiration of a single master, and will cease to follow any favorite where he ceases to excel. This period is, however, still a time of subjection and discipline. Though the student will not resign himself blindly to any single authority, when he may have the advantage of consulting many, he must still be afraid of trusting his own judgment.

The third and last period emancipates the student from subjection to any authority but what he shall himself judge to be supported by reason. Confiding now in his own judgment, he will consider and separate those different principles to which different modes of beauty owe their original. In the former period he sought only to know and combine excellence, wherever it was to be found, into one idea of perfection; in this, he learns, what requires the most attentive survey and the most subtle disquisition, to discriminate perfections that are incompatible with each other.

He is from this time to regard himself as holding the same rank with those masters whom he before obeyed as teachers, and as exercising a sort of sovereignty over those rules which have hitherto restrained him. Comparing now no longer the performance of the Art with each other, but examining the Art itself by the standard of nature, he corrects what is erroneous, supplies what is scanty, and adds by his own observation what the industry of his predecessors may have yet left wanting to perfection. Having well established his judgment, and stored his memory, he may now without fear try the power of his imagination. The mind that has been thus disciplined may be indulged in the warmest enthusiasm, and venture to play on the borders of the wildest extravagance. The habitual dignity which long converse with the greatest minds has imparted to him, will display itself in all his attempts; and he will stand among his instructors, not as an imitator, but a rival.

. . . The great use in copying, if it be at all useful, should seem to be in learning color; yet even coloring will never be perfectly attained by servilely copying the model before you. An eye critically nice can only be formed by observing well-colored pictures with attention: by close inspection, and minute examination, you will discover the manner of handling the artifices of contrast, glazing, and other expedients, by which good colorists have raised the value of their tints, and by which nature has been so happily imitated.

I must inform you, however, that old pictures deservedly cele-

brated for their coloring are often so changed by dirt and varnish that we ought not to wonder if they do not appear equal to their reputation in the eyes of unexperienced painters or young students. An artist whose judgment is matured by long observation considers rather what the picture once was, than what it is at present. He has by habit acquired a power of seeing the brilliancy of tints through the cloud by which it is obscured. An exact imitation, therefore, of those pictures, is likely to fill the student's mind with false opinions; and to send him back a colorist of his own formation, with ideas equally remote from nature and from art, from the genuine practice of the masters, and the real appearances of things.

Following these rules, and using these precautions, when you have clearly and distinctly learned in what good coloring consists, you cannot do better than have recourse to nature herself, who is always at hand, and in comparison with whose true splendor the best-colored pictures are but faint and feeble.

However, as the practice of copying is not entirely to be excluded, since the mechanical practice of painting is learned in some measure by it, let only those choice parts be selected which have recommended the work to notice. If its excellence consists in its general effort, it would be proper to make slight sketches of the machinery and general management of the picture. Those sketches should be kept always by you for the regulation of your style. Instead of copying the touches of those great masters, copy only their conceptions. Instead of treading in their footsteps, endeavour only to keep the same road. Labor to invent on their general principles and way of thinking. Possess yourself with their spirit. Consider with yourself how a Michelangelo or a Raphael would have treated this subject: and work yourself into a belief that your picture is to be seen and criticized by them when completed. Even an attempt of this kind will rouse your powers.

THE IMPORTANCE OF "STUDIES"

DECEMBER 10, 1784

. . . We are not to suppose that when a painter sits down to deliberate on any work, he has all his knowledge to seek; he must not only be able to draw *extempore* the human figure in every variety of action, but he must be acquainted likewise with the general principles of composition, and possess a habit of foreseeing, while he is composing, the effect of the masses of light and shadow that will attend such a disposition. His mind is entirely occupied by his attention to the whole. It is a subsequent consideration to determine the attitude and expression of individual figures. It is in this period of

his work that I would recommend to every artist to look over his portfolio, or pocket book, in which he has treasured up all the happy inventions, all the extraordinary and expressive attitudes that he has met with in the course of his studies; not only for the sake of borrowing from those studies whatever may be applicable to his own work, but for the great advantage he will receive by bringing the ideas of great artists more distinctly before his mind, which will teach him to invent other figures in a similar style.

From *The Second and Twelfth Discourses*, by Sir Joshua Reynolds

John Singleton Copley

(1738–1815)

Copley brought the quality of naturalness of English portrait painting to paintings that dealt with historical subjects—paintings which often abounded with figures. It was his intention to paint an historical scene just like it would have appeared to eyewitnesses.

ANTON SPRINGER

FROM A LETTER TO HIS WIFE

FLORENCE, June 9, 1775

. . . General Gage's opinion that I could not leave Rome till next spring was judicious, but I shall find means to carry with me the most valuable pieces of Art—casts in plaster of Paris of the finest works in the world. And should I have stayed in Rome till next spring my whole time would have been spent in the study of those statues, but by having some of the best of them in my apartments I shall always have the advantage of studying them, which will be much superior to one or two years spent in Rome. I mentioned in my last that I had purchased a cast of Laocoön. This is not only the best piece of Art now in the world, but it was esteemed by the Ancients the first thing, in point of merit, that Art had ever produced. Although I had seen fine casts—seen Pliny's description of it—when I saw the original I stood astonished, not that copies are defective in form, for the molds have been made as the originals and are just as good to study from as the original itself, but there is in marble that fine transparency that gives it both the softness and animation of real life. The Apollo is another wonderful thing, and after selecting a few of the first things (indeed the number in Rome itself of the very excellent is not great) I shall possess all that

96

I would recommend to an artist to study—for it is not the number of things that an Artist studies, but thoroughly understanding those he studies and the principles of Art that are in them, that will make him great. Michel Angelo, it is said, obtained that astonishing gusto that we see in all his works from only the fragment of a figure, just the trunk of the body, yet we see the great Angelo in delicate as well as in the most robust figures. The same genius appears in all that he does, as well in the folds of his drapery as in his Christ sitting in Judgment. I am convinced that a man who is incapable of producing a female figure in an excellent style because he has only seen the Farnese Hercules, must in his muscular figures of men be* but a copy of the Hercules however he may artfully disguise his theft. The principle that gives beauty to the different characters within it, is the beauty of an Hercules or a Venus being the same; although knowledge of the human form with a fine taste to give to all characters those particular forms that suit best with each of them, is absolutely necessary to procuring the character of a great and original artist.

* Produce.

COPLEY: *Watson and the Shark*. The Metropolitan Museum of Art
(Gift of Mrs. Gordon Dexter, 1942).

Francisco Goya

(1746–1828)

> *And while Goya studied nature with a passionate and jealous devotion, he glories in the debt he owes Rembrandt and Velazquez. "I have had three masters," he wrote to a friend, "Nature, Velazquez, and Rembrandt."*
>
> ALBERT F. CALVERT

> *Goya is always a great and often a terrifying artist. To the gaiety, the joviality, the typically Spanish satire of the good old days of Cervantes he unites a spirit far more modern, or at least one that has been far more sought after in modern times—I mean a love of the ungraspable, a feling for violent contrasts, for the blank horrors of nature and for human countenances weirdly animalized by circumstances.*
>
> CHARLES BAUDELAIRE

A LETTER TO DON MIGUEL CAYETANO SOLER

MADRID, October 9, 1803

Your Excellency:

I am in receipt of H.M. Royal Order which Your Excellency communicated to me on the 6th inst., accepting the offer of my work the *Caprices** on eighty copper plates engraved with aqua fortis by my hand, which I will hand to the Royal Calcografía with the lot of prints I had printed by way of precaution, amounting to 240 copies of 80 prints, in order not to defraud H.M. in the least and for my own satisfaction.

* The series of engravings known as the *Caprichos*—a slashing attack on Spanish society, representing not a reformer's point of view, but strictly a humanistic one—got Goya into difficulties with the Church and the society of the time. The office of the Inquisition decided to take action against him, and for a while it seemed that he was powerless to counteract it. Reprieve, surprisingly, came from unexpected quarters. The king of Spain stated that the engravings had been ordered by him, and that consequently the plates were to be acquired by the State. Whether the king did this for the sake of art, or because he was vainly flattered because Goya had dedicated the *Caprichos* to him, is a question that has never been clearly resolved.

I am very grateful for the pension of twelve thousand reals which H.M. has been pleased to concede to my son, for which I give my best thanks to H.M. and to Your Excellency.

Your Excellency has not replied to a letter of mine, in which I said.that the portraits were finished, and also the copy of Your Excellency's by Esteve which only lacked the inscription, for which he has asked me several times. I also suggested that if Your Excellency approved I would get the frames made for the originals and would myself go and put them where Your Excellency might order, so that you might have the pleasure of finding them in their places.

I only desire Your Excellency's orders and that you keep well. May God preserve Your Excellency's valuable life for many years.

Your excellency's obedient and grateful servant,

FRANCISCO DE GOYA

GOYA: *The Forge.* The Frick Collection.

99

Jacques Louis David

(1748–1825)

*The new social order now taking form was coming
to regard David as its representative in art. He was to
be the painter of the Revolution, pending the day
when he became the painter of the Empire. . . .
Revolutions in art are made by great artists and
not by theorists. David is at his best in his portraits
and in the paintings stemming from contemporary
history, and not from the quest of some pedantic* beau
idéal.*

FRANÇOIS FOSCA

LETTER TO CITIZEN DENON*

16 Frimaire, An XII
(December 7, 1805)

My dear colleague:

I thank you for the interest that you take in my work. I work
very hard at my painting, but once the painting is finished I concern
myself very little with what becomes of it. I agree that this is wrong,
but everyone is different, and that's the way I am. Hence, it is good
friends that have become very useful, and you have given me proof
of it on this occasion. Certainly I prefer that my painting *Androma-
che Crying on the Body of Hector* be exhibited at the museum at
Versailles rather than in the rooms of the School of Painting, where
it is seen only by amateurs.

But, my dear colleague, I will show you that you have rendered
me only a half-service if you do not obtain permission, from the
minister, for me to retouch the painting. It was more than ten years
ago that I tolerated seeing certain flaws that are easy to repair. First
of all, the shadows that cut the whiteness of the draperies around
Andromache's throat are too hard. The hand of the child which
rests on the bosom of his mother is too dark; the sides of Hector are
too well defined and the body gives an anatomical impression,
rather than one of a hero who is protected by Venus even after his
death. I will add a half-tint to the arms of Hector, on the side where
the light is too dark. I will restrain myself there, however, so as not
to get carried away and actually paint a different picture. Finally,
I want simply to retouch the picture, and not repaint it after having

* Member of the Institute, General Director of the Musée Napoléon.

100

removed the varnish. It is understood that there is nothing there that will prevent me from making it a better painting, and it will not take long to do. . . .

When you ask the professor at the school of design for this painting don't forget also to ask for the frame. Find out what they have done with it. My name and the year when I made it were written on the top. The wardens who will look for it will certainly find it in the storeroom of the museum.

Good-bye, my dear colleague, I greet you with friendship,

DAVID

William Blake

(1757–1825)

He had an exceptional power of secreting retinal images, and it was, to some extent, the unconscious memory of these images that he identified with inspiration. He was justified in saying that "all forms are perfected in the poet's mind," but it was seldom in his own mind that the forms in his work had originally been perfected. . . . Sometimes it is as if the old Celtic spiral had been wound up tight and was ready to impel his figures through space, and sometimes his spiritual radiance shines through a dead form and transfigures it.

KENNETH CLARK

AN ADDRESS TO THE PUBLIC

The wretched state of the arts in this country and in Europe, originating in the wretched state of political science (which is the science of sciences), demands a firm and determined conduct on the part of artists, to resist the contemptible counter-arts, established by such contemptible politicians as Louis XIV, and originally set on foot by Venetian picture traders, music traders, and rhyme traders, to the destruction of all true art, as it is this day. To recover art has been the business of my life, that is, to reattain the Florentine original, and if possible, to go beyond that original: this I thought the only pursuit worthy of man. To imitate I abhor: I obstinately adhere to the true style of art, such as Michelangelo, Raphael, Guilio Romano, Albert Dürer left it. I demand, therefore, of the amateurs of art the encouragement which is my due; if they continue to refuse, theirs is the loss, not mine, and theirs is the contempt of posterity. I have enough in the approbation of fellow-

laborers: this is my glory and exceeding great reward. I go on, and nothing can hinder my course. . . .

I do not condemn Rubens, Rembrandt, Titian, because they did not understand drawing, but because they did not understand coloring: how long shall I be forced to beat this into men's ears? I do not condemn Strange and Woollett because they did not understand drawing, but because they did not understand engraving. I do not condemn Pope or Dryden because they did not understand imagination, but because they did not understand verse. Their coloring, engraving, and verse, can never be applied to art: that is not either coloring, engraving, or verse which is inappropriate to the subject: He who makes a design must know the effect and coloring proper to be put to that design, and will never take that of Rubens, Rembrandt, or Titian, to turn that which is soul and life into a mill or machine.

They say there is no straight line in nature. This is a lie like all that they say, for there is every line in nature. But I will tell them what there is not in nature. An even tint is not in nature—it produces heaviness. Nature's shadows are ever varying, and a ruled sky

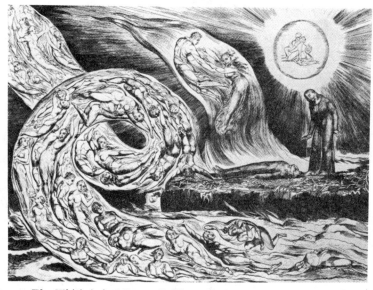

BLAKE: *The Whirlwind of Lovers.* Etching. The Metropolitan Museum of Art (Rogers Fund, 1917).

that is quite even never can produce a natural sky. The same with every object in a picture—its spots are its beauties. Now, gentlemen critics, how do you like this? You may rage; but what I say I will prove by such practice (and have already done so) that you will rage to your own destruction.

. . . Men think that they can copy nature as correctly as I copy imagination. This they will find impossible: and all the copies, or pretended copies, of nature, from Rembrandt to Reynolds, prove that nature becomes to its victims nothing but blots and blurs. Why are copies of nature incorrect, while copies of imagination are correct? This is manifest to all. . . .

A man sets himself down with colors, and with all the articles of painting; he puts a model before him, and he copies that so neat as to make it a deception. Now, let any man of sense ask himself one question: Is this art? Can it be worthy of admiration to anybody of understanding? Who could not do this? What man, who has eyes and an ordinary share of patience, cannot do this neatly? Is this art, or is it glorious to a nation to produce such contemptible copies? Countrymen, do not suffer yourselves to be disgraced! . . .

I do not pretend to paint better than Raphael or Michelangelo, or Giulio Romano, or Albert Dürer; but I do pretend to paint finer than Rubens, or Rembrandt, or Corregio, or Titian. I do not pretend to engrave finer than Albert Dürer; but I do pretend to engrave finer than Strange, Woollett, Hall, or Bartolozzi, and all because I understand drawing which they understood not. Englishmen have been so used to journeymen's undecided bungling that they cannot bear the firmness of a master's touch. Every line is the line of beauty; it is only fumble and bungle which cannot draw a line. This only is ugliness. That is not a line which doubts and hesitates in the midst of its course.

I know my execution is not like anybody else's. I do not intend it should be so. None but blockheads copy one another. My conception and invention are, on all hands, allowed to be superior; my execution will be found so too. To what is it that gentlemen of the first rank both in genius and fortune have subscribed their name? To my inventions. The executive part they never disputed. . . .

I defy any man to cut cleaner strokes than I do, or rougher, when I please; and assert, that he who thinks he can engrave or paint either, without being a master of drawing, is a fool. Painting is drawing on canvas, and engraving is drawing on copper, and nothing else. Drawing is execution and nothing else; and he who draws best must be the best artist. To this I subscribe my name as a public duty.

From *A Public Address*, by William Blake

Joseph Mallord William Turner

(1775–1851)

Turner, a visionary . . . ventured upon a series of astonishing anticipations of later developments. With a variegated palette and a brush heedless of restricting notions of form or outline, he painted pictures as brilliant and as dazzling as iridescent mirages.
RENÉ HUYGHE

ON FLEMISH LANDSCAPE PAINTING

. . . Of the Flemish School approaches to individual nature . . . only two, Rembrandt and Rubens, dared to raise her above commonality. Rembrandt depended upon his chiaroscuro, his bursts of light and darkness, to be felt. He threw a mysterious doubt over the meanest piece of Common; nay, more, his forms, if they can be called so, are the most objectionable that could be chosen, namely, the three *Trees* and the *Mill,* but over each he has thrown that veil of matchless color, that lucid interval of morning dawn and dewy light on which the eye dwells so completely enthralled, and it seeks not for its liberty but, as it were, thinks it a sacrilege to pierce the mystic shell of color in search of form.

No painter knew so well the extent of his own powers and his own weakness. Conscious of the power as well as the necessity of shade, he took the utmost boundaries of darkness and allowed but one-third of light, which light dazzles the eye thrown upon some favorite point, but where his judgment kept pace with his choice, surrounded with impenetrable shade.

From Turner's lecture at the Royal Academy

LETTER TO MRS. CALCOTT

. . . Let me thank you for sending me to Orvieto. It is a most extraordinary place as to situation as well as Signorelli's works. The whole of the Chapel is fine and although the Inferno and the Pest may be most esteemed yet the other subjects have some good figures. The picture in the Dominicans at Sienna which you did not tell me of by him is more red in color and tone but has none of that daring foreshortening of the Orvieto subjects. The picture

is close to the Chapel of St. Catherine which you say contains Reni's best work. Granted in Fresco the 3 Mary's and St. Catherine may for —and tone with charming execution be considered his best work. But I mean to have a squabble with you over the pictures in the Palace of Justice. The Holy Family for richness of tone and effect of light . . . [was] not very unlike Giulio Romano's and Raphael's. Much was said about Piazzi Sybils but I was mainly disappointed. The figure is good certainly, but that is all. The picture at Viterbo of Sebastiano del Piombo is fine indeed particularly the Christ but the Madone was without dignity and expression and scarcely above common nature. . . .

John Constable

(1776–1837)

Constable's genius lies somewhere between the lyric and the heroic; and the fact that he was perhaps the first painter in Europe to strike this balance in terms of romantic naturalism assures him a unique position in the history of art.

JONATHAN MAYNE

ART MUST CHANGE WITH THE AGES

The difference between the judgments pronounced by men who have given their lives to a particular study, and by those who have attended to that study as the amusement only of a few leisure hours, may thus be illustrated. I will imagine two dishes, the one of gold, the other of wood. The golden dish is filled with diamonds, rubies, and emeralds, and chains, rings, and brooches of gold; while the other contains shell-fish, stones, and earths. These dishes are offered to the world, who choose the first; but it is afterwards discovered that the dish itself is but copper gilt, the diamonds are paste, the rubies and emeralds painted glass, and the chains, rings, etc., counterfeit. In the meantime, the naturalist has taken the wooden dish, for he knows that the shell-fish are pearl oysters and he sees that among the stones are gems, and mixed with the earths are the ores of the precious metals.

The decline of painting, in every age and country, after arriving at excellence, has been attributed by writers who have not been art-

ists to every cause but the true one. The first impression and a natural one is that the fine arts have risen or declined in proportion as patronage has been given to them or withdrawn, but it will be found that there has often been more money lavished on them in their worst periods than in their best, and that the highest honors have frequently been bestowed on artists whose names are scarcely now known. Whenever the arts have not been upheld by the good sense of their professors, patronage and honors, so far from checking their downward course, must inevitably accelerate it.

The attempt to revive old styles that have existed in former ages may for a time appear to be successful, but experience may now surely teach us its impossibility. I might put on a suit of Claude Lorrain's clothes and walk into the street, and the many who know Claude but slightly would pull off their hats to me, but I should at last meet with someone more intimately acquainted with him, who would expose me to the contempt I merited.

It is thus in all the fine arts. A new Gothic building, or a new missal, is in reality little less absurd than a *new ruin*. The Gothic architecture, sculpture, and painting, belong to peculiar ages. The feelings that guided their inventors are unknown to us, we contemplate them with associations, many of which, however vague and dim, have a strong hold on our imaginations, and we feel indignant at the attempt to cheat us by any modern mimicry of their peculiarities.

It is to be lamented that the tendency of taste is at present too much towards this kind of imitation, which, as long as it lasts, can only act as a blight on art, by engaging talents that might have stamped the Age with a character of its own, in the vain endeavor to reanimate deceased Art, in which the utmost that can be accomplished will be to reproduce a body without a soul.

Attempts at the union of uncongenial qualities in different styles of Art have also contributed to its decline. . . .

The young painter who, regardless of present popularity, would leave a name behind him must become the patient pupil of nature. If we refer to the lives of all who have distinguished themselves in art or science, we shall find they have always been laborious. The landscape painter must walk in the fields with an humble mind. No arrogant man was ever permitted to see nature in all her beauty. If I may be allowed to use a very solemn quotation, I would say most emphatically to the student, "Remember now thy Creator in the days of thy youth." The friends of a young artist should not look or hope for precocity. It is often disease only. Quintilian makes use of a beautiful simile in speaking of precocious talent. He compares it

to the forward ear of corn that turns yellow and dies before the harvest. Precocity often leads to criticism—sharp, and severe as the feelings are morbid from ill health. Lord Bacon says, "When a young man becomes a critic, he will find much for his amusement, little for his instruction." The young artist must receive with deference the advice of his elders, not hastily questioning what he does not yet understand, otherwise his maturity will bear no fruit. The art of seeing nature is a thing almost as much to be acquired as the art of reading the Egyptian hieroglyphics. The Chinese have painted for two thousand years, and have not discovered that there is such a thing as chiaroscuro.

From *Constable's Fifth Lecture,* given at the Royal Institution (July 25, 1856)

Jean Auguste Dominique Ingres

(1780–1867)

One man took his stand against Delacroix and condemned his innovations. Considering himself of the line of Raphael, Ingres fought to preserve the classical tradition. Less virile than David, whose pupil he was, capable of refinements and of a subtlety within flexibility, especially conspicuous in his prodigious drawings, Ingres was the painter of the nineteenth-century bourgeoisie. In his double program, realism was to be achieved through idealism: realism by means of a probity that scrupulously refrains from "cheating" in the presence of what the eyes behold, in order to capture it with the skill of a Flemish primitive; idealism that seeks to subject art to the laws of beauty, in order to extract from reality its purest harmonies. Here once again we have the aims of the classical Renaissance.

RENÉ HUYGHE

EXTRACTS FROM FOUR LETTERS

FLORENCE, August 29, 1822

To Jean François Gilibert:

. . . I hope to prove that there is no such thing as an indifferent subject in painting; the whole matter is to see well, and above all truly.

Thank the Lord! I can think out loud with you. I should consider myself only too happy if the legitimate means for making a name

for oneself were not just the ones that rouse up against an honest artist the whole rabble of the envious and ignorant men of this century. I feel that I am in the full force of my talents, and I find in myself a facility for producing. One thing is the enemy of my repose. I, who am not at all a man for society, am continually required to see people. I am obliged to tear myself from my studio in order to receive the visits of merely curious persons. To put on full dress is one of the labors of Hercules for me. What I should like would be to remain here unknown, to concern myself exclusively with historical painting and never to sacrifice myself in doing little pictures that take up more time than the big ones. I should wish above all to have my life go on only in my studio. The life of study is the happiest one; it makes one forget everything that disgusts one in this world. I intend to begin isolating myself, and then I shall surprise and hit hard.

INGRES: *Portrait of a Gentleman*. The Metropolitan Museum of Art (Bequest of Mrs. H. O. Havemeyer, 1929, The Havemeyer Collection).

FLORENCE, November 1, 1822

To Jean François Gilibert:

. . . When one considers carefully, Raphael is himself simply for the reason that, better than others, he has known nature. And *there is his whole secret,* a secret that everybody knows and of which so few can make use for the progress of art.

ROME, May 26, 1814

To M. Marcotte:

. . . I am sorry that my little picture *The Sword of Henry IV* did not please you. But I will defend myself on every point. For that picture is true in drawing and in pantomime, pure in the details, with well-proportioned figures and carefully considered taste in the relationships. All those who saw it here have considered, and I was of their opinion, that it was true and strong in color, and that it had a good deal of the quality of the Venetian School, which I shall always think of when I paint. It is very delicately executed, and all the details are finally worked out, but not with the finish of a Gerard Drou, whose type of execution is wearisome and not esteemed the least bit by the painters of the Italian School, nor even by the excellent Flemings, as to whose works you give me a very proper reminder. The most able pictures by any of them are those of Teniers which are only brushed in but which are fine because the brushwork is exactly in place and used with feeling.

DAMPIERRE, August 8, 1847

To M. Marcotte:

. . . That cruel tyrant* even prevents me from sleeping, so absolute is her demand that she alone shall rule, and you can't imagine how she makes me toe the mark! In the first place, she won't even let me take a bit of a walk, even to go around the château, or perhaps only on the rarest occasions. As soon as I'm out of bed, my orders are: get to work, prepare your materials, and be off with you until noon. Then I am allowed to give a little glance at the newspaper; after that, from two o'clock on, she drives me forth to the gallery, where I have to keep on the go until eight o'clock without a stop. I come in for dinner harassed by fatigue . . . and yet I love her, the hussy, and with passion, at that; for looking at things squarely, she loves me too, and if I did not repay her in full, she would threaten me with weakness, with decadence in my work; she would threaten me with abandonment and even with death. And that's how it is that, after many an effort and keeping up one's courage, one does not too much feel the weight of one's sixty-seven years.

* Painting.

109

Jean Baptiste Camille Corot

(1796–1875)

By temperamental preference, rather than from any reaction to social problems, extensive reading, or close contact with the world of affairs, he set his models into a position which made them equal, but not superior, to the trees and water he loved so well, an equation of man and nature which is one of the premises of much modern art.

JOSEPH C. SLOANE

THE PAINTERS' REPUTATION

There are those painters who, after having produced their masterpieces, after having received their rewards and having attained the highest honors, stop themselves; some for the reason that they are afraid of damaging their reputation, others for the commercial reason of wanting their work to obtain a higher value. As far as I go, I will continue to work all the same: one owes it to art and to those who have rewarded one's work. So let them say, *"Le père Corot baisse"* (Father Corot is on the decline). Well, if I decline, it's too bad! One must show the young people that it is important to withstand them, and to hold on to one's guard, so that one does not fall.

I WORK ON ALL PARTS OF MY PAINTING AT ONCE

I always look immediately to see the effect. I am like a child who blows up a bubble of soap. At first the bubble is very small, but it is already spherical. Then the child blows the bubble up very softly, until he is afraid that it will burst. Similarly, I work on all parts of my painting at once, improving it very gently until I find that the effect is complete.

THE START OF A PAINTING

Very logically, I always begin by painting the shades, because the part that creates the greatest difficulties is also the one which one should finish first of all.

COLOR AND TONES

That which I look for while I paint is the form, the harmony, the value of the tones. Color comes afterwards. It is like someone one welcomes, and because that someone will be upright, honest, and

beyond reproach, one receives him with real pleasure and without fear. . . . Color comes afterwards for me because above all I like the unity, the harmony in the tones; whereas color by itself sometimes gives a harshness which I do not like. When people say that I make "leady" tones, it may be because I have carried this principle to excess.

THE LUMINOUS POINT

In a painting, there is always a luminous point; but this point must be unique. You may place it where you wish: in a cloud, in the reflection of the water, or in a bonnet. However, there must only be a single tone of this value.

NATURE THROUGH THE EYES OF A CHILD

I pray every day that God make me a child, that is to say that he will let me see nature in the unprejudiced way that a child sees it.

Nature above all.

From *Portrait of Corot, by Himself*

COROT: *Woman Reading.*
The Metropolitan Museum of Art (Gift of Louis Senff Cameron, 1928).

111

Eugène Delacroix

(1798–1863)

Delacroix is decidedly the most original painter of ancient or modern times. That is how things are, and what is the good of protesting? . . .

Nature, for Eugène Delacroix, is a vast dictionary whose leaves he turns and consults with a sure and searching eye; and his painting which issues above all from memory, speaks above all to the memory. . . .

Delacroix is the most suggestive *of all painters. . . .*

Like Michelangelo, Delacroix has made painting his unique muse, his exclusive mistress, his sole and sufficient pleasure.

CHARLES BAUDELAIRE

EXCERPTS FROM *THE JOURNAL*

APRIL 7, 1824

The first and most important thing in painting is the contour. Even if all the rest were to be neglected, provided the contours were there, the painting would be strong and finished. I have more need than most to be on my guard about this matter; *think constantly about it, and always begin that way.*

It is to this that Raphael owes his finish, and so, very often, does Géricault.

MAY 7, 1824

I must try not to break off on any account, except to finish the Velazquez. How strange the human mind is! When I first began, I think I should have been willing to work at it from the top of a church steeple, whereas now, even to think of finishing requires a real effort. And all this, simply because I have been away from it for so long. It is the same with my picture and with everything else I do. There is always a thick crust to be broken before I can give my whole heart to anything; a stubborn piece of ground, as it were, that resists the attacks of plough and hoe. But with a little perseverance the hardness suddenly gives and it becomes so rich in fruit and flowers that I am quite unable to gather them all.

If painters left nothing of themselves after their deaths, so that we were obliged to rank them as we do actors according to the judgement of their contemporaries, how different their reputations would be from what posterity has made them! How many forgotten names must have created a stir in their own day, thanks to the vagaries of fashion or to the bad taste of their contemporaries! But luckily, fragile though it is, painting (and failing this, engraving) does pre-

DELACROIX: *The Abduction of Rebecca.* The Metropolitan Museum of Art (Wolfe Fund, 1903).

113

serve the evidence for the verdict of posterity, and thus allows the reputation of an artist of real superiority to be reassessed, even though he may have been underestimated by the shallow judgement of contemporary public opinion, which is always attracted by flashiness and a veneer of truth.

Demay called, and while he was still with me M. Haussoullier arrived. There is something priggish about these young men of the school of Ingres. They seem to think it highly meritorious to have joined the ranks of "serious painting." This is one of the *party* watch-words. I said to Demay that a great number of talented artists had never done anything worthwhile because they surrounded themselves with a mass of prejudices, or had them thrust upon them by the fashion of the moment. It is the same with their famous word *beauty* which, everyone says, is the chief aim of the arts. But if beauty were the only aim, what would become of men like Rubens and Rembrandt and all the northern temperaments, generally speaking, who prefer other qualities? Demand purity, in other words, beauty, from an artist like Puget and farewell to his verve! This is an idea to develop. Northerners are usually less inclined in this direction. Italians prefer ornamentation. This is confirmed by their music.

Felt unwell when I got up. Took up the sketch for the *Entombment* once more, and became so fascinated that it drove away my disorder, but I paid for it that evening with a stiff neck that lasted all through the following day. The sketch is very good. It has lost some of its mystery, but that is the disadvantage of a methodical sketch. With a good drawing to settle the main lines of the composition and the placing of the figures the sketch can be done away with. It almost becomes an unnecessary repetition of the work itself. The qualities of the sketch are retained in the picture by leaving the details vague.

Today, Wednesday, repainted the rocks in the background of the "Christ" and finished the lay-in, the Magdalen, and the naked figure in the foreground. *I wish I had applied the paint rather more thickly in this lay-in. It is incredible how time smooths out a picture; my Sibyl* seems to me to have sunk into the canvas, already. It is a thing I must watch carefully.*

* *The Sibyl with the Golden Bough.*

Painted the Magdalen in the *Entombment*.

Must remember the simple effect of the head. It was laid in with a very dull, grey tone. I could not make up my mind whether to put it more into shadow or to make the light passages more brilliant. Finally, I made them slightly more pronounced compared with the mass and it sufficed to cover the whole of the part in shadow with warm and reflected tones. Although the light and shadow were almost the same value, the cold tones of the light and the warm tones of the shadow were enough to give accent to the whole. We were saying when we were with Villot on the following day that it requires very little effort to produce an effect in this way. It occurs very frequently, especially out of doors. Paolo Veronese owes much of his admirable simplicity to it. A principle which Villot considers most useful and of very frequent occurrence is to make objects stand out as a darker note against those that lie behind; this is attained through the mass of the object and at the stage of the lay-in, when the local tone is settled at the beginning. I do not understand how to apply this rule as well as Villot. I must study it.

Veronese also owes much of his simplicity to the absence of details, which allows him to establish the local color from the beginning. Painting in distemper almost forces him to do this. The simplicity of the draperies adds greatly to this quality in the rest. The vigorous contour which he draws so appropriately round his figures helps to complete the effect of simplicity in his contrasts of light and shade, and finishes and sets off the whole picture.

<div align="right">OCTOBER 5, 1847</div>

The way in which I treated the figure of "Italy" is a very satisfactory method to use for painting figures where you wish the form to be rendered as fully as imagination can desire, without ceasing to be full of color, etc.

Prud'hon's style was formed with a view to this need for going over the work again and again *without losing in frankness.* With the usual methods you always have to spoil one effect in order to obtain another. Rubens was *unrestrained* in the *Naiads* so as to avoid losing his light and color. *It is the same with portraiture;* if you want to obtain extreme strength of expression and character, the freedom of the touch disappears, and with it the light and the color. By the other method one could get results very quickly and need never feel exhausted. The work can always be taken up again, because the result is almost certain.

I found wax very useful when I was painting this figure; it made the paint dry quickly and allowed me to go back over the form

whenever I wished. *Copal varnish,* or . . . fulfils the same purpose, and wax might be mixed with it.

What gives paintings on white paper such delicacy and brilliance is most probably the transparency inherent in the essential whiteness of the paper. The brilliance of the Van Eycks, and later, of the pictures by Rubens, is due, no doubt, to the whiteness of their panels.

In all probability, the early Venetian painters used very white grounds. Their brown flesh seems to be nothing but simple glazes with lakes over a background that always shows through. And in the same way, in the early Flemish pictures, for example, not only the flesh, but the backgrounds, the earth, and the trees are all put in with glazes over a white ground. . . .

In the early Flemish pictures on wooden panels, which were painted in the same way with glazes, the brownish color shows through clearly. The difficulty is to find suitable compensating grey to offset the gradual yellowing and the hotness of the colors.

ANTWERP, AUGUST 10, 1850

How strange that I never noticed until now the extent to which Rubens proceeds by means of half-tone, especially in his finest works! His sketches ought to have put me on the track. In contrast to what they say about Titian, he first lays in the tone of his figures which appear dark against the light tone. It also explains how, when he afterwards comes to put in the background, and in his urgent need to obtain his effect, he deliberately sets out to render the flesh tones exaggeratedly brilliant by making the background dark.

JUNE 6, 1851

Although one has to keep in mind every part of the figure so as not to lose the proportions when they are hidden by drapery, I cannot think that this is a good method to follow in every case, but Raphael seems to have conformed to it scrupulously, judging by the studies that are still in existence. I feel convinced that Rembrandt would never have achieved his power of representing character by a significant play of gestures, or those strong effects that make his scenes so truly representative of nature, if he had bound himself down to this studio method. Perhaps they will discover that Rembrandt is a far greater painter than Raphael.

This piece of blasphemy will make every good academician's hair stand on end, and I set it down without having come to any final decision on the subject. The older I grow the more certain I become in my own mind that *truth* is the rarest and most beautiful of all qualities. It is possible, however, that Rembrandt may not quite have had Raphael's nobility of mind.

It may well be, however, that where Raphael expressed this grandeur in his lines and in the majesty of each of his figures, Rembrandt expressed it in his mysterious conception of his subjects and the profound simplicity of their gestures and expression. And although one may prefer the note of majesty in Raphael which echoes, as it were, the grandeur of some of his subjects, I think that without being torn to pieces by people of taste (and here I mean people whose taste is genuine and sincere) one might say that the great Dutchman was more of a natural painter than Perugino's studious pupil.

OCTOBER 12, 1853

On the use of the model. It is a question of effect and of how to obtain it when working from a model or from nature in general; true effect is the rarest thing to find in most pictures where the model plays a prominent role. The model seems to draw all the interest to itself so that nothing of the painter remains. When an artist is very learned and very intelligent the use of a model, if properly understood, allows details to be suppressed which a painter who works from his imagination always includes too lavishly for fear of leaving out something important. This fear prevents him from treating really characteristic details freely and from showing them in their full light. Shadows, for example, always have too much detail in the painting one does from imagination, especially in trees, draperies, etc. . . .

I make the above remarks and reaffirm all my earlier observations on the need for a great deal of intelligence in using the imagination, as I look at the sketches which I made at Nohant for the *Saint Anne*. The first sketch, which I did from nature, seems unbearable when I look at the second, although this is really almost a tracing of the earlier one. But my intentions are shown more clearly in it, useless details have been eliminated, and I have introduced the degree of elegance which I felt was needed to render a true impression of the subject.

It is therefore far more important for an artist to come near to the ideal which he carries in his mind, and which is characteristic of him, than to be content with recording, however strongly, any transitory ideal that nature may offer—and she does offer such aspects; but once again, it is only certain men who see them and not the average man, which is a proof that the beautiful is created by the artist's imagination precisely because he follows the bent of his own genius. . . .

On the imitation of nature. This important matter is the starting point of every school and one on which they differ widely as soon as they begin to explain it. The whole question seems to come to this:

is the purpose of imitation to please the imagination, or is it merely intended to obey the demands of a strange kind of conscience which allows an artist to be satisfied with himself when he has copied the model before his eyes as faithfully as possible?

<div align="right">APRIL 29, 1854</div>

Took up work again on my picture of *The Women Bathing.*

Since coming here* I am beginning to understand the *principle* of the trees better, although the leaves are not yet fully out. They must be modelled with a colored reflection, as in treating flesh; the method seems even more suitable in their case. The reflection should not be entirely a reflection. When you are finishing you must increase the reflection in places where it appears necessary, and when you paint on top of light or grey passages the transition is less abrupt. I notice that one should always model with masses that turn, as one would in objects not composed of an infinity of small parts, such as leaves. But as the latter are extremely transparent, the tone of the reflection plays an important part in their treatment.

Note:

(1) The general tone, which is neither entirely *reflection,* nor *shadow,* nor yet *light,* but is *almost everywhere transparent.*

(2) The edge is colder and darker; this will mark the passage from the reflection into the *light,* which must be indicated in the lay-in.

(3) The leaves that lie wholly in the shadow cast from those above, which it is best merely to indicate.

(4) The *matt passages in the light,* which must be painted in last.

You must always argue it out in this way and above all, bear in mind the direction from which the light is coming. If it comes from behind the tree, the latter will be almost entirely reflection. It will present the appearance of a mass of reflection in which a few touches of *matt tone* are scarcely visible; if, on the other hand, the light comes from behind the beholder, i.e. facing the tree, the branches on the other side of the trunk instead of receiving reflected light will be massed in a *shadow* tone that is unbroken and *completely flat.* To sum up, the flatter the different tones are laid on, the more lightness the tree will have.

The more I think about color, the more convinced I become that this reflected half-tint is the principle that must predominate, because it is this that gives the true tone, the tone that constitutes the value, the thing that matters in giving life and character to the object. Light, to which the schools teach us to attach equal importance and which they place on the canvas at the same time as the half-tint and shadow, is really only an accident. Without grasping this prin-

* Champrosay.

<div align="center">118</div>

ciple, one cannot understand true color, I mean the color that gives the feeling of thickness and depth and of that essential difference that distinguishes one object from another.

I have made it a rule never to allow myself to finish a picture unless the effect and the tone have been completely caught, and I find this plan very successful. I am always going back over my work, redrawing and correcting, and always in the light of *what I feel is needed at that particular moment;* indeed, it would be stupid to do otherwise. What I felt yesterday can be no guide for me today. I do not know how other men work, this is the only method for me. When everything has been carried forward in this way there is no difficulty about finishing, especially when one uses tones that at once fit in with those already set down. Without this, the freshness of the execution is lost and one spoils the liveliness of sensitive touches; proceeding in this way, the touches seem scarcely to have been modified. Before repainting, any passages of thick paint must be scraped down.

The main source of interest comes from the soul of the artist, and flows into the soul of the beholder in an irresistible way. Not that every interesting work strikes all its beholders with equal force merely because each of them is supposed to possess a soul; only people gifted with feeling and imagination are capable of being moved. These two faculties are equally indispensable to the beholder and the artist, although in different proportions.

Mannered talents cannot awaken true interest; they can excite curiosity, flatter a momentary whim, or appeal to passions that have nothing in common with art. But since the principal characteristic of mannerism is a lack of sincerity both in feeling and conception, these mannered talents cannot touch our imagination, which is simply a kind of mirror where nature is reflected as she really is; thus giving us, through a powerful form of memory, the sight of things which the soul alone enjoys.

The great masters are almost the only artists who excite interest, but they do so by different means according to the particular bent of their genius. It would be absurd to expect from a painter like Rubens the form of interest which Leonardo or Raphael knows how to arouse by such details as hands and heads, in which correctness and expression are united. It is equally useless to require from Leonardo and Raphael the great combined effects, the animation and breadth that commend themselves in the works of Rubens, that most brilliant of painters.

Gustave Courbet

(1819–1877)

*He destroyed, almost single-handed, the dominance
of the Classical and Romantic schools, which had be-
come, by 1850, stagnant and decadent. He founded a
new movement, Realism, which replaced the obsoles-
cent portrayals of gods and nymphs, knights and
damsels, with honest, earthy pictures of contemporary
French peasants and townsfolk, and with forthright
landscapes and seascapes, uncontaminated by literary
idealization.*

GERSTLE MACK

TO MAKE ART LIFELIKE, THIS IS MY OBJECTIVE

I studied the art of the ancients and that of the moderns using no
systematized approach and without preconceived ideas. I no more
wanted to imitate the former than I sought to copy the latter.

Neither did I strive towards the futile objective called "art for
art's sake." No! Quite simply, I wanted to draw from the entire body
of tradition a rational, independent sense of my own individuality.

To know in order to create—this was my purpose. To be able to
interpret the customs, ideas, and point of view of my time according
to my own frame of reference; in a word, to make art lifelike, this is
my objective.

From the Courbet exhibition (1855), by Courbet

LETTER TO THE MINISTER OF BEAUX ARTS (1870)

While staying at the home of my friend, Jules Dupré, I was in-
formed of an official decree, appearing in the *Journal officiel,* nam-
ing me a Chevalier of the Legion of Honor. This decree, from which
my outspoken opinions about rewards for artists and titles of nobil-
ity should have spared me, was issued without my consent, and it was
you, *monsieur le Ministre,* who felt obliged to take the initiative.

Have no fear that I misunderstand the motives which have
prompted your action. Arriving at the Beaux Arts ministry after
a disastrous administration which seemed to feel obliged to put an
end to art in our country, and would have done so, either through
corruption or violence, had there not been a few courageous men
here and there to thwart its machinations, you were anxious to
herald your coming into office by taking measures that would con-
trast sharply with your predecessor's policies.

Your behaviour does you honor, *monsieur le Ministre,* but allow me to say that it will affect neither my attitude nor my determination. As a citizen I am opposed to accepting an honor instituted by a monarchial regime. The Legion of Honor decoration which you arranged for in my absence and on my behalf is repugnant to my principles.

At no time, in no case, and for no reason whatsoever would I have accepted it. I would do so even less today, when treachery is rampant and the human conscience saddened by so many mercenary recantations. Honor is not to be found in a title or in a ribbon; it resides in

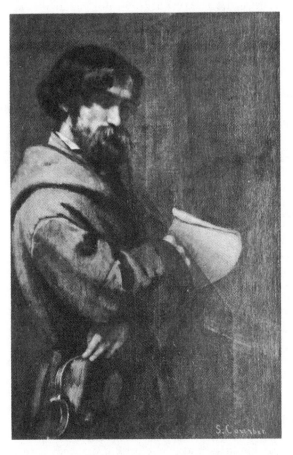

COURBET: *Alphonse Promayet.* The Metropolitan Museum of Art (Bequest of Mrs. H. O. Havemeyer, 1929, The Havemeyer Collection).

121

human deeds and in the mover of deeds. Self-respect, respect for one's ideas is its prime factor. I honor myself by remaining faithful to life-long principles; should I abandon them for a mere token, I would give up my honor.

My artistic consciousness is just as strongly opposed to accepting any reward from the State. The State is incompetent in matters of art. When it attempts to grant rewards, it encroaches upon public taste. Its intervention is completely demoralizing and disastrous to the artist whom it deceives as to his real worth. It is fatal to art itself which it imprisons in the tower of official expediency and condemns to sterile mediocrity. Prudence would dictate that it abandons this task. The day on which the State will have left us free, will be the day on which it will have fulfilled its duty towards us.

Therefore permit me, *monsieur le Ministre,* to decline the honor you thought to bestow upon me. I am fifty years old and I have always lived as a free man. Let me be free for the rest of my days; for when I die, let it be said of me: "He never belonged to any school, to any church, to any institution, to any academy—least of all to any regime, lest it be the regime of liberty."

George Inness

(1825–1894)

There was never anything small or petty about either his conception or execution. His vision was broad, and all his life he was striving for the ensemble of earth, air, sky and light. He knew they were a unit and could figure it out cleverly with geometrical figures, and it was his great aim to demonstrate it in art. He never did demonstrate it to his own satisfaction, but he certainly made his aim intelligible to many people. . . .
New York Evening Post (January 5, 1895)

ON IMPRESSIONISM

. . . Now there has sprung up a new school, a mere passing fad, called Impressionism, the followers of which pretend to study from nature and paint it as it is. All these sorts of things I am down on. I will have nothing to do with them. They are shams.

The fact came to my mind in the beginning of my career. I would sit down before nature, and under the impulse of a sympathetic feeling put something on canvas more or less like what I was aiming at.

It would not be a correct portrait of the scene, perhaps, but it would have a charm. Certain artists and certain Philistines would see that and would say: "Yes, there is a certain charm about it, but did you paint it outdoors? If so, you could not have seen it this and that and the other." I could not deny it, because I then thought we saw physically and with the physical eye alone. Then I went to work again and painted what I thought I saw, calling on my memory to supply missing details. The result was that the picture had no charm; nothing about it was beautiful. What was the reason? When I tried to do my duty and paint faithfully I didn't get much; when I didn't care so much for duty I got something more or less admirable. As I went on I began to see little by little that my feeling was governed by a certain principle that I did not then understand as such.

But these are merely scientific formulae. Every artist must, after all, depend on his feeling, and what I have devoted myself to is to try to find out the law of the unit; that is, of impression. Landscape is a continued repetition of the same thing in a different form and in a different feeling. When we go outdoors our minds are overloaded; we do not know where to go to work. You can only achieve something if you have an ambition so powerful as to forget yourself, or if you are up in the science of your art. If a man can be an eternal God when he is outside, then he is all right; if not he must fall back on science.

The worst of it is that all thinkers are apt to become dogmatic, and every dogma fails because it does not give you the other side. The same is true of all things—art, religion, and everything else. You must find a third as your standpoint of reason. That is how I came to work in the science of geometry, which is the only abstract truth, the diversion of the art of consciousness and so on, which I have already mentioned.

And no one can conceive the mental struggles and torment I went through before I could master the whole thing. I knew the principle was true, but it would not work right. I had constantly to violate my principle to get in my feeling. This was my third. I found I was right, and went on in perfect confidence, and I have my understanding under perfect control, except when I overwork myself, when I am liable to get wriggly, like anybody else. Then I shut myself up with my books and write, applying the principles I have found true in art to pure reasoning on the subject of theology. That is what you see in my pictures, that is the feeling and the sentiment. I have always had it, but have not always understood the principles which govern it.

From *The Documents of George Inness*

Camille Pissarro

(1831–1903)

*We are perhaps all derived from Pissarro. Already
in '65 he had eliminated black, bitumen, sienna, and
ochre. Only paint with the three primary colors and
their immediate derivatives.*

PAUL CÉZANNE

EXTRACTS FROM THREE LETTERS

JULY 5, 1883

. . . Are you drawing?—Don't waste time, try to improve your
work, remember the drawings of Holbein you copied, he is the real
master. Don't strive for skillful line, strive for simplicity, for the es-
sential lines which give the physiognomy. Rather incline towards
caricature than towards prettiness.

JULY 25, 1883

. . . You must accustom yourself to seeing the ensemble in a
flash and to rendering its character at once, but you also have to
grow in strength and attack in a serious way bigger things with firm
contours, like what you began here. . . . It is good to draw every-
thing, anything. When you have trained yourself to see a tree truly,
you know how to look at the human figure. Specialization is not
necessary, it is the death of art, whose requirements are exactly op-
posed to those of industry. Once again I say, you can't waste time
drawing landscapes industriously. The classroom is good only when
you are strong enough not to be influenced.

NOVEMBER 20, 1883

. . . Sometimes I am horribly afraid to turn round canvases
which I have piled against the wall; I am constantly afraid of find-
ing monsters where I believed there were precious gems! . . .
Thus it does not astonish me that the critics in London relegate me
to the lowest rank. Alas! I fear that they are only too justified! How-
ever, at times I come across works of mine which are soundly done
and really in my style, and at such moments I find great solace. But
no more of that. Painting, art in general, enchants me. It is my life.
What else matters? When you put all your soul into a work, all that
is noble in you, you cannot fail to find a kindred soul who under-
stands you, and you do not need a host of such spirits. Is not that
all an artist should wish for?

From *Camille Pissaro, Letters to His Son Lucien*

Édouard Manet

(1832–1883)

*His art, or rather his instinct, led Manet to make
unexpected chromatic harmonies, forbidden by the
Academy, those sorts of harmonies which to a concert
audience seem discordant until the moment when the
"dissonance" which has been hurting their ears sud-
denly affords more musical pleasure than a perfect
chord.*

JACQUES ÉMILE BLANCHE

LETTER TO FANTIN-LATOUR

MADRID, 1865

Oh, what a pity you are not here; what pleasure it would have
given you to see Velazquez, who alone is worth the whole journey.*
The painters of every school who surround him in the Madrid
Museum, and who are very well represented, all seem second-rate in
comparison with him. He is the painter to beat all painters. He
didn't astonish me, he enchanted me. The full-length portrait in the
Louvre is not by him; only the authenticity of the Infanta cannot
be doubted. There is an enormous picture here, filled with small
figures like those in *The Cavaliers* in the Louvre, but the figures
of the women and men in this one are perhaps better, and all of
them are perfectly free from retouching. The background—the
landscape—is by a pupil of Velazquez.

The most astonishing work in this splendid collection, and per-
haps the most astonishing piece of painting that has ever been done,
is the one entitled in the catalogue *Portrait of a Celebrated Actor in
the Time of Philip IV*. The background fades into nothing; the old
boy all in black, so olive, seems to be surrounded by air. And, ah,
The Spinners; and the beautiful portrait of Alonzo Cano; and *Las
Meninas*—another extraordinary picture! The philosophers—what
astonishing works! And all the dwarfs too!—one in particular,
seated full face with his hands on his hips: a painting for the real
connoisseur. And his magnificent portraits!—one would have to in-
clude the lot; they are all masterpieces. . . .

* After exhibiting *Olympia* in the Salon of 1865, Manet was strongly attacked by
the critics. He decided to go to Spain in order to change his "ideas."

FROM THE MEMOIRS OF ANTONIN PROUST (1876)

. . . What idiots they must be! (he exclaimed during the meal). Fancy accusing me of deliberately trying to kill a line. Have *I ever* had the idea of assassinating the Duc de Guise or of trying to resuscitate Napoleon? I put things down on canvas, as simply as I can, as I see them. Take *Olympia,* for example, what could be more simple then that? I'm told there are some harsh passages in it: so there were; that's how I saw them. I painted what I saw. And what about *Le Port de Boulogne?* Tell me, is there a more sincere work, more free from convention, more true to life?

What would have been more easy than to introduce into these pictures those qualities which M. Wolff* likes so much? People wrangle over what pleases that critic as though they were fighting over pieces of the True Cross. Ten years from now his opinions won't be worth a nickel.

Now, if instead of painting Jeanne Lorgnon mending her old clothes, I had painted the Empress Josephine washing her dirty linen, what a success *that* would have been! There wouldn't have been enough engravers to make this majestic work known to the public, not enough critics to praise it: but there, *I* didn't know the Empress Josephine; I leave that to Meissonier, he knew her *and* Napoleon!

REMARKS MADE TO G. JEANNIOT (1882)

Color is all a question of taste and sensibility. You must have something to say—if not, you might as well pack up. One isn't a painter if one doesn't love painting more than anything else in the world, and it isn't enough to know your job; you've got to be excited by it. . . .

Concision in art is both necessary and elegant. The concise man makes one think; the talkative man irritates. . . . In a figure, look for the highlights and the deepest shadows; the rest will come naturally; often it is very little. Also train your memory; for nature will never give you more than indications.

From *Portrait of Manet, by Himself*

* Wolff was the art critic of *Le Figaro.*

Hilaire Germain Edgar Degas

(1834–1917)

Degas's naturalism was only a temporary concession to the new ideology; basically a classicist, he preferred elegant subjects—especially racing and the world of ballet. Despite his involvement with the Impressionist movement, with its fights and its experiments, he retained a certain upper-class, noncommittal aloofness. He always remained a spectator rather than a participant, victimized by his prejudices, shy, afraid of displays of emotion, an outsider. Keenly analytical, he was the only one among his contemporaries who knew how to capture an instantaneous vision without sacrificing truth.

<div align="right">FRANÇOIS MATHEY</div>

REMARKS TO THREE ARTISTS

To Berthe Morisot:
. . . The study of nature is unimportant because painting is a conventional art and it would be infinitely better to learn drawing from Holbein.

To Max Liebermann:
I would like to be rich enough to buy back all my pictures and destroy them by pushing my foot through the canvas.

To Bartholomé (Naples, January 17, 1886):
How pretty the photographed drawing is that you gave me! But it is essential to do the same subject over again, ten times a hundred times. Nothing in art must seem to be chance, not even movement.

<div align="right">From the Degas manuscripts</div>

LETTER TO MME. DIETZ MONNIN

Dear Madame:
Let us leave the portrait* alone, I beg of you. I was so surprised by

* An oil painting of Mme. Dietz Monnin, probably destroyed by Degas. A study for the painting shows a lady with pink hat and a large boa around her neck.

your letter suggesting that I reduce it to a boa and a hat that I shall not answer you. I thought that Auguste or M. Groult, to whom I had already spoken about your last idea and my own disinclination to follow it, would have informed you about the matter.

Must I tell you that I regret having started something in my own manner only to find myself transforming it completely into yours. That would not be too polite and yet. . . .

But, dear Madame, I cannot go into this more fully without showing you only too clearly that I am very much hurt. Outside of my unfortunate art please accept all my regards.

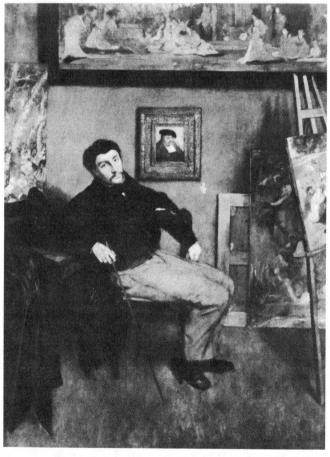

DEGAS: *James Tissot*. The Metropolitan Museum of Art (Rogers Fund, 1939).

James Abbott McNeill Whistler

(1834–1903)

Reacting against the popular ancedotal painting, whose objective was story-telling and naturalistic imitation, Whistler became a champion of "art for art's sake."

<div style="text-align: right">HELEN GARDNER</div>

Whistler had taken part in the first battle of the new movement, he had exhibited with Manet in the Salon des Refusés in 1863, and he shared the enthusiasm of his painter colleagues for Japanese prints. He was not an Impressionist in the strict sense of the word, any more than was Degas or Rodin, for his main concern was not with the effects of light and color but rather with the composition of delicate patterns. . . . He stressed the point that what mattered in painting was not the subject but the way in which it was translated into colors and forms.*

<div style="text-align: right">E. H. GOMBRICH</div>

THE CRITICS, THE PUBLIC, AND THE MEANING OF ART

It is with great hesitation and much misgiving that I appear before you, in the character of the Preacher.

If timidity be at all allied to the virtue of modesty, and can find favor in your eyes, I pray you, for the sake of that virtue, accord me your utmost indulgence.

I would plead for my want of habit, did it not seem preposterous, judging from precedent, that aught save the most efficient effrontery could be ever expected in connection with my subject—for I will not conceal from you that I mean to talk about Art. Yes, Art—that has of late become, as far as much discussion and writing can make it, a sort of common topic for the tea-table.

Art is upon the Town!—to be chucked under the chin by the passing gallant—to be enticed within the gates of the householder —to be coaxed into company, as a proof of culture and refinement.

* Impressionism.

If familiarity can breed contempt, certainly Art—or what is currently taken for it—has been brought to its lowest stage of intimacy.

The people have been harassed with Art in every guise, and vexed with many methods as to its endurance. They have been told how they shall love Art, and live with it. Their homes have been invaded, their walls covered with paper, their very dress taken to task—until, roused at last, bewildered and filled with the doubts and discomforts of senseless suggestion, they resent such intrusion, and cast forth the false prophets, who have brought the very name of the beautiful into disrepute, and derision upon themselves.

Alas! ladies and gentlemen, Art has been maligned. She has naught in common with such practices. She is a goddess of dainty thought—reticent of habit, abjuring all obtrusiveness, purposing in no way to better others.

She is, withal, selfishly occupied with her own perfection only—having no desire to teach—seeking and finding the beautiful in all conditions and in all times, as did her high priest Rembrandt, when he saw picturesque grandeur and noble dignity in the Jews' quarter of Amsterdam, and lamented not that its inhabitants were not Greeks.

As did Tintoretto and Paul Veronese, among the Venetians, while not halting to change the brocaded silks for the classic draperies of Athens.

As did, at the Court of Philip, Velazquez, whose Infantas, clad in inaesthetic hoops, are, as works of Art, of the same quality as the Elgin marbles.

No reformers were these great men—no improvers of the way of others! Their productions alone were their occupation, and, filled with the poetry of their science, they required not to alter their surroundings—for, as the laws of their Art were revealed to them, they saw, in the development of their work, that real beauty which, to them, was as much a matter of certainty and triumph as is to the astronomer the verification of the result, foreseen with the light given to him alone. In all this, their world was completely severed from that of their fellow-creatures with whom sentiment is mistaken for poetry; and for whom there is no perfect work that shall not be explained by the benefit conferred upon themselves.

Humanity takes the place of Art, and God's creations are excused by their usefulness. Beauty is confounded with virtue, and, before a work of Art, it is asked: "What good shall it do?"

Hence it is that nobility of action, in this life, is hopelessly linked with the merit of the work that portrays it; and thus the people have acquired the habit of looking, as who should say, not *at* a picture,

but *through* it, at some human fact, that shall, or shall not, from a social point of view, better their mental or moral state. So we have come to hear of the painting that elevates, and of the duty of the painter—of the picture that is full of thought, and of the panel that merely decorates.

A favorite faith, dear to those who teach, is that certain periods were especially artistic, and that nations, readily named, were notably lovers of Art.

So we are told that the Greeks were, as a people, worshippers of the beautiful, and that in the fifteenth century Art was engrained in the multitude.

That the great masters lived in common understanding with their patrons—that the early Italians were artists—all—and that the demand for the lovely thing produced it.

That we, of today, in gross contrast to this Arcadian purity, call for the ungainly, and obtain the ugly.

That, could we but change our habits and climate—were we willing to wander in groves—could we be roasted out of broadcloth—were we to do without haste, and journey without speed, we should again *require* the spoon of Queen Anne, and pick at our peas with the fork of two prongs. And so, for the flock, little hamlets grow near Hammersmith, and the steam horse is scorned.

Useless! quite hopeless and false is the effort!—built upon fable, and all because "a wise man has uttered a vain thing and filled his belly with the east wind."

Listen! There never was an artistic period.

There never was an Art-loving nation.

In the beginning, man went forth each day—some to do battle, some to the chase; others, again, to dig and to delve in the field—all that they might gain and live, or lose and die. Until there was found among them one, differing from the rest, whose pursuits attracted him not, and so he stayed by the tents with the women, and traced strange devices with a burnt stick upon a gourd.

This man, who took no joys in the ways of his brethren—who cared not for conquest, and fretted in the field—this designer of quaint patterns—this deviser of the beautiful—who perceived in Nature about him curious curvings, as faces are seen in the fire—this dreamer apart, was the first artist. . . .

Nature contains the elements, in color and form, of all pictures, as the keyboard contains the notes of all music.

But the artist is born to pick, and choose, and group with science, these elements, that the result may be beautiful—as the musician

gathers his notes, and forms his chords, unil he bring forth from chaos glorious harmony.

To say to the painter, that Nature is to be taken as she is, is to say to the player, that he may sit on the piano.

That nature is always right, is an assertion, artistically, as untrue, as it is one whose truth is universally taken for granted. Nature is very rarely right, to such an extent even, that it might almost be said that Nature is usually wrong: that is to say, the condition of things that shall bring about the perfection of harmony worthy a picture is rare, and not common at all.

This would seem, to even the most intelligent, a doctrine almost blasphemous. So incorporated with our education has the supposed aphorism become, that its belief is held to be part of our moral being, and the words themselves have, in our ear, the ring of religion. Still, seldom does Nature succeed in producing a picture.

The sun blares, the wind blows from the east, the sky is bereft of cloud, and without, all is of iron. The windows of the Crystal Palace are seen from all points of London. The holiday-maker rejoices in the glorious day, and the painter turns aside to shut his eyes.

How little this is understood, and how dutifully the casual in Nature is accepted as sublime, may be gathered from the unlimited admiration daily produced by a very foolish sunset. . . .

For some time past, the unattached writer has become the middle-man in this matter of Art, and his influence, while it has widened the gulf between the people and the painter, has brought about the most complete misunderstanding as to the aim of the picture.

For him a picture is more or less a hieroglyph or symbol of story. Apart from a few technical terms, for the display of which he finds an occasion, the work is considered absolutely from a literary point of view; indeed, from what other can he consider it? And in his essays he deals with it as with a novel—a history—or an anecdote. He fails entirely and most naturally to see its excellences, or demerits—artistic—and so degrades Art, by supposing it a method of bringing about a literary climax.

It thus, in his hands, becomes merely a means of perpetrating something further, and its mission is made a secondary one, even as a means is second to an end.

The thoughts emphasized, noble or other, are inevitably attached to the incident, and become more or less noble, according to the eloquence or mental quality of the writer, who looks the while, with disdain, upon what he holds as "mere execution"—a matter belonging, he believes, to the training of schools, and the reward of assidu-

ity. So that, as he goes on with his translation from canvas to paper, the work becomes his own. He finds poetry where he would feel it were he himself transcribing the event, invention in the intricacy of the *mise en scène,* and noble philosophy in some detail of philanthropy, courage, modesty, or virtue, suggested to him by the occurrence.

All this might be brought before him, and his imagination appealed to, by a very poor picture—indeed, I might safely say that it generally is.

Meanwhile, the *painter's* poetry is quite lost to him—the amazing invention that shall have put form and color into such perfect harmony, that exquisiteness is the result, he is without understanding —the nobility of thought that shall have given the artist's dignity to the whole, says to him absolutely nothing.

So that his praises are published, for virtues we would blush to possess—while the great qualities, that distinguish the one work from the thousand, that make of the masterpiece the thing of beauty that it is—have never been seen at all.

That this is so, we can make sure of, by looking back at old reviews upon past exhibitions, and reading the flatteries lavished upon men who have since been forgotten altogether—but upon whose works the language has been exhausted, in rhapsodies—that left nothing for the National Gallery.

A curious matter, in its effect upon the judgment of these gentlemen, is the accepted vocabulary of poetic symbolism, that helps them, by habit, in dealing with Nature: a mountain, to them, is synonymous with height—a lake, with depth—the ocean, with vastness—the sun, with glory.

So that a picture with a mountain, a lake, and an ocean—however poor in paint—is inevitably "lofty," "vast," "infinite," and "glorious"—on paper. . . .

So Art has become foolishly confounded with education—that all should be equally qualified.

Whereas, while refinement, culture, and breeding are in no way arguments for artistic result, it is also no reproach to the most finished scholar or greatest gentleman in the land that he be absolutely without eye for painting or ear for music—that in his heart he prefers the popular print to the scratch of Rembrandt's needle, or the songs of the hall to Beethoven's C minor Symphony.

Let him have but the wit to say so, and not feel the admission a proof of inferiority.

Art happens—no hovel is safe from it, no Prince may depend

upon it, the vastest intelligence cannot bring it about, and puny efforts to make it universal end in quaint comedy and coarse farce.

This is as it should be—and all attempts to make it otherwise are due to the eloquence of the ignorant, the zeal of the conceited.

This is as it should be—and all attempts to make it otherwise are due to the eloquence of the ignorant, the zeal of the conceited.

The boundary-line is clear. Far from me to propose to bridge it over—that the pestered people be pushed across. No! I would save them from further fatigue. I would come to their relief, and would lift from their shoulders this incubus of Art.

Why, after centuries of freedom from it, and indifference to it, should it now be thrust upon them by the blind—until wearied and puzzled, they know no longer how they shall eat or drink—how they shall sit or stand—or wherewithal they shall clothe themselves —without afflicting Art. . . .

False again, the fabled link between the grandeur of Art and the glories and virtues of the State, for Art feeds not upon nations, and peoples may be wiped from the face of the earth, but Art *is*.

It is indeed high time that we cast aside the weary weight of responsibility and co-partnership, and know that, in no way, do our virtues minister to its worth, in no way do our vices impede its triumph!

How irksome! how hopeless! how superhuman the self-imposed task of the nation! How sublimely vain the belief that it shall live nobly or art perish.

Let us reassure ourselves, at our own option is our virtue. Art we in no way affect.

From "Ten O'Clock," a lecture delivered by Whistler at Oxford University

Winslow Homer

(1836–1910)

. . . While visual perception was his starting point and his objective, he painted with economy and with as much concern for the organization through which he expressed this raw material as for the material itself.

HELEN GARDNER

EXTRACTS FROM AN INTERVIEW

Q. Mr. Homer, do you ever take the liberty in painting nature, of modifying the color of any part?

A. Never! Never! When I have selected the thing carefully, I paint it exactly as it appears. . . .

When I was painting the Luxembourg picture, I carried the canvas repeatedly, from the rocks below, hung it on that balcony, and studied it from a distance with reference solely to its simple and absolute truth. Never!

From an interview with Homer, by John W. Beatty

THREE LETTERS

SCARBORO, ME., October 23, 1893

Messrs. O'Brien & Sons:

Gentlemen, I am in receipt of your letter of October the 8th inviting me to have an exhibition at your Galleries. In reply I would say that I am extremely obliged to you for your offer, and if I have anything in the picture line again I will remember you.

At the present and for some time past I see no reason why I should paint any pictures.

P.S. I will paint for money at any time. Any subject, any size.

OCTOBER 16, 1896

My dear Mrs. Clarke:

I send you today by the American Express the long and much talked-of sketch that was made at the same time of the *Eight-Bells.* The date I was doubtful about (either '85 or '86). I considered, on looking at it, that it was much better left as it is than it would be made into a picture by figures in the distance, as it has a tone on it now that the ten years have given it, and it also has the look of being made at once, and is interesting as a quick sketch from nature.

135

I only hope that you have not expected any more of a picture than this that you now receive. I wish it were better, but such as it is I now offer it to you. I would give you this with pleasure, but I know your ideas on that point, so you can send me, any time in the next ten years (the time you have so patiently waited), two hundred and fifty dollars in payment for this sketch. . . .

MARCH 20, 1902

Messrs. O'Brien & Sons:

Gentlemen, You ask me if the picture *Lee Shore,* recently sold in Providence, is a duplicate. It is not. Only once in the last thirty years have I made a duplicate, and that was a watercolor from my oil picture now owned by Layton Art Gallery, Milwaukee, called *Hark! the Lark!* It is the most important picture I ever painted, and the very best one, as the figures are large enough to have some expression in their faces. The watercolor was called *A Voice from the Cliff,* and well known.

Why do you not try and sell the *Gulf Stream* to the Layton Art Gallery, or some other public gallery? No one could expect to have it in a private house. I will write you again next week.

Paul Cézanne

(1839–1906)

Cézanne's world is dense, solid, stable, and—above all—pictorial. . . . The more he strove to discipline his brush, to escape "the infernal facility of the brush," the greater became the warmth of his technique. He waged a fierce, exhausting struggle for style and for truth.

FRANÇOIS MATHEY

EIGHT LETTERS

APRIL 15, 1904

To Émile Bernard:

May I repeat what I told you here: treat nature in terms of the cylinder, the sphere, the cone, everything in proper perspective so that each side of an object or a plane is directed towards a central point. Lines parallel to the horizon give breadth, that is a section of

nature, or if you prefer, of the spectacle that the *Pater Omnipotens Aeterne Deus* spreads out before our eyes. Lines perpendicular to this horizon give depth. But nature for us men is more depth than surface, whence the need of introducing into our light vibrations, represented by reds and yellows, and a sufficient amount of blue to give the impression of air.

JUNE 27, 1904

To Émile Bernard:

. . . You remember the fine pastel by Chardin, equipped with a pair of spectacles and a visor to shade the eyes. What a sly fellow this painter is. Have you noticed that by passing a small transverse plaque backwards and forwards across the nose, the color tones are thrown up better? Verify this fact and tell me if I am wrong.

AIX, July 25, 1904

To Émile Bernard:

. . . I do not want to be right in theory, but in nature. Ingres, in spite of his "estyle" (Aixian pronunciation) and his admirers, is only a very little painter. You know the greatest painters better than I do; the Venetians and the Spaniards.

To achieve progress nature alone counts, and the eye is trained through contact with her. It becomes concentric by looking and working. I mean to say that in an orange, an apple, a bowl, a head, there is a culminating point; and this point is always—in spite of the tremendous effect of light and shade and colorful sensations—the closest to our eye; the edges of the objects recede to a center on our horizon. With a small temperament one can be very much of a painter. One can do good things without being very much of a harmonist or a colorist. It is sufficent to have a sense of art—and this sense is doubtless the horror of the bourgeois. Therefore institutions, pensions, honors can only be made for cretins, rogues, and rascals. Do not be an art critic, but paint, therein lies salvation.

AIX, December 9, 1904

To Charles Camoin:

. . . Should you at the moment be under the influence of one who is older than you, believe me as soon as you begin to feel yourself, your own emotions will finally emerge and conquer their place in the sun—*get the upper hand,* confidence,—what you must strive to attain is a good method of *construction.* Drawing is merely the outline of what you see.

Michelangelo is a constructor, and Raphael an *artist* who, great as he is, is always limited by the model. When he tries to be thoughtful he falls below the *niveau* of his great rival.

137

To Émile Bernard:

. . . This is true without possible doubt—I am very positive— an optical impression is produced on our organs of sight which makes us classify as *light*, half-tone or quarter-tone, the surfaces represented by color sensations. (So that light does not exist for the painter.) As long as we are forced to proceed from black to white, the first of these abstractions being like a point of support for the eye as much as for the mind, we are confused, we do not succeed in mastering ourselves, in *possessing ourselves*. During this period (I am necessarily repeating myself a little) we turn towards the admirable works that have been handed down to us throughout the ages, where we find comfort, a support such as a plank is for the bather.

CÉZANNE: *The Card Player*. Drawing. The Museum of Art, Rhode Island School of Design. 138

To Émile Bernard:

. . . I am able to describe to you again, rather too much I am afraid, the obstinacy with which I pursue the realization of that part of nature, which, coming into our line of vision, gives the picture. Now the theme to develop is that—whatever our temperament or power in the presence of nature may be—we must render the image of what we see, forgetting everything that existed before us. Which, I believe must permit the artist to give his entire personality whether great or small.

Now, being old, nearly 70 years, the sensations of color, which give light, are the reasons for the abstractions which prevent me from either covering my canvas or continuing the delimitation of the objects when their points of contact are fine and delicate; from which it results that my image or picture is incomplete. On the other hand the planes are placed one on top of the other from whence neo-impressionism emerged, which outlines the contours with a black stroke, a failing that must be fought at all costs. Well, nature when consulted, gives us the means of attaining this end.

To Émile Bernard:

. . . It is, however, very painful to have to register that the improvement produced in the comprehension of nature from the point of view of form of the picture and the development of the means of expression should be accompanied by old age and a weakening of the body.

If the official Salons remain so inferior it is because they only employ more or less widely known methods of production. It would be better to bring more personal feeling, observation, and character.

The Louvre is the book in which we learn to read. We must not, however, be satisfied with retaining the beautiful formulas of our illustrious predecessors. Let us go forth to study beautiful nature . . . let us strive to express ourselves according to our personal temperaments. Time and reflection, moreover, modify little by little our vision. And at last comprehension comes to us.

To Émile Bernard:

. . . But I believe in the logical development of everything we see and feel through the study of nature and turn my attention to technical questions later; for technical questions are for us only the means of making the public feel what we feel ourselves and of making ourselves understood.

Claude Monet

(1840–1926)

He undertook to prove that the object painted was of no importance, the sensation of light was the only true subject.

KENNETH CLARK

The artist stands face to face with nature without thinking of himself; he receives everything from it, lets himself be impressed by it without afterthought, and abandons himself to the joy of contemplation. Thus it is in Monet's cathedrals or water lilies, or in Debussy's Ibéria or La Mer.

PAUL COLLAER

GLEYRE'S STUDIO

In Gleyre's studio I found Renoir, Sisley, and Bazille. . . . While we sketched from a model, Gleyre criticized my work: "It is not bad," he said, "but the breast is heavy, the shoulder too powerful, and the foot too big." I can only draw what I see, I replied timidly. "Praxiteles borrowed the better elements of a hundred imperfect models in order to create a masterpiece," retorted Gleyre dryly. "When one does something, one must go back to the ancients." The same evening I took Sisley, Renoir, and Bazille aside: Let us leave, I told them. This place is unwholesome: there is no sincerity here. We left after two weeks of lessons of that kind . . . and we did the right thing.

From Monet's documents

TALK WITH CLEMENCEAU

Once by the bier of a woman who had been and still was very dear to me, I caught myself, my eyes fixed on her forehead in the act of mechanically looking for the sequence of tones, seeking to make my own the gradations of color which death had just settled upon the immobile face. Tones of blue, of yellow, of gray. . . . See to what a pass things had come. The desire was natural enough to reproduce the last likeness of her who was going to leave us forever. But even before the idea occurred to me of fixing the features to which I was so deeply attached, my organism automatically reacted to the stimulus of color, my reflexes led me in spite of myself into an unconscious operation which repeated the daily course of my life. So the beast in his treadmill. Pity me, *mon ami.*

From *The Water Lilies,* by Clemenceau

TWO LETTERS

April 5, 1886

My dear Zola:

You were good enough to send me *L'Oeuvre*.* I am very grateful to you for it. I have always enjoyed reading your books, and this one was doubly interesting to me because it raises questions about art for which we have been fighting so long. I have just read it and I am worried and upset, I admit.

You were purposely careful to have none of your characters resemble any one of us, but, in spite of that, I am afraid lest our enemies among the public and the press identify Manet or ourselves with failures, which is not what you have in mind, I cannot believe it.

Forgive me for telling you this. It is not a criticism; I have read *L'Oeuvre* with great pleasure, finding memories on every page. Moreover, you are aware of my fanatical admiration for your talent. No; but I have been struggling for a long time and I am afraid that, just as we are about to meet with success, our enemies may make use of your book to overwhelm us.

Excuse this long letter. Remember me to Madame Zola, and thank you again.

July 22, 1889

Dear Monsieur Choquet:

I am writing to ask you if you would be kind enough to subscribe to the fund which the friends and admirers of Manet are raising to

* This book, which deals with artistic failure, caused the final break between Zola and his old friend Cézanne, who thought that Zola was modeling the book after him. But the novel offended most of Zola's painter friends not only because of its distortions but also because it reiterated Zola's pronouncement of 1880 in *Le Voltaire* concerning the Impressionists:

"They all keep rough drafts, hasty impressions, and not one of them seems to have the power to be the awaited master. Is it not irritating to see this new recording of light, this passion for truth carried to the point of scientific analysis, this evolution which began with such originality and is delayed and falls into the hands of the clever and is not completed because the essential man has not been born?"

Renoir commented: "What a fine book he could have written, not only as a historical record of a very original movement in art, but also as a *human document* . . . if in *L'Oeuvre* he had taken the trouble simply to relate what he had seen and heard in our gatherings and our studios; for here he actually happened to have lived the life of his models. But, fundamentally, Zola did not give a hoot about portraying his friends as they really were, that is to say, to their advantage."

Pissarro did not think otherwise. "I dined with the Impressionists," he wrote his son Lucien in March 1886. "I had a long talk with Huysmans; he is very conversant with the new art and is anxious to break a lance for us. We talked about *L'Oeuvre.* . . . It seems that he had a quarrel with Zola, who is very worried."

purchase *Olympia* and offer it to the Louvre. This is the finest homage we can pay to his memory, and it is also a discreet way of assisting his widow.

We would be very happy to number you among our subscribers, a list of whom I am sending you herewith.* We need 20,000 francs. We should get this easily after such a good beginning.

Please be good enough to answer me as soon as possible, letting me know how much I can put you down for. . . . I am thinking of coming to Paris quite soon to re-hang some of the pictures in my exhibition which have been badly shown. In this way, if you wish, I could sell you two or three of your paintings so that you won't be deprived of them too long.

Please give my kind regards to Madame Choquet . . .

* At the time this letter was written 9,500 francs had been raised. The necessary money was raised within about six months.

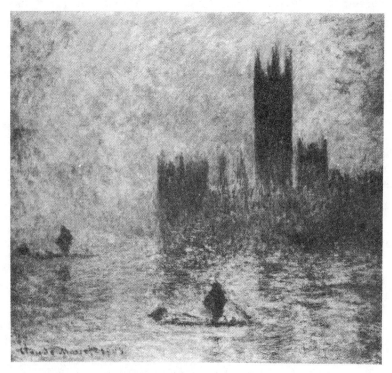

MONET: *Houses of Parliament.* The Metropolitan Museum of Art (Bequest of Julia W. Emmons, 1956).

Odilon Redon

(1840–1916)

The imagination of the artist cannot create in a void, it depends essentially on the attentive observation of the real, even when it evokes a world of fantasy, indeed of the demoniac. . . . Redon's work was an exact pictorial parallel of the experiments of the Symbolist poets.

FRANÇOIS MATHEY

SYMBOLISM IN PAINTING

Once he* said to me in a voice of gentle authority: "Do you see this chimney flue? Does it speak to you? If you have the energy to observe and understand well and can imagine the strangest and most bizarre object, it will tell you a story. And if it is based on and rests on the limits of this simple and bare stone, your dream will come alive. There is art." Bresdin made this statement in 1864. I noted the date down because then it was not the method of teaching.

I am happy today to have heard, when I was young, a very original artist I liked and admired say these somewhat subversive things which I understood so well and which confirmed my own mind. In an apparently simple form, they gave the principles of a noble education. They open the painter's eyes to two sides of life, to two realities it is impossible to separate without lessening art and depriving it of what it can give us so supremely.

For the most part, the artists of my generation have looked at a chimney flue and have seen—only a chimney flue. They were not able to give a blank wall anything of their own essential imagination. Everything that exists in the beyond that illuminates and amplifies the object and raises the spirit into the region of mystery, into the troublous and irresolute and delicious vapor, was absolutely closed to them. Everything that lent itself to symbolism or that allowed for the unforeseen, the imprecise, the indefinable, whose aspect was confused with the enigmatic, led them astray; they were afraid. True parasites of the object, they cultivated art on a

* Bresdin.

143

purely visual plane and, in some way, neglected to go to a place where the humblest work, even black and white, became spiritual; I mean, the illumination which takes hold of our spirit—and which escapes analysis. . . .

I compare the student at the academy with the seed sowed and covered by the plow with fertile or sterile soil. Drudgery is the rule at school and the painting academy. Without love and indifferent, the teacher comes, perhaps, to teach for an hour on certain days. The pupil is far away from the soft and welcome leisure, the beneficent hours when intuition guides him.

I believe in a fruitful education through natural communication by a master of our choice, and, if possible, an intimacy as was practiced a long time ago.

From an essay by Redon

TO DEAL WITH ONLY THE
REPRESENTATION OF THINGS

Everything is derived from universal life: a painter who will not draw a high wall vertically will draw badly because he changes the idea of stability. Those who do not make the water horizontal will do the same—to cite only simple examples. . . .

It is the same with animals and human beings. We cannot move a hand without displacing the rest of our body obedient to the laws of weight. A draftsman knows that. I believe I have obeyed the intuitive indications of the instinct in creating certain monsters. They are not relieved, as Huysmans has insinuated, by a microscope in front of the frightening world of the infinitely little. No, while doing them, I had a more important care: organizing their structure.

There is a way of drawing which the imagination has freed from the embarrassing care of real particulars, so as to deal freely with only the representation of conceived things. I have made fantasies with the stem of a flower or a human face, or even with those elements derived from a skeleton, which, I believe, are drawn, constructed, and built as they should have been. . . .

From *An Artist's Journal,* by Redon

Pierre Auguste Renoir

(1841–1919)

Renoir made for himself the place which he often said he wished to have—as one of the decorative realists like the Venetians, Rubens, and Watteau. But he is not an eclectic or imitator of past styles. His place is in the 19th century.

DAVID M. ROBB

Renoir did not break away from reality, since the passion for life by which he was animated could never be satisfied or find expression except in its contemplation. But from reality he took exclusively those things which sing the praise of life, its sovereignty and its splendor: woman, the flesh in which blood pulses and on which brightness lingers; flowers, which are light's perfume; fruit assembled in still lifes; and landscape—the landscape of the Midi, saturated with sunshine, riotous with verdure.

RENÉ HUYGHE

MY WAY OF PAINTING

I arrange my subject as I want it, then I go ahead and paint it, like a child. I want a red to be sonorous, to sound like a bell; if it doesn't turn out that way, I add more reds and other colors until I get it. I am no cleverer than that. I have no rules and no methods; anyone can look at my materials or watch how I paint—he will see that I have no secrets. I look at a nude; there are myriads of tiny tints. I must find the ones that will make the flesh on my canvas live and quiver. Nowadays they want to explain everything. But if they could explain a picture, it wouldn't be art. Shall I tell you what I think are the two qualities of art? It must be indescribable and it must be inimitable. . . . The work of art must seize upon you, wrap you up in itself, carry you away. It is the means by which the artist conveys his passions; it is the current which he puts forth which sweeps you along in his passion. . . .

Granted that our craft is difficult, complicated. I understand the soul searchings. But all the same, a little simplicity, a little candor, is necessary. As for me, I just struggle with my figures until they are a harmonious unity with their landscape background, and I want people to feel that neither the setting nor the figures are dull and lifeless.

145

As for me when I stand before a masterpiece, I am content with enjoyment. It's the professors who have discovered "defects" in the masters. . . . But those very "defects" may be needed. In Raphael's *St. Michael* there is a thigh that is a kilometer long! And perhaps it wouldn't be so good otherwise. . . . Again, take Veronese's *Marriage at Cana.* If that picture were in true perspective, it would be empty; for the people in the background, who are as big as those in the foreground and who play their part so well, would be little figures indeed. In the same way, the floor does not go back according to the rules, and perhaps that's the reason why it's so beautiful.

From Renoir's conversation with Walter Pach

RENOIR: *Children Playing Ball.* Color lithograph. The Museum of Modern Art, New York, Lillie P. Bliss Collection.

Thomas Eakins

(1844–1916)

I never knew of but one artist, and that's Tom Eakins, who could resist the temptation to see what they thought ought to be rather than what is.

WALT WHITMAN

Every figure he painted was a portrait, every scene or object a real one—always the particular rather than the generalized, the individual rather than the type, the actual rather than the ideal. His whole philosophy was naturalistic, with little bent towards the romantic, the exotic, or the literary.

LLOYD GOODRICH

RESIGNATION FROM THE SOCIETY OF AMERICAN ARTISTS (May 1892)

I desire to sever all connections with the Society of American Artists.

In deference to some of its older members, who perhaps from sentimental motives requested me to reconsider my resignation last year, I shall explain.

When I was persuaded to join the Society almost at its inception, it was a general belief that without personal influence it was impossible to exhibit in New York a picture painted out of a very limited range of subject and narrow method of treatment.

The formation of the young Society was a protest against exclusiveness and served its purpose.

For the last three years my paintings have been rejected by you, one of them the Agnew portrait, a composition more important than any I have ever seen upon your walls.

Rejection for three years eliminates all elements of chance; and while in my opinion there are qualities in my work which entitle it to rank with the best in your Society, your Society's opinion must be that it ranks below much that I consider frivolous and superficial. These opinions are irreconcilable.

EAKINS: *Max Schmitt in a Single Scull.* The Metropolitan Museum of Art (Alfred N. Punnett Fund and Gift of George D. Pratt, 1934).

LETTER TO A STUDENT

1906

. . . I am sorely puzzled to answer your letter. If you care to study in Philadelphia you could enter the life classes of the Pennsylvania Academy of the Fine Arts and I could give advice as to your work and studies, or you might go to Paris and enter some life classes there. Nearly all the schools are bad here and abroad.

The life of an artist is precarious. I have known very great artists to live their whole lives in poverty and distress because the people had not the taste and good sense to buy their work. Again I have seen the fashionable folk give commissions of thousands to men whose work is worthless.

When a student in your evident state of mind went to Papa Corot for advice, the old man always asked how much money he had. When the boy offered to show his sketches and studies, the old man gently pushed them aside as being of no importance.

Henri Rousseau

(1844–1910)

The Douanier's views on painting would have met with more agreement in the Middle Ages, and even in the Renaissance, than would those of Monet, but of course he himself was unaware of this, and believed himself to be perfectly up to date. He said to Picasso: "Nous sommes le deux plus grands peintres de l'époque—toi dans le genre égyptien, moi dans le genre moderne.

KENNETH CLARK

LETTER TO ANDRÉ DUPONT

PARIS, April 1, 1910

Dear Sir:

I am replying to your letter immediately so as to explain to you why I included the divan.* The woman who is sleeping on the di-

* In the painting *The Dream.*

ROUSSEAU: *The Dream.* Collection, The Museum of Modern Art, New York (Gift of Nelson A. Rockefeller).

149

van is dreaming that she has been transported into a forest and that she hears the sounds of music. This is the reason why the divan is depicted in the painting. Thank you for your appreciation; if I have retained my naïveté, it is because M. Gérôme, the former professor at the *École des Beaux-Arts,* as well as M. Clément, the Director of the Art School at Lyons, have told me to keep it always. In the future you will no longer find this amazing. I have also been told that I do not belong to this century. You can well imagine that it is impossible for me to now change my way of painting, which I have acquired after such intensive work. I finish this short note by thanking you in advance for the article which you will write about me. I ask you to accept by best wishes and a hearty and sincere handshake.

H. ROUSSEAU

P.S. If it should give you pleasure to visit me, I am in my studio daily between 2 and 5:30, or between 9 and 11 in the mornings.

Albert Pinkham Ryder

(1847–1917)

> *Everything is ordained to the definite purpose of illustrating the significance of ideas and ideals rather than the patent potency of artistic arrangements complete in themselves.*

F. F. SHERMAN

I SAW NATURE SPRINGING INTO LIFE UPON MY DEAD CANVAS

When my father placed a box of colors and brushes in my hands, and I stood before my easel with its square of stretched canvas, I realized that I had in my possession the wherewith to create a masterpiece that would live throughout the coming ages. The great masters had no more. I at once proceeded to study the works of the great* to discover how best to achieve immortality with a square of canvas and a box of colors.

Nature is a teacher who never deceives. When I grew weary with

* In *Albert P. Ryder,* by Lloyd Goodrich (George Braziller, 1959), the following reference is made to this statement: "Ryder wrote Professor John Pickard in 1907: 'In the paragraphs from a studio you will find what is practically an interview by Miss Adelaide Samson, now Mrs. Maundy; it was done from memory: and gives a wrong impression in the instance of copying old masters: otherwise quite correct'" (*Art in America,* April, 1939).

the futile struggle to imitate the canvases of the past, I went out into the fields, determined to serve nature as faithfully as I had served art. In my desire to be accurate I became lost in a maze of detail. Try as I would, my colors were not those of nature. My leaves were infinitely below the standard of a leaf, my finest strokes were coarse and crude. The old scene presented itself one day before my eyes framed in an opening between two trees. It stood out like a painted canvas—the deep blue of a midday sky—a solitary tree, brilliant with the green of early summer, a foundation of brown earth and gnarled roots. There was no detail to vex the eye. Three solid masses of form and color—sky, foliage, and earth—the whole bathed in an atmosphere of golden luminosity; I threw my brushes aside; they were too small for the work in hand. I squeezed out big chunks of pure, moist color and, taking my palette knife, I laid on blue, green, white, and brown in great sweeping strokes. As I worked I saw that it was good and clean and strong. I saw nature springing into life upon my dead canvas. It was better than nature, for it was vibrating with the thrill of a new creation. Exultantly I painted until the sun sank below the horizon.

From "The Studio of a Recluse," an interview with Ryder (1905)

Paul Gauguin

(1848–1903)

Exactitude is not truth is the thesis of the whole of the modern period in art, but as a thesis it was first clearly formulated by Matisse and the Fauves. Gauguin and the synthetists had formulated a different thesis which we call symbolism: the work of art is not expressive but representative, a correlative for feeling and not an expression of feeling.

HERBERT READ

It is extraordinary that so much mystery can be put into so much splendor.

STÉPHANE MALLARMÉ

EIGHT LETTERS

JANUARY 14, 1885

To Emile Schuffenecker:

Look around at the immense creation of nature and you will find laws, unlike in their aspects and yet alike in their effect, which generate all human emotions. Look at a great spider, a tree trunk in a forest—both arouse strong feeling, without your knowing why.

151

Why is it you shrink from touching a rat, and many similar things: no amount of reasoning can conjure away these feelings. All our five senses reach the brain *directly*, affected by a multiplicity of things, and which no education can destroy. Whence I conclude there are lines that are noble and lines that are false. The straight line reaches to infinity, the curve limits creation, without reckoning the fatality in numbers. Have the figures 3 and 7 been sufficiently discussed? Colors, although less numerous than lines, are still more explicative by virtue of their potent influence on the eye. . . .

Go on working, *freely and furiously*, you will make progress and sooner or later your worth will be recognized, if you have any. Above all, don't perspire over a picture. A strong emotion can be translated immediately: dream on it and seek its simplest form.

ARLES, December, 1888

To Emile Bernard:

. . . I am at Arles* quite out of my element, so petty and shabby do I find the scenery and the people. Vincent and I do not find ourselves in general agreement,† especially in painting. He admires Daumier, Daubigny, Ziem, and the great Rousseau, all people I cannot endure. On the other hand, he detests Ingres, Raphael, Degas, all people whom I admire; I answer: "Corporal, you're right," for the sake of peace. He likes my paintings very much, but while I am doing them he always finds that I am doing this or that wrong. He is romantic while I am rather inclined towards a private state. When it comes to color he is interested in the accidents of the pigment . . . whereas I detest this messing about in the medium. . . .

TAHITI, March, 1892

To his wife:

. . . For I am an artist and you are right, you are not mad, I am a great artist and I know it. It is because I am such that I have endured such sufferings. To do what I have done in any other circumstances would make me out as a ruffian. Which I am no doubt for many people. Anyhow, what does it matter? What distresses me most is not so much the poverty as the perpetual obstacles to

* See Van Gogh letter, page 164.

† Gauguin's visit ended dramatically. On December 24, Vincent, in a fit of madness, rushed at his friend with an open razor in his hand. Returning home, he cut off his right ear, which he washed and slipped into an envelope in order to deliver it to a prostitute he frequented. Gauguin, who had escaped, but was badly frightened, left for Paris the next day without seeing Vincent again. (*Note:* Other sources indicate that Gauguin stayed at Arles for another week, and awaited the arrival of Theo van Gogh.)

my art, which I cannot practice as I feel it ought to be done and as I could do it if relieved of the poverty which ties my hands. You tell me that I am wrong to remain far away from the artistic center. No, I am right, I have known for a long time what I am doing, and why I do it. My artistic center is in my brain and not elsewhere and I am strong because I am never sidetracked by others, and do what is in me. Beethoven was blind and deaf, he was isolated from everything, so his works are redolent of the artist living in a world of his own. You see what has happened to Pissarro, owing to his always wanting to be in the vanguard, abreast of everything; he has lost every atom of personality, and his whole work lacks unity. He has always followed the movement from Courbet and Millet up to these petty chemical persons who pile up little dots.

No, I have an aim and I am always pursuing it, building up material. There are transformations every year, it is true, but they always follow each other in the same direction. I alone am logical. Consequently, I find very few who follow me for long.

Poor Schuffenecker, who reproaches me for being wholehearted in my volitions! But if I did not behave in this manner, could I have endured the endless struggle I am waging for one year? My actions, my painting, etc., are criticized and repudiated every time, but in the end I am acknowledged to be right. I am always starting all over again. I believe I am doing my duty, and strong in this, I accept no advice and take no blame. The conditions in which I am

GAUGUIN: *Women at the River.* Woodcut. Collection, The Museum of Modern Art, New York (Gift of Mrs. John D. Rockefeller, Jr.).

153

working are unfavorable, and one must be a colossus to do what I am doing in these circumstances. . . .

To his wife:

. . . Many of the pictures, of course, will be incomprehensible and you will have something to amuse you. To enable you to understand, I proceed to explain the most questionable and the ones I would keep or sell dear. *Le Manao tupapau.* I have painted a young girl in the nude. In this position, a trifle more, and she becomes indecent. However, I want it in this way as the lines and the movement interest me. So I make her look a little frightened. This fright must be excused if not explained in the character of the person, a Maori. This people have by tradition a great fear of the spirit of the dead. One of our own young girls would be startled if surprised in such a posture. Not so a woman here. I have to explain this startled look with an economy of literary effort as was done formerly. So I did this. General harmony, somber, mournful, startled look in the eye like a funeral knell. Violet, dark blue, and orange yellow. I make the linen greenish yellow (1) because the natives' linen is different from ours (flattened bark of a tree), (2) because it suggests artificial light (the Kanaka woman never goes to bed in the dark) and yet I do want the effect of lamplight, (3) this yellow binding the orange yellow and the blue completes the musical accord. There are some flowers in the background, but they are not real, only imaginary, and I make them resemble sparks. The Kanaka believes the phosphorescences of the night are the spirits of the dead and they are afraid of them. To finish I make the ghost merely a good little woman because the young girl, unacquainted with the sprites on the French stage, could not visualize death itself except as a person like herself. Here endeth the little sermon, which will arm you against the critics when they bombard you with their malicious questions. To end up, the painting has to be done quite simply, the *motif* being savage, childlike. . . .

*To Arsene Alexandre:**

. . . For restoring pictures I describe a delicate operation which must be made by deft hands. First I want to explain the defects of restoring oil paintings. The colors are laid on the canvas with an agglomerative substance, either glue or oil. When they are old, and therefore their oil has evaporated, the perfectly dry color is a hard but porous material like a plump body. It is beyond question that

* Journalist and art critic, as well as author of one of Gauguin's biographies.

154

all the fresh oil will gradually be absorbed by the dry color surrounding the defective part. Hence these yellow patches which grow larger every day. Make a test on a porous block of dry color, Spanish White, for example. You will then see yourself that oil is the enemy. I now describe a different process.

The holes must be filled with color agglomerated by caseine glue, the only glue exempt from the influence of humidity, and only soluble by prolonged immersion in ammonia. To discover by this means the exact tone is not easy, I know, but it is easy to finish the process by a layer of oil color very much scoured by a volatile essence such as mineral essence or benzine. The fleshy body disappears almost entirely and a hard substance remains.

TAHITI, July, 1900

To Emmaneul Bibesco.

. . . If you insist on questions of price "you say" it is because my painting is so different from others that nobody wants it. The dictum is hard if it is not a little exaggerated. I am a little skeptical about the matter, I have seen Claude Monets sold in 1875 at 30 francs each, and I myself bought a Renoir for 30 francs. . . . No, the truth is that it is the picture dealer who makes prices when he goes to work the right way. When he is himself convinced and especially when the painting is good. *Good painting always fetches its price.* . . . And in spite of the fact that nobody wants my painting because it is different from that of others. What a strange and mad public it is that exacts from the painter the utmost originality and then only accepts him when he is like the others! . . .

TAHITI, July, 1901

To Charles Morice:

. . . Puvis de Chavannes explains his idea, yes, but he does not paint it. He is Greek whereas I am a savage, a wolf in the woods without a collar. Puvis will call a picture *Purity* and to explain it will paint a young virgin with a lily in her hand—a hackneyed symbol, but which is understood by all. Gauguin under the title *Purity* will paint a landscape with limpid streams; no taint of civilized man, perhaps an individual.

Without going into details there is a whole world between Puvis and me. Puvis as painter is a scholar and not a man of letters while I myself am not a scholar but perhaps a man of letters.

Why, when they gather in front of a picture, will the critic seek for points of comparison with old ideas and other authors. Not finding there what he expected, he fails to understand and remains unmoved. Emotion first! understanding afterwards.

155

In this big picture:

> *Whither are we going?*
> *Near the death of an old woman.*
> *A strange stupid bird concludes.*
> *What are we?*

Day-to-day existence. The man of instinct wonders what all this means.

> *Whence come we?*
> *Spring.*
> *Child.*
> *Common life.*

The bird concludes the poem by comparing the inferior being with the intelligent being in this great whole which is the problem indicated by the title.

Behind a tree are two sinister figures, shrouded in garments of somber color, recording near the tree of science their note of anguish caused by this science itself, in comparison with the simple beings in a virgin nature, which might be the human idea of paradise, allowing everybody the happiness of living.

Explanatory attributes—known symbols would congeal the canvas into a melancholy reality, and the problem indicated would no longer be a poem.

In a few words I explain the picture to you. Few are required by a man of your intelligence. But for the public, why should my brush, free from all constraint, be obliged to open everybody's eyes.

Are the forms rudimentary? They have to be.

Is the execution thereof far too simple? It has to be. Many people say that I cannot draw because I draw particular shapes. When will they understand that execution, drawing and color (style), must harmonize with the poem? My nudes are chaste without clothes. To what can this be due if not to certain shapes and colors which are remote from reality?

ATUANA, September, 1902

To Andre Fontainas:

"Although Gauguin's drawing reminds one a little of van Gogh's. . . ."*

As a matter of information, merely to do me justice, re-read some of van Gogh's letters which were published in *Mercure:*

"Gauguin's arrival at Arles is calculated to change my painting considerably."

* Refers to a criticism that had been made of Gauguin.

156

In his letter to Aurier: "I owe much to Gauguin."

If you have an opportunity, study van Gogh's painting before and after my stay with him at Arles. Van Gogh, influenced by his neo-impressionist studies, always worked with strong contrasts of tone on a complementary, yellow on violet, etc. Whereas, later, following my advice, and my instructions, he worked quite differently. He painted yellow suns on a yellow surface, etc., learned the orchestration of a pure tone by all the derivatives of this tone. Then in the landscape all the usual medley, the subjects of still life, a former necessity was replaced by great harmonies of solid colors suggesting the total harmony of the picture, the literary or explanatory part, whatever you like to call it, taking a back seat in consequence. He had to make a great effort to get his drawing to fit this new technique. That is all in the day's work, to be sure, but very necessary.

But as all this impelled him to make experiments in accordance with his intelligence and his fiery temperament, his originality and his personality could only gain in the process. All this is *between ourselves*, to show you that I would not take anything away from van Gogh, while reserving a little credit to myself; to show you also that the critic has everything *to see* and discern—that he is liable to err, however well-intentioned. . . .

My work from the start until this day—as can be seen—is congruent with all the gradations which comprise an artist's education —about all this I have preserved silence and shall continue to do so, being persuaded that truth does not emerge from argument but from the work that is done.

Moreover, my life in such remote parts sufficiently proves how little I seek transient glory—my pleasure is to see the display of talent by others.

And if I write all this to you it is because, valuing your respect, I should not like my manuscript* to be imperfectly understood by you, nor should I like to detect therein merely a desire to talk about myself, no—only I am furious when I see a man like Pissarro maltreated, wondering whose turn it will be tomorrow.

When I am maltreated it is another thing, I am not in the least annoyed, as I reflect: I may be nobody after all. In all candor,

*Gauguin sent his manuscript *Reflections of a Dauber* to Fontainas, requesting the critic to try and have it published in the *Mercure de France*. The publications committee rejected it, stating that the article was not "topical."

Ferdinand Hodler

(1853–1918)

*Edvard Munch and James Ensor, Ferdinand Hodler
and Vincent Van Gogh are all driven by this restless
energy* to depict a "spectrally heightened and dis-
torted actuality." . . . Hodler was a lonely and mys-
ticizing figure, condemned to isolation and suffering
in one of the most unsympathetic environments possi-
ble for an artist—Calvinistic Geneva.*

HERBERT READ

THE MISSION OF THE ARTIST

It is the mission of the artist to give expression to the eternal ele-
ments of nature, to unfold its inner beauty. The artist tells of
nature in that he makes things visible; he sanctifies the forms of the
human body. He shows us a greater, a simpler nature—one free of
all the details that have no meaning. He gives us a work that is
based upon the limits of his experience, his heart, and his spirit.

Art is the *gestus* of beauty. Plato defines beauty as being the re-
flection of truth, that is to say, that one should open one's eyes and
study nature.

When the artist creates, he borrows the elements of a representa-
tion of a world which is already in existence and in which he lives.
The strongest phantasy is nourished by nature—this inexhaustible

* Read refers to a passage of Worringer's *Formprobleme der Gothik* (1912), which
he translated in 1927 under the title *Form in Gothic*. The passage which de-
scribes the aspects of Northern Expressionism reads as follows: "The need in
Northern man for activity, which is precluded from being translated into a clear
knowledge of actuality and which is intensified for lack of this natural solution,
finally disburdens itself in an unhealthy play of fantasy. Actuality, which the
Gothic man could not transform into naturalness by means of clear-sighted
knowledge, was overpowered by this intensified play of fantasy and transformed
into a spectrally heightened and distorted actuality. Everything becomes weird
and fantastic. Behind the visible appearance of a thing lurks its caricature, be-
hind the lifelessness of a thing an uncanny, ghostly life, and so all actual things
become grotesque. . . . Common to all is an urge to activity, which, being bound
to no one object, loses itself as a result in infinity." (*A Concise History of Modern
Painting* by Herbert Read.)

source of instruction. It is nature which stimulates our power of imagination. The deeper one has penetrated into the being of nature, the more complete is the experience which one is able to re-create. The more methods of expression one possesses, the better one succeeds in achieving pictorial communication.

One paints that what one loves; that is why one gives preference to *this* figure rather than to *that* one. One reproduces that particular landscape in which one had been happy. For the painter, an emotion is one of the basic stimuli that cause him to create. He feels compelled to tell of the beauty of the landscape, or of the human figure, that is to say, of that particular small part of truth which had "moved" him so profoundly.

We retain traces of different depth and for different lengths of time of the impressions we have obtained from nature. The selection of these impressions determines all the characteristics of the work, that is to say, they are the "being," the character of the painter.

The beauty which surrounds us is transmitted to us through the eye and the brain with either stronger or weaker intensity, depending upon the receptive possibilities of the particular individual.

From Hodler's lecture delivered at the University of Fribourg (1897)

Vincent van Gogh

(1853–1890)

Van Gogh's view of reality is an entirely subjective one, differing from both the objective approach of impressionism, and the "scientific" aims of the neo-impressionists.

<div align="right">PAUL ZUCKER</div>

Vincent van Gogh had found his destiny and died in wild rebellion against misery and insanity. He left the world more than merely the heritage of a painter whose inner vision transformed man's picture of the world. He lost his life and his sanity in search for the true content of life.

<div align="right">FRANÇOIS MATHEY</div>

TWO LETTERS

<div align="right">JULY 1885</div>

*Dear Theo:**

. . . Although I have no *parti pris,* I feel for Raffaelli, who paints quite other things than peasants. I feel for Alfred Stevens, for Tissot, to mention something quite different from peasants. I feel for a beautiful portrait.

Though in my opinion he makes colossal blunders in his judgment of pictures, Zola says a beautiful thing about art in general in *Mes Haines*—"*dans le tableau (l'oeuvre d'art) je cherche, j'aime l'homme—l'artiste.*" †

Look here, I think this is perfectly true; I ask you what kind of a man, what kind of a prophet, or philosopher, observer, what kind of a human character is there behind certain paintings, the technique of which is praised?—in fact, often *nothing.* But a Raffaeli is a personality, Lhermitte is a personality, and before many pictures by almost unknown artists, one feels that they are made with a *will,* with *feeling,* with passion and love. The technique of a painting from rural life or—like Rafaelli—from the heart of the city workmen—brings difficulties quite different from those of the

* Vincent's brother.

† "In the picture (the work of art) I seek, I love the man—the artist."

smooth painting and pose of a Jacquet or Benjamin Constant. It means living in those cottages day by day, being in the fields like peasants, in summer in the heat of the sun, in winter suffering from snow and frost; not indoors but outside, and not during a walk, but day after day like the peasants themselves.

And I ask you if one considers these things, am I then so far wrong when I find fault with the criticism of those critics who, these days more than ever, talk humbug about this so *often* misused word, technique (its significance is getting more and more conventional), considering all the trouble and drudgery needed to paint the *"rouwboerke"* (mourning peasant) and his cottage. I dare maintain this is a longer and more tiring journey than many painters of exotic subjects (maybe *Justice in the Harem* or *Reception at a Cardinal's*) make for their most exquisitely eccentric subjects. For in Paris any kind of Arabic or Spanish or Moorish model is to be had provided only that one pays for them. But he who paints, like Raffaelli, the ragpickers of Paris in their *own quarter* has far more difficulties, and his work is more serious.

Nothing seems simpler than painting peasants, ragpickers and laborers of all kinds, but—no subjects in painting are so difficut as these commonplace figures!

As far as I know there isn't a single academy where one learns to draw and paint a digger, a sower, a woman putting the kettle over the fire, or a seamstress. But in every city of some importance there is an academy with a choice of models for historical, Arabic, Louis XV, in short, *all really nonexistent figures.*

When I send you and Serret some studies of diggers or peasant women weeding, gleaning, etc., *as the beginning* of a whole series of all kinds of labor in the fields, then it may be that either you or Serret will discover faults in them which will be useful for me to know, and which I may even admit myself.

But I want to point out something which is perhaps worthwhile. All academic figures are put together in the same way and, let's say, *on ne peut mieux.* Irreproachable, *faultless.* You will guess what I am driving at, they do not reveal anything new.

This is not true of the figures of a Millet, a Lhermitte, a Régamey, a Daumier; they are also well put together, but after all in a different way than the academy teaches.

But I think that however correctly academic a figure may be, it will be superfluous in these days, though it were by Ingres himself (his *Source,* however, excepted, because that really was, and is, and will always be, something new), when it lacks the essential modern note, the intimate character, the real *action.*

161

Perhaps you will ask: When will a figure *not* be superfluous, though there may be faults, great faults in it, in my opinion?

When the digger digs, when the peasant is a peasant, and the peasant woman, a peasant woman.

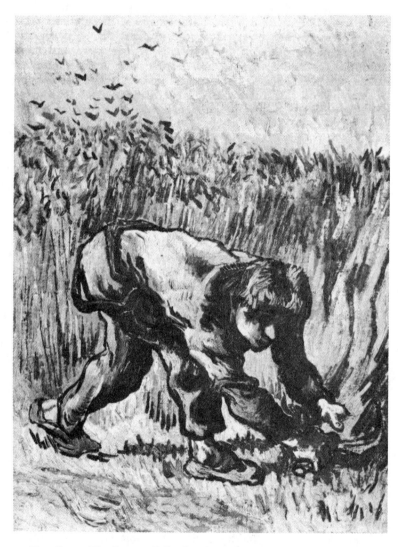

VAN GOGH: *The Reaper.* Collection, Ir. V. W. van Gogh, Amsterdam.

Is this something new?—yes—even the figures by Ostade, Terboch, are not in action like those painted nowadays.

I would like to say a lot more about this, and I would like to say how much I myself want to improve my work and how much I prefer the work of some other artists to my own.

I ask you, do you know a single digger, a single sower in the old Dutch school? Did they ever try to paint "a laborer"? Did Velazquez try it in his water carrier or types from the people? No.

The figures in the pictures of the old masters do not *work*. I am drudging just now on the figure of a woman whom I saw digging for carrots in the snow last winter.

Look here, Millet has done it, Lhermitte, and in general the painters of rural life in this century—Israëls for instance—they think it more beautiful than anything else.

But *even* in this century, how relatively few among the innumerable painters want the figure—yes, above all—for the figure's sake, that is to say for the sake of line and modeling, *but cannot imagine* it otherwise than in action, and want to do what the old masters avoided—even the old Dutch masters who clung to many conventional actions—and I repeat—want *to paint the action for the action's sake*.

So that the picture or the drawing has to be a drawing of the figure for the sake of the figure and the inexpressibly harmonious form of the human body, but at the same time a digging of carrots in the snow. Do I express myself clearly? I hope so, and just tell this to Serret. I can say it in a few words: a nude by Cabanel, a lady by Jacquet, and a peasant woman, *not by Bastien Lepage himself*, but a peasant woman by a Parisian who has learned his drawing at the academy, will always indicate the limbs and the structure of the body in one selfsame way, sometimes charming—correct in proportion and anatomy. But when Israëls, or when Daumier or Lhermitte, for instance, draws a figure, the shape of the figure will be felt much more, and yet—that's why I like to include Daumier—the proportions will sometimes be almost *arbitrary*, the anatomy and the structure often quite wrong "in the eyes of the academician." But it will *live*. And especially Delacroix too.

It is not yet well expressed. Tell Serret that *I should be desperate if my figures were correct*, tell him that I do not want them to be academically correct, tell him that I mean: If one photographs a digger, *he certainly would not be digging then*. Tell him that I adore the figures by Michelangelo though the legs are undoubtedly too long, the hips and the backsides too large. Tell him that, for me, Millet and Lhermitte are the real artists for the very reason that they

do not paint things as they are, traced in a dry, analytical way, but as *they*—Millet, Lhermitte, Michelangelo—feel them. Tell him that my great longing is to learn to make those very incorrectnesses, those deviations, remodelings, changes in reality, so that they may become, yes, lies if you like—but truer than the literal truth.

ARLES, October, 1888

My dear Gauguin:

. . . I must tell you that even while at work I do not cease thinking of this enterprise of starting a studio with you and me for permanent residents, but both of us desiring to make it a shelter and a refuge for the comrades when they are knocked out in the struggle. After you left Paris my brother and I spent some time together which will ever remain memorable. The discussions took an ever wider sweep—with Guillaimin, with Pissarro father and son, with Seurat, whom I did not know (I only visited his studio a few hours before my departure).

In these discussions what frequently cropped up was what my brother and I have so much at heart, namely what steps can be taken to safeguard the material existence of painters and to safeguard their means of production (colors, canvases) and secure them a direct share in the price their pictures may fetch at any time after they have parted with them. . . .

I have an extraordinary fever for work these days, actually I am struggling with a landscape, showing a blue sky above an immense vineyard, green, purple, and yellow, with black and orange vine branches. Little figures of ladies with red parasols, little figures of vineyard workers with their carts enliven the piece. Canvas of 30 square millimetres for house decoration.

I have a self-portrait all ash-colored. The ash color comes from mixing the veronese with orange mineral on a pale veronese background, and dun-colored clothes. But in exaggerating my personality I sought rather the character of a simple adorer of the eternal Buddha. It has given me a lot of trouble, but I shall have to do it all over again if I want to succeed in expressing the idea. I must get myself still further cured of the conventional brutishness of our so-called civilization, in order to have a better model for a better picture. . . .

I find my artistic ideas extremely vulgar compared with yours.

I have always the gross appetite of a beast.

I forget everything for the external beauty of things which I am unable to reproduce, for I reproduce it badly in my picture and coarsely, whereas nature seems to me perfect.

Georges Seurat

(1859–1891)

He had surveyed everything and had established, almost definitively, the use of black and white, harmony of line, composition, and the contrast and harmony of color. What more can one ask of a painter?

PAUL SIGNAC

FROM A LETTER TO BEAUBOURG
EXPLAINING HIS THEORY*

AUGUST 28, 1890

Esthetic

Art is harmony. Harmony is in the analogy of contraries and in the analogy of similar elements of *tone, tint,* and *line,* considered according to their dominants and under the influence of light, in gay, calm, or sad combinations.

The contraries are:

For *tone,* a more $\left\{ \begin{array}{l} \text{luminous} \\ \text{clear} \end{array} \right.$ shade against a darker one.

For *tint,* the complementaries, that is to say, a certain red opposed to its complementary, and so on (red-green; orange-blue; yellow-violet).

For *line,* those forming a right angle. └

Gaiety of *tone* is given by the luminous dominant; of *tint* it is given by the warm dominant; of *line* it is given by lines above the horizontal.

Calm of *tone* is the equality of dark and light; of *tint,* the equality of warm and cold; calm of *line* is given by the horizontal.

Sadness of *tone* is given by the dark dominant; of *tint* by the cold dominant; of *line* by descending directions.

* The theory is known as "pointillism" or "divisionism."

165

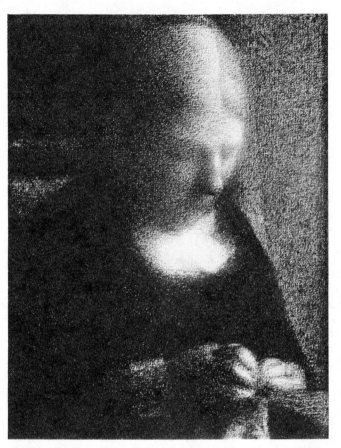

SEURAT: *The Artist's Mother (Woman Sewing)*. Conte crayon. The Metropolitan Museum of Art (Joseph Pulitzer Bequest, 1951, from The Museum of Modern Art, Lillie P. Bliss Collection).

Technique

Taking for granted the phenomena of the duration of a light-impression on the retina—

Synthesis necessarily follows as a result. The means of expression is the optical mixture of the tones, the tints (local color and that resulting from illumination by the sun, an oil lamp, gas, and so on), that is to say, of lights and their effects (shadows), in accordance with the laws of contrast, gradation, and irradiation.

The frame is in the harmony opposed to that of the tones, tints, and lines of the picture.

166

James Ensor

(1860–1949)

Familiar with the work of the Impressionists, he ignored their theories and even those of the Post-Impressionists. Lightly tossing them aside, he developed an unclassifiable style uniquely his own. In spirit it is a true descendant of Hieronymus Bosch.

SARAH NEWMEYER

REFLECTIONS ON ART

Vision modifies as it observes. The first vision is the vulgar one. It is of the simple, dry line, and it has no recourse to color. In the second vision the more experienced eye discerns the values of tone and its refinements: this vision is less frequently understood than

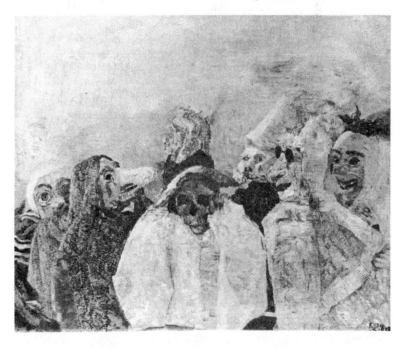

ENSOR: *Masks Confronting Death*. Collection, The Museum of Modern Art, New York (Mrs. Simon Guggenheim Fund).

the vulgar one. The last vision is the one in which the artist sees the subtleties and multiple plays of the light, its planes, and what it gravitates towards. These progressive discoveries modify the primitive vision, with the result that the line suffers and becomes of secondary importance. This vision will be understood only slightly. It requires lengthy observation and careful study. The vulgar vision recognizes nothing but chaos, disorder, and incorrectness. It is in this way that art has evolved from the Gothic line and has traversed the color and the movement of the Renaissance, in order to attain modern light.

From *The Writings of James Ensor* (1922)

Edvard Munch

(1863–1944)

*Munch, the most dominant influence throughout the whole of Northern Europe, was the most isolated, the most introspective, and the most mordant of all these melancholy natures.**

HERBERT READ

Edvard Munch, aged thirty-two, the esoteric painter of love, jealousy, death, and sadness, has often been the victim of the deliberate misrepresentations of the executioner-critic who does his work with detachment and, like the public executioner, receives so much per head.

AUGUST STRINDBERG

THE FRIEZE OF DEATH

I have worked on this Frieze, with long intervals, for close to thirty years. The first rough drafts dates back to 1888-89. *The Kiss*, the so-called *Yellow Boat, The Street, Man and Wife,* and *Anxiety* were painted between 1890 and 1891, and on view here in this

* Reference to Rohlfs, Hodler, Ensor, Munch, von Jawlensky, Kandinsky, Nolde, and Barlach, the "precursors and founders of Expressionism who for the most decisive years of their lives were struggling in individual isolation, in hostile provincial environments."

city in the Trostrupgården and later in the same year at my Berlin exhibition. The following year fresh works were added to the series, including *Vampire*, *The Cry*, and *Madonna*, and it was exhibited as an independent Frieze in a private gallery on the Unter den Linden. These pictures were exhibited in 1902* in the Berlin Secession, where they were displayed as a continuous Frieze all around the imposing entrance hall, as examples of modern psychic life.

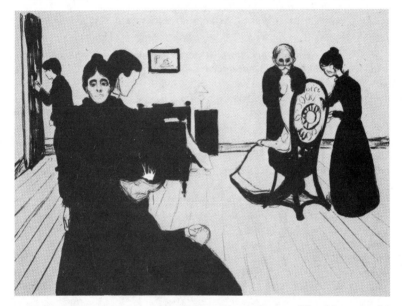

MUNCH: *The Death Chamber.* Lithograph. Collection, The Museum of Modern Art, New York (Gift of Mrs. John D. Rockefeller, Jr.).

They were later shown at Blomquist's in 1903 and 1909. Certain art critics have sought to prove that the thought content of this Frieze was influenced by German ideas and my acquaintance with Strindberg; I trust that the foregoing comments will suffice to refute this assertion. . . .

The Frieze was conceived as a series of decorative pictures which would collectively present a picture of life. They are traversed by the indented coastline; beyond lies the ever-restless sea, and under the treetops is life in all its fullness, its variety, its joys and its sorrows.

From a statement by Munch on the occasion of his 1918 exhibition

* Actually, in February, 1904. See J. Thiis, *Munch* (Oslo, 1933), p. 215.

Henri de Toulouse-Lautrec

(1864–1901)

*With a gift for incisive drawing, his characteristic
is the crackling and leaping pictorial stroke; laid on
in vivid arabesques, the color itself is compelled to
seize the revealing detail in an attitude or a face, and
even to develop it to the point of biting irony.*

RENÉ HUYGHE

*He was neither moralist nor muckraker. He simply
had to see, and what he saw he painted.*

SARAH NEWMEYER

TWO LETTERS

MAY 7, 1882

To his uncle:

. . . Perhaps you are wondering about the kind of encouragement
Bonnat is giving me. He tells me: "Your painting isn't bad, it is
'chic,' but even so it isn't bad, but your drawing is absolutely atro-
cious."

So I must gather my courage and start once again. . . .

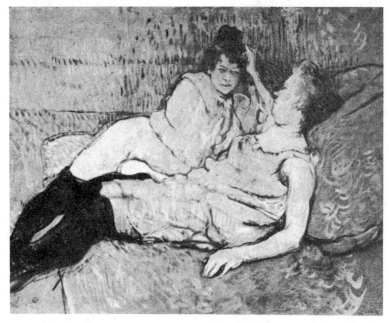

TOULOUSE-LAUTREC: *The Sofa*. The Metropolitan Museum of Art (Rogers
Fund, 1951).

To Joyant:

Only the figure exists. Landscape is nothing and should be nothing else but an accessory. The pure landscape painter is a fool. The function of landscape should be nothing more than to make the character of the figure more understandable. Corot is great only because of his figures. The same is true of Millet, Renoir, Manet, Whistler, and all the others. When figure painters paint landscapes, they treat the landscapes as if they were faces. Landscapes by Degas are marvelous because they are the landscapes of dreams. Those of Carrière are like human masks. If Monet had not given up figure painting, what might he not have accomplished!

Robert Henri

(1865–1929)

Robert Henri . . . was the leader of "The Eight." *
This twentieth-century revolution of the so-called
"Ash Can School" brought to art subjects from slums
and saloons, poolrooms and theaters, factories and
workshops.

ERWIN O. CHRISTENSEN

PERSONS AND THINGS ARE WHATEVER
WE IMAGINE THEM TO BE

We have little interest in the material person or the material thing. All our valuation of them is based on the sensations their presence and existence arouse in us.

And when we study the subject of our pleasure it is to select and seize the salient characteristics which have been the cause of our emotion.

Thus two individuals looking at the same objects may both exclaim "Beautiful!"—both be right, and yet each have a different sensation—each seeing different characteristics as the salient ones, according to the prejudice of their sensations.

Beauty is no material thing.

Beauty cannot be copied.

Beauty is the sensation of pleasure on the mind of the seer.

* Robert Henri, Maurice B. Prendergast, Arthur B. Davies, George B. Luks, William J. Glackens, Ernest Lawson, John Sloan, and Everett Shinn.

No *thing* is beautiful. But all things await the sensitive and imaginative mind that may be aroused to pleasurable emotion at sight of them. This is beauty.

The art student that should be and is so rare, is the one whose life is spent in the love and the culture of his personal sensations, the cherishing of his emotions, never undervaluing them, the pleasure of exclaiming them to others, and an eager search for their clearest expression. He never studies drawing simply because it will come in useful later when he is an artist. He has no time for that. He is an artist in the beginning and is busy finding the lines and forms to express the pleasures and emotions with which nature has already charged him.

No knowledge is so easily found as when it is needed.

Teachers have too long stood in the way; have said: "Go slowly —you want to be an artist before you've learned to draw!"

Oh! Those long and dreary years of learning to draw! How can a student, after the drudgery of it, look at a man or an antique statue with any other emotion than a plum-bob estimate of how many lengths of head he has.

One's early fancy of man and things must not be forgotten. One's appreciation of them is too much sullied by coldly calculating and dissecting them. One's fancy must not be put aside, but the excitement and the development of it must be continued through the work. From the antique cast there should be no work done if it is not to translate your impression of the beauty the sculptor has expressed. To go before the cast or the living model without having them suggest to you a theme, and to sit there and draw for hours without a theme, is to begin the hardening of your sensibilities to them—the loss of your power to take pleasure in them. What you must express in your drawing is not "what model you had," but "what were your sensations," and you select from what is visual of the model the traits that best express you.

In drawing from the cast the work may be easier. The cast always remains the same—the student has but to guard against his own digressions. The living model is never the same. He is only consistent to one mental state during the moment of its duration. He is always changing. The picture which takes hours—possibly months—must not follow him. It must remain in the one chosen moment, in the attitude which was the result of the sensation of that moment. Most students wade through a week of changings of both the subject and their own views of it. The real student has remained with the idea which was the commencement. He has simply used the model as the indifferent manikin of what the model

172

was. Or, should he have given up the first idea, it was then to take on another, having destroyed the work which was the expression of the former. . . .

When a student comes before his model his first question should be: "What is my highest pleasure in this?" and then, "Why?" All the greatest masters have asked these questions—not literally—not consciously, perhaps. And with them this highest pleasure has grown until, with their great imagination, they have come to something like a just appreciation of the most important element of their subject, having eliminated its lesser qualities. With their prejudices for its greater meaning, their eyes take note only of the lines and forms which seem to be the manifestation of that greater meaning.

This is selection. And the result is extract.

The great artist has not reproduced nature, but has expressed by his extract the most choice sensation it has made upon him.

A teacher should be an encourager.

An artist must have imagination.

An artist who does not use his imagination is a mechanic.

No material thing is beautiful.

All is as beautiful as we think it.

There is a saying that "love is blind"—perhaps the young man is the only one who appreciates her.

From an address by Robert Henri to the students of the School of Design for Women, Philadelphia (1901)

Wassily Kandinsky

(1866–1944)

These men rejected the visible, organic world so completely that they dropped even those traces of our common perceptual and emotional experience to which the most extreme cubists and expressionists still appealed. Nothing appears on the canvas but a "pure design," an arrangement of color and form sequences entirely unrelated to the perceivable world. Whatever the visual materials of his picture—color, depth, linear or three-dimensional patterns, or pure line alone—the non-objective painter presents an esthetic structure without illusionist, verbal, or cultural overtones.*

PAUL ZUCKER

CONCERNING THE SPIRITUAL IN ART

A work of art consists of two elements, the inner and the outer.

The inner is the emotion in the soul of the artist; this emotion has the capacity to evoke a similar emotion in the observer.

Being connected with the body, the soul is affected through the medium of the senses—the felt. Emotions are aroused and stirred by what is sensed. Thus the sensed is the bridge—i.e., the physical relation—between the immaterial (which is the artist's emotion) and the material, which results in the production of a work of art. And again, what is sensed is the bridge from the material (the artist and his work) to the immaterial (the emotion in the soul of the observer).

The sequence is: emotion (in the artist)→the sensed→the work of art→the sensed→emotion (in the observer).

The two emotions will be like and equivalent to the extent that the work of art is successful. In this respect painting is in no way different from a song: each is a communication. The successful singer arouses in listeners his emotions; the successful painter should do no less.

The inner element—i.e., emotion—must exist; otherwise the work of art is a sham. The inner element determines the form of the work of art.

* Kandinsky, Arp, and Mondrian.

In order that the inner element, which at first exists only as an emotion, may develop into a work of art, the second element—i.e., the outer—is used as an embodiment. Emotion is always seeking means of expression, a material form, a form that is able to stir the senses. The determining and vital element is the inner one, which controls the outer form, just as an idea in the mind determines the words we use, and not vice versa. The determination of the form of a work of art is therefore determined by the irresistible inner force: this is the only unchanging law in art. A beautiful work is the consequence of a harmonious co-operation of the inner and the outer; i.e., a painting is an intellectual organism which, like every other material organism, consists of many parts.

KANDINSKY: *Composition* (*3*). Collection, The Museum of Modern Art, New York (Mrs. Simon Guggenheim Fund).

THE ARTIST AND THE WORK OF ART

*The artist must have something to communicate, since mastery over form is not the end but, instead, the adapting of form to internal significance.**

The artist's life is not one of pleasure. He must not live irresponsibly; he has a difficult work to perform, one which often proves a crown of thorns. He must realize that his acts, feelings, and thoughts are the imponderable but sound material from which his work is to rise; he is free in art, but not in life.

Compared with non-artists the artist has a triple responsibility: (1) he must return the talent which he has; (2) his actions, feelings, and thoughts, like those of every man, create a spiritual atmosphere which is either pure or infected; (3) his actions and thoughts are the material for his creations, which in turn influence the spiritual atmosphere. The artist is a king, as Peladan says, not only because he has great powers, but also because he has great obligations.

If the artist be guardian of beauty, beauty can be measured only by the yardstick of internal greatness and necessity.

That is beautiful which is produced by internal necessity, which springs from the soul.†

Maeterlinck, one of the first modern artists of the soul, says: "There is nothing so curious of beauty or so absorbent of it as a soul. For that reason few mortal souls are able to withstand the leadership of a soul that gives itself to beauty." ‡

This property of the soul facilitates the slow, scarcely visible, but irresistible movement of the spiritual triangle, upwards and forwards.

From *Concerning the Spiritual in Art,* by Kandinsky

* This does not mean that the artist is to instill forcibly and deliberately into his work a meaning. The generation of a work of art is a mystery. If artistry exists, there is no need of theory or logic to direct a painter's activity. The inner voice tells him what form he needs, whether inside or outside of nature. Every artist who works with feeling knows how suddenly the right form comes. Böcklin said that a true work of art must be a grand improvisation; that is, meditation and composition should be steps to a goal which the artist will glimpse unawares. In this sense may the coming counterpoint be understood.

† By this "beauty" we do not mean the contemporary external or even inner morality, but that quality which, itself imponderable, enriches and refines the soul. In painting any color is intrinsically beautiful, for each color causes a spiritual vibration. Each vibration, in turn, enriches the soul. Thus any outward ugliness contains potential beauty.

‡ *De la beauté intérieure.*

176

Pierre Bonnard

(1867–1947)

Nature remained the source of his inspiration, but his reinvention of reality is so ingenious that it is impossible to find the "little sensation" of the Impressionists which was at the source of his canvases.

FRANÇOIS MATHEY

EXTRACTS FROM TWO LETTERS

1915

To Charles Terrasse:
 I have sent myself back to school. I want to forget all I know; I am trying to learn what I do not know. I am restarting my studies from the beginning, from ABC . . . and I am on guard against myself, against everything that used to thrill me so much, against the color that bewilders you.

LATER in 1915

To Charles Terrasse:
 I think I have found it. Certainly I had been carried away by color. I was almost unconsciously sacrificing form to it. But it is true that form exists and that one cannot arbitrarily and indefinitely reduce or transpose it; it's drawing, then, that I need to study. . . . I draw constantly. And after drawing comes composition, which should form a balance. A well-composed picture is half completed. And such is the art of composition that with nothing but black and white, a pencil, a pen, an engraver's burin, one can achieve results that are almost as complete and fine in quality as can be produced by a whole palette of colors.

THE PRIMARY CONCEPTION

 Through attraction or primary conception the painter achieves universality. It is attraction which determines the choice of motif and which conforms exactly to the picture. If this attraction, this primary conception fades away, the painter becomes dominated solely by the motif, the object before him. From that moment he ceases to create his own painting. In certain painters—Titian, for example—this conception is so strong that it never abandons

177

them, even if they remain for a long time in direct contact with the object. But I am very weak; it is difficult for me to keep myself under control in the presence of the object.

I often see interesting things around me, but for me to want to paint them they must have a particular attraction—what may be called beauty. When I paint them I try not to lose control of the primary conception; I am weak, and if I let myself go, in a moment I have lost my primary vision, I no longer know where I am going.

The presence of the object, the motif, is very disturbing to the painter at the time he is painting. Since the starting point of a picture is an idea, if the object is there at the moment he is working, the artist is always in danger of allowing himself to be distracted by the effects of direct and immediate vision, and to lose the primary idea on the way. Thus, after a certain period of work, the painter can no longer recover his original idea and depends on accidental qualities, he reproduces the shadows he sees . . . and such details as did not strike him at the beginning.

<div align="right">From a statement by Bonnard (1943)</div>

BONNARD: *Portrait of Ambroise Vollard.* Etching. Collection, The Museum of Modern Art, New York.

Emil Nolde

(1867–1956)

*What is of more interest, in retrospect, is the obsti-
nate retention, in the case of artists like Jawlensky,
Nolde, Kokoschka, and Soutine of a figurative* motif
*in apparently flagrant conflict with their symbolic in-
tentions. . . . Some of Nolde's masks, and the paint-
ings he made after his visit to the South Seas in 1913-
14, carry distortions to limits that are nearly abstract.
Color takes on an independent function as it does in
Rembrandt's* Slaughtered Ox: *it transcends the object
that has evolved it to become in itself an alchemical
substance, a* materia prima *with its own mystery and
power. But Nolde, too, was never to desert the* motif.

HERBERT READ

REFLECTIONS

Why is it that we artists are so entranced by the primitive expres-
sion of the savages? . . . With the material in his hand, between
his fingers, the savage creates his work. The expressed purpose is
desire for and love of creation. The absolute originality, the in-
tense, frequently grotesque expression of strength and life in the
simplest possible form—that could be the factor which gives us so
much joy. . . .

The further one removes oneself from nature and still remains
natural, the greater the art. . . .

I was interested from the very beginning in the characteristics of
color, from its tenderness to its strength—especially in cold and
warm colors, which mixture always becomes muddy and kills light.

. . . Colors, the materials of the painter; colors in their own lives,
weeping and laughing, dream and bliss, hot and sacred, like love
songs and the erotic, like songs and glorious chorals! Colors in vibra-
tion, pealing like silver bells and clanging like bronze bells, pro-
claiming happiness, passion and love, soul, blood and death.

From *Das eigene Leben* and *Jahre der Kämpfe,* by Nolde

179

Édouard Vuillard

(1868–1940)

I know few works where one is brought more directly into communion with the painter. This is due, I suspect, to his emotions never losing their hold on the brush and to the outside world always remaining for him a pretext and handy means of expression. . . . By a grasp of relations, at once intuitive and studied, he explains each color by its neighbor and obtains from both a reciprocal response.

ANDRÉ GIDE

LETTER TO MAURICE DENIS

1898

. . . I suffer too much in my life and my work from what you speak of* not to reply immediately. . . . It is not while I am working that I think of the technique of picture making or of immediate satisfaction. To speak generally—it is not while I am doing this or that, that I consider the quality of my actions (you have only to think of my diffidence and my character). Whatever I have the happiness to be working at, it is because there is an idea in me in which I have faith. As to the quality of the result, I do not worry myself. . . . I conceive, but in fact I actually experience only very rarely, that will and effort of which you like to speak. You have so long been accustomed by nature, education, and circumstances and in the presence of certain results that please you, to give a particular sense to the word *will* that you attempt others, me for instance, by your own logic. You may sometimes deceive yourself. The important thing is that I have faith enough to produce. And I admit one could call that work. In general, I have a horror or rather a blue funk of general ideas which I haven't discovered for myself, but I don't deny their value. I prefer to be humble rather than pretend to understanding.

* Denis had written Vuillard: "The value of a work of art lies in the plenitude of the artist's effort, in the force of his will."

VUILLARD: *The Park.* The Museum of Modern Art, New York (Fractional gift of Mr. and Mrs. William B. Jaffe).

Henri Matisse

(1869–1954)

His easel pictures, exhibited decade after decade, were so variously arresting and intriguing by auda-cious design and pictorial counterpoint that we were apt to concentrate on the artist's virtuosity (the prod-uct of his brains, his aesthetic, and his taste) and leave unnoticed what his paintings were about.

R. H. WILENSKI

ABOUT MY PAINTING

All my life I have been influenced by the opinion current at the time I first began to paint, when it was permissible only to render observations made from nature. All that derived from the imagi-nation or memory was called *"chiqué"* and worthless for the con-struction of plastic work. The teachers at the Beaux-Arts used to say to their pupils, "Copy nature stupidly."

Throughout my career I have reacted against this attitude, to which I could not submit; my struggle gave rise to various changes of course during which I searched for means of expression beyond the literal copying—such as divisionism and fauvism.

These rebellions led me to study each element of construction separately—drawing, color, values, composition; to explore how these elements could be combined into a synthesis without dimin-ishing the eloquence of any one of them by the presence of the others; and to construct with these elements, combining them with-out reducing their intrinsic quality; in other words, to respect the purity of the means.

Each generation of artists looks differently upon the production of the previous generation. The paintings of the Impressionists, con-structed with pure colors, proved to the next generation that these colors, while they might be used to describe objects or the phenom-ena of nature, contain within them, independently of the objects that they serve to express, the power to affect the feeling of those who look at them.

Thus it is that simple colors can act upon the inner feelings with all the more force because they are simple. A blue, for instance, ac-companied by the shimmer of its complementaries, acts upon the feelings like a sharp blow on a gong. The same with red and yellow; and the artist must be able to sound them when he needs to.

In the chapel* my chief aim was to balance a surface of light and color against a solid white wall covered with black drawings.

This chapel is for me the ultimate goal of a whole life of work and the culmination of an enormous effort, sincere and difficult.

This is not a work that I chose, but rather a work for which I have been chosen by fate towards the end of the course that I am still pursuing in my researches. The chapel has afforded me the possibility of realizing them by uniting them.

I foresee that this work will not be in vain and that it may remain the expression of a period in art, perhaps already surpassed, though I do not believe so. One cannot be sure about this today before the new movements have come to fruition.

Whatever weaknesses this expression of human feeling may contain will fall away, but there will remain a living part which will unite the past with the future of plastic tradition.

I trust that this part, which I call my revelation, may be expressed with sufficient power to be fertilizing and so return to its source.

From *La Chapelle du Rosaire*, by Matisse

* La Chapelle du Rosaire, consecrated on June 25, 1951.

John Marin

(1870–1953)

Marin did not wish to free himself from nature completely, and he remained, even in this last phase,† as visual as he was architectural, conveying a heightened, transposed "impression," but an impression nevertheless.

SAM HUNTER

THE ARTIST AND THE PUBLIC

NOVEMBER 15, 1940

It is Said—We are becoming—Art-Conscious—therefore let there be an—Art Week—focused on work done in—of and by America.

That out of it all will blossom forth—that—worth the looking at—

This is the hope—produce the artist and—presto—realization—not so fast—know you—that the artist is—not too Common—and

† A reference to Marin's expressed purpose "to show paint as paint."

that to produce he must have Encouragement—though courageous himself—he must have—like others about him—a good living—to do good work—this the art-conscious public must help to bring about by purchasing that which they profess to love.

For the public to know—to discern the artist—the one who is—from the one who professes to be—isn't too easy.

One says—"I live here"—"I use the objects of my locality—for subject matter"—if he is not an Artist, for one living in Australia may be better than he of our soil.

It is a legitimate hope though that our soil will produce the artist.

The people must gradually learn to discern the fine things—those sensitive to beauty can—those not sensitive cannot.

Those sensitive will want—and if the want is great enough—the artist will appear to supply that want and—I repeat—he's to be helped—to withhold that is to disobey the law of human relationships—and rest assured that he being an artist gives as much as he gets—he gives abundantly.

This work, etc.—this artist is to be found in his—workshop—there seek him—expect him not to play the game social or of self-advertisement—it would appear in his work and the sensitive ones will have none of it. Beware of the ambitious one and the one who works all the time—he hasn't time to think.

Go to him whose every effort is—the good job—

To him who delights in his living—to him who takes not himself too seriously and who can at times look and make faces at himself.

Don't rave over bad paintings.

Don't rave over good paintings.

Don't everlastingly read messages into paintings—there's the Daisy—you don't rave over or read messages into it—You just look at that bully little flower—isn't that enough!

From an editorial by John Marin

Lyonel Feininger

(1871–1956)

Feininger is fascinated by the problem of how to represent space on a flat surface without thereby destroying the lucid design. He has developed an ingenious device of his own, that of building his pictures out of overlapping triangles which look as if they were transparent and thus suggest a succession of layers—much like the transparent curtains one sometimes sees on the stage. As these shapes appear to lie one behind the other they convey the idea of depth and allow the artist to simplify the outlines of his objects without the picture looking flat.

E. H. GOMBRICH

EXTRACTS FROM FIVE LETTERS

1905

You know, you can work anywhere and learn everywhere, from everyone. . . . If you are to be an artist it will come in spite of all, but no teaching will help you if you are not to be an artist. Only learn to be steady and discipline your efforts, so that they are not useless.

1905

Expressive simplicity can only be attained contrariwise inasmuch as one gradually learns to eliminate all superfluous details. Because one has learned to master them one may suppress them. That constitutes the highest degree of proficiency. One should always strive to achieve this.

1906

All the sketches I sent you have been done in great loneliness. I was always alone—and only while working at such things I grasped drawing—I never had any other instruction to speak of. . . .

The slightest difference in relative proportions creates enormous differences with regard to the resulting monumentality and intensity of the composition. Monumentality is not attained by making

185

FEININGER: *Glassy Sea*. Water color, pen and ink, charcoal. Collection, The Museum of Modern Art, New York.

things larger! how childish! but by contrasting large and small in the same composition. On the size of a postage stamp one can represent something gigantic, while yards of canvas may be used in a smallish way and squandered.

1907
Already I visualize quite different values of light and form—different possibilities of translation than heretofore—but it seems nearly impossible to free oneself from the accepted reality of nature. That which is seen optically has to go through the process of transformation and crystallization to become a picture.

1914
I shall probably never in my pictures represent humans in the usual way—all the same whatever urges me is human. I am incapable of producing without a warm human feeling.

Georges Rouault

(1871–1958)

Georges Rouault: a solitary figure in an era of group manifestoes and shared directions; a devout Catholic and devotional painter in a period when artists more often have run the gamut of anti-religious feeling, from indifference to irreverence; a painter of sin and redemption in the face of prevailing estheticism and counter-estheticism; an artist with a limited vision of unlimited ferocity in contrast to many other leading painters who have scanned and pivoted but seldom stared fixedly for long. . . .

JAMES THRALL SOBY

I HAVE RESPECTED A CERTAIN INTERNAL ORDER

Without assuming the attitude of the figures David painted in his *Tennis Court Oath,* let me give briefly my artistic confession of faith, although for reason of space I will not be able to develop the nuances of it.

I must say, without boasting too much about it, that I have practiced this often legendary art with more or less luck; I have respected a certain internal order and laws which I hope are traditional; removed from passing fashions and contemporaries—critics, artists, and dealers—I believe I have kept my spiritual liberty.

ON POUSSIN

The twisted little man with the broken nose (Michelangelo) tells us that "every noble art is devout"; our own Poussin, sometimes judged a little pompous by certain green youths of my generation who are very much attached to Impressionism and have profited and benefited from it more than the originators themselves, does he not speak of noble, mute art? A certain classical perfume emanates from his works. I used to go and revisit them in the almost deserted halls (of the Louvre) around 1895, on Sunday promenades with our good *animateur,* Gustave Moreau.

THE PAINTING IS A MUTE WITNESS

Of all criticisms, of judgments more or less enlightened, biased or rash, of all miseries and vanities of the moment, there remains a mute though sometimes eloquent witness. I mean the poor fragment of canvas or paper before which our contemporaries and those to follow will sing "Halleluiah" or else "Miserere," sometimes without having any idea of the conditions under which the creator may have been constrained to work.

ON PAINTING

If I go back to my first childhood, I see myself armed with a piece of chalk, sketching large heads on the kitchen tiles or on the parquet floor of the old apartment of my grandfather, Alexandre Champdavoine, which faced the Musée Carnavalet, rue de Sévigné, in Paris, my home territory.

Heads larger than nature. Why? "Why?" Grock, the old clown, would say lowering his voice. What do I know about it myself?

Perhaps quite simply to give pleasure to grandfather, who loved the fine arts—but outside of official circles.

He loved Courbet, with his magnificent gifts for painting, who ended his life at La Chaux de Fond in Switzerland, ruined and exiled after having allegedly knocked down the Vendôme column.

He loved Manet and talked to me of the *Dead Toreador*. (I found among some old papers an invitation from Manet to come to his studio and look at the works refused by the official Salon.)

My grandfather died when I was about fifteen. He was my sole spiritual support until Gustave Moreau. I was only thirty when Moreau died. Then there was a desert to cross, and painting: the oasis or the mirage? Well knowing that I knew nothing—having certainly learned quite a bit between twenty and thirty, but considering that I perhaps did not know the essential thing, which is *to strip oneself*, if that grace is accorded us after having learned much.

And yet?

Is it not dangerous to talk this way to green youths?

Are they not capable of falsifying the facts of the problem and of believing themselves able to begin where one must end and sometimes conclude? Am I not myself often impatient, too, and in a hurry to come to a conclusion?

Our old masters started out very young generally and did not pursue two hares at one time. Having produced their masterwork early in the guilds, they possessed the means of expressing themselves very young, having sometimes begun by grinding colors in the master's studio while still children.

In order to have a taste for enriching the mind, it is perhaps not necessary to be a graduate or have a degree or to be a mandarin with mother-of-pearl buttons.

RÓUAULT: *Acrobat*. Collection, The Museum of Modern Art, New York (Gift of Mrs. John D. Rockefeller, Jr.).

They once brought me a child who used to cut out with scissors the silhouettes of animals he had just seen at the zoo. When I told the mother, who was of good bourgeois family, that this child should be placed with a sculptor if the bent continued, she replied: *"He must first know and learn all that one must know in our world."* That was perhaps putting off to a distant time the culmination of a fortunate gift.

It is not the worldly eclecticism of knowledge of many things that enriches, but perseverance in a favorable furrow and the loving, silent effort of a whole life.

False Michelangelos or Leonardos in the making or Raphaels who have scarcely the gift or breadth of a follower of Chardin— these think themselves absolutely capable of one day bestowing upon us a new *Last Judgment*. If they do not achieve it, they die of vexation.

That is why I sometimes tremble with sacred anger, may I say, when I am compared in my various attempts with some of the great old masters whom I love. . . . *I am so far away from them*—in a certain way. But can we not say, here more than ever, to make ourselves better understood if possible with regard to this cult of the old masters:

"The letter killeth and the spirit giveth life."

<div align="right">From notes by Rouault (1947)</div>

Piet Mondrian

(1872–1944)

> *The purely neo-plastic work of Mondrian is a kind of metaphysics of painting. One must approach it as one approaches icons which seek to express an immutable truth: that truth which, for the artist, is embodied in the dualism of horizontal and vertical, and glides towards us on black rails. These stark works . . . demand intellectual rather than visual contemplation.*

<div align="right">MICHEL SEUPHOR</div>

PLASTIC ART AND PURE PLASTIC ART

The only problem in art is to achieve a balance between the subjective and the objective. But it is of the utmost importance that this problem be solved in the realm of plastic art—technically, as it were —and not in the realm of thought. The work of art must be "pro-

duced," "constructed." One must create as objective as possible a representation of forms and relations. Such work can never be empty because the opposition of its constructive elements and its execution arouse emotion.

If some have failed to take into account the inherent character of the form and have forgotten that this—untransformed—predominates, others have overlooked the fact that an individual expression does not become a universal expression through figurative representation which is based on our conception of feeling, be it classical, romantic, religious, surrealist. Art has shown that universal expression can be created only by *a real equation of the universal and the individual.*

Gradually art is purifying its plastic means and thus bringing out the relationships between them. Thus, in our day two main tendencies appear: the one maintains the figuration, the other eliminates it. While the former employs more or less complicated and particular forms, the latter uses simple and neutral forms, or, ultimately, the free line and the pure color. It is evident that the latter (non-figurative art) can more easily and thoroughly free itself from the domination of the subjective than can the figurative tendency; particularly forms and colors (figurative art) are more easily exploited than neutral forms. It is, however, necessary to point out that the definitions "figurative" and "non-figurative" are only approximate and relative. For every form, even every line, represents a figure; no form is absolutely neutral. Clearly, everything must be relative, but, since we need words to make our concepts understandable, we must keep to these terms.

Among the various forms we may consider those as being neutral which have neither the complexity nor the particularities possessed by the natural forms or abstract forms in general. We may call those neutral which do not evoke individual feelings or ideas. Geometrical forms, being so profound an abstraction of form, may be regarded as neutral; and on account of their tension and the purity of their outlines they may even be preferred to other neutral forms.

If, as a conception, non-figurative art has been created by the mutual interaction of the human duality, this art has been *realized* by the mutual interaction of *constructive elements and their inherent relations.* This process consists in mutual purification; purified constructive elements set up pure relationships, and these in their own turn demand pure constructive elements. Figurative art today is the outcome of figurative art of the past, and non-figurative art is the outcome of figurative art of today. Thus the unity of art is maintained.

From *Plastic Art and Pure Plastic Art,* by Mondrian (1937)

Jacques Villon

(1875–1963)

Jacques Villon was and remains a Cubist painter. If his present work differs in many respects from what we customarily call Cubist, it demonstrates that any artistic tradition, to be truly traditional, must not be statically imitative but progressively inventive.

GEORGE H. HAMILTON

REFLECTIONS ON PAINTING

Painting . . . why do I paint? How do I paint? I paint precisely because I want to discover of what painting consists. When I was young, I believed, with the man on the street, that painting was a sort of reaction which reconstructed the spectacle before our eyes, preserving our memory of it, or that it allowed us to reconstruct or imagine some scene which illustrated an idea.

Now I think that painting is rather in the domain of philosophy. We paint to discover ourselves, to explain our deepest nature. Obviously subject-matter has always been seen as a mere pretext by the enlightened onlooker, but all the same, even the enlightened onlooker is drawn in spite of himself toward the subject. Subject-matter is important on the literal side, if one may say so, rather than on the literary side. It is important because it allows an indirect approach to a marvelous and unknown world. Because the painter makes his choice out of whatever moves him the most and most stirs his deepest responses—just as in sexual aberrations the most unforeseen associations excite a reaction.

But this marvelous world which we bring forth by means of our sympathy and penetrate through our intuition, will we ever come to know it? Perhaps we will be able to lift the vague indications of our intuition out of their limited sphere into the precise and clear plane of intelligence. But such triumphs are bounded by our capacities and we cannot rise above ourselves—that is the drama.

We are like a man before a mirror who lifts himself up to dominate his reflection, but his own image rises to his own height, and he will never rise above it or dominate it. He cannot admit this. He stamps, he rages, he distorts his appearance in the hope of releasing an image which corresponds to his pretensions, but all in vain.

VILLON: *Portrait of a Young Woman.* Drypoint. Yale University Art Gallery, New Haven (Collection Société Anonyme).

Worn out, he sinks back; he turns against the art which has deceived him. And the best are the victims of too much ambition. Too much? Why? Since we are captive to it. And who tells us that so much ambition is bankrupt? It is by the hidden content that one must judge the value of new assets. The unknown quantity which makes us tremble before a great work is not weighed in earthly balances. It is little, and immense, and rare.

How many beacons illuminate a century?

Man, we are told, is a fallen angel who remembers, but his memory may be good or bad. We must accept the memory we have, and not rely too much on artificial means, which smell of death.

And at the end of all this? I don't know—but since we must work, let us work. Let us plow the field to find the treasure, and if there is no treasure, never mind; the earth will give us back a good crop of potatoes.

And then we pass on the torch.

From *Reflections on Painting*, by Jacques Villon (1950)

Kasimir Malevich

(1878–1935)

He called his new art "Suprematism—the suprem-acy of pure sensitivity or perception." He placed black squares on a white background, went a step fur-ther and put black circles on white. He reached a peak of purgation and purity in painting a white square on a white background, appropriately calling the composition White on White.

SARAH NEWMEYER

SUPREMATISM

The black square on the white field was the first form of expression of the non-objective perception: the square = the perception, the white field = the "nothing" outside of this perception.

However, people saw in this non-objective representation the end of art, and they did not recognize the reality, namely, the development of the perception of form.

The square of the Suprematists and the forms which were created from this square are to be compared with the primitive lines made by the first man, which in their combinations did not represent an ornament but rather the perception of rhythm.

It is not a new world of perceptions which enters life as a result of Suprematism, rather it is a totally new, direct delineation of the world of perception.

The square changes and creates new forms whose elements, according to the proportion of the causative perceptions, are categorized in this or that way.

When we look at an antique pillar whose construction, in terms of architectural reasons, no longer has any meaning for us, we recognize therein the form of a pure perception. We no longer see in the pillar an architectural purpose, but rather, a work of art as such.

From *The Non-Objective World*, by Malevich (1927)

Paul Klee

(1879-1940)

Klee realized, perhaps more clearly than any artist since Goethe, that all effort is vain if it is forced: that the essential formative process takes place below the level of consciousness. In this matter he agrees with the Surrealists, but he would never accept their view that a work of art could be projected automatically from the unconscious: the process of gestation is complex, involving observation, meditation, and finally a technical mastery of the pictorial elements.

HERBERT READ

THE ARTIST MUST PROCEED
FROM TYPE TO PROTOTYPE

And isn't it true that if we only take the relatively small step of glancing into a microscope, we will see images that we would all call fantastic and exaggerated if we happened to see them in a painting without realizing the joke? Mr. X, coming across a reproduction of a microphotograph in a cheap journal, would exclaim indignantly: Are those supposed to be natural forms? Why, the man just doesn't know how to draw!

Then does the artist have to deal with microscopy? History? Paleontology? Only by way of comparison, only by way of gaining greater scope, not so that he has to be ready to prove his fidelity to nature! The main thing is freedom, a freedom which does not necessarily retrace the course of evolution, or project what forms nature will someday display, or which we may someday discover on other planets; rather, a freedom which insists on its right to be just as inventive as nature in her grandeur is inventive. The artist must proceed from the type to the prototype!

The artist who soon comes to a halt en route is one who has pretensions, but no more. The artists with real vocations nowadays are those who travel to within fair distance of that secret cavern where the primal law is hidden; where the central organ of all temporal and spatial movement—we may call it the brain or the heart of creation—makes everything happen. What artist would not wish to dwell there—in the bosom of nature, in the primordial source of

KLEE: *Old Man Figuring.* Etching. Collection, The Museum of Modern Art, New York.

creation, where the secret key to everything is kept? But not all are meant to reach it. Everyone must go where his own instinct leads him. Thus the Impressionists who today are our polar opposites were in their own time absolutely right to stay with their hair-roots, the ground-cover of everyday phenomena. But our own instinct drives us downward, deep down to the primal source. Whatever emerges from this activity, call it what you will, dream, idea, fantasy, should be taken quite seriously if it combines with proper pictorial elements and is given form. Then curiosities become realities, realities of art, which add something more to life than it usually seems to have. For then we no longer have things seen and reproduced with more or less display of temperament, but we have visionary experiences made visible.

"With proper pictorial elements," I have said. For that tells us whether the result is a painting or something else, and what kind of a painting it is to be.

Our age has passed through many confusions and vicissitudes, or so it seems to us, for we may be so close that our judgment is faulty.

But one general tendency seems to be gradually winning ground among artists, even among the youngest of them: pure cultivation of these pictorial elements and their pure application. The myth about the childishness of my drawing must have started with those linear structures in which I attempted to combine the idea of an object—a man, say—with pure representation of the linear elements. If I wanted to render a man "just as he is," I would need such a bewildering complex of lines that pure representation of the elements would be impossible; instead, they would be blurred to the point of being unrecognizable. Moreover, I don't at all want to represent a man as he is, but only as he might be.

Only by such procedures can I succeed in combining philosophy with the pure practice of my art.

These principles hold true for the entire procedure. Blurring must be everywhere avoided, in dealing with colors too. This effort to avoid blurring lies behind what people sneer at as the "false" coloration in modern art.

As I have just suggested in my remark on "childishness," I also deal separately with the various elements of painting. That is, I am also a draftsman. I have tried pure drawing; I have tried pure chiaroscuro painting; and I have tried all sorts of experiments with color as these arose out of my meditations on the color wheel. Thus I have worked out the various types of colored chiaroscuro painting, complementary color painting, particolored painting, and totally colored painting. And in each case I have combined these experiments with the more subconscious dimensions of painting.

Then I have tried all possible syntheses of the two types, combining and recombining, but always trying to keep hold of the pure elements as far as possible. Sometimes I dream of a work of vast expanse which would encompass the whole realm of elements, objects, contents, and styles. Doubtless that will remain a dream, but it is good occasionally to imagine this possibility which at present remains a vague one.

Creation cannot be done with undue haste. A thing must grow, must mature, and if the time ever comes for that vast, all-embracing work, so much the better. We must go on seeking. We have found parts of it, but not yet the whole. Nor do we have the strength for it as yet, for we have no public supporting us. But we are seeking a public; we have made a beginning at the Bauhaus. We have begun with a community to which we are giving everything we have to give. More than that we cannot do.

From an address by Paul Klee (1924)

Hans Hofmann
(1880–1966)

Except for his consistent interest in the creative possibilities of color, Hofmann's work displays great variety. Hofmann refuses to limit himself to one easily recognizable style, but ranges widely and simultaneously along several lines of thought which sometimes run parallel, sometimes cross and sometimes are dominated by a single concept. Because of his vitality and exuberance, his creativity is unlimited and ever open to new stimuli.

KIM LEVIN

I CONDEMN DOGMATISM
AND CATEGORIZATION

Every figurative attempt in the visual arts is positively to be condemned when made without consideration of the underlying esthetic principle of Abstraction, because such mortal negligence will necessarily lead to uninspired, imitative, and academic formalism. Creation deals with nature's physical laws, with the picture's esthetic surface laws, and with the laws of the operating medium of expression —all of which are dissimilar, but in no way repulsive and unadjustable to each other when handled by a creative mind. By these means, an anatomical detail in nature is transformed into a pictorial means —a point, a line, a plane, a color, etc.—and functions thereby in accordance with the pictorial surface laws in the meaning of a profound and deeply sensed composition. This is then creation, as opposed to amateurish imitation.

Creative figuration in the visual arts, in the sense of subject matter, is in no way to be condemned, when achieved through the qualitative and esthetic substance of every work intended toward such ends.

As an artist I condemn dogmatism and categorization because the scent of death accompanies every such style.

From a statement by Hans Hofmann (1961)

Franz Marc

(1880–1916)

He is more human than I; his affections are warmer, more pronounced. He responds to animals in human terms, raising them to his own level. Unlike me, he does not need to dissolve himself in the universe in order to feel that he stands on the same plane as animals, plants, and stones. In Marc earthiness comes before identification with the cosmos. . . . There was a Faustian, an unredeemed element in him. He was eternally questioning. Is it true? The words "false doctrine" were forever on his lips.

PAUL KLEE

ART IS METAPHYSICAL

1912

Art is metaphysical . . . it will free itself from man's purpose and desires. We will no longer paint the forest or the horse as they please us or appear to us, but as they really are, as the forest or the horse feel themselves—their absolute being—which lives behind the appearance which we see. We will be successful insofar as we can succeed in overcoming the traditional "logic" of millennia with artistic creativity. There are art forms which are abstract, which can never be proven by human knowledge. These forms have always existed, but were always obscured by human knowledge and desire. The faith in art itself was lacking, but we shall build it: it lives on the "other side."

NOTES

March, 1912

Is there a more mysterious idea for the artist than the conception of how nature may be mirrored in the eye of the animal? How does a horse see the world, or an eagle, or a deer, or a dog? How poor and how soulless is our convention of placing animals in a landscape which belongs to our eyes, instead of penetrating into the soul of the animal in order to imagine his perception?

From *Notes and Aphorisms,* by Franz Marc

199

Fernand Léger

(1881–1955)

Léger's art can be truly appreciated only if one realizes that the question "What do you represent?" has no meaning in this context. . . . Léger is not trying to copy nature, because he is not seeking comparison with something already existing. There is therefore no distortion in his art. It is . . . immediately approachable and comprehensible provided that one does not seek beyond the apparent pictorial logic for some hidden meaning or misplaced representational aims.

DOUGLAS COOPER

NOT TO LOSE TOUCH WITH REALITY

To be free *and yet not to lose touch with reality,* that is the drama of that epic figure who is variously called inventor, artist, or poet. Days and nights, dark or brightly lit, seated at some garish bar; renewed visions of forms and objects bathed in artificial light. Trees cease to be trees, a shadow cuts across the hand placed on the counter, an eye deformed by the light, the changing silhouettes of the passers-by. The life of fragments: a red fingernail, an eye, a mouth. The elastic effect produced by complementary colors which transform objects into some other reality. He fills himself with all of this, drinks in the whole of this vital instantaneity which cuts through him in every direction. He is a sponge: sensation of being a sponge, transparency, acuteness, new realism.

ABSTRACT ART IS TRUE PURISM

Abstract art is dominated by that same desire for complete and absolute freedom and perfection which inspires saints, heroes, and madmen. It is a peak on which only a few creative artists and their admirers can maintain themselves. In fact the very danger of this peak is the rarefied atmosphere by which it is surrounded. Modeling, contrasts, and objects disappear. All that remains are the purest and the most precise of relationships, a few colors, a few lines, some

200

LÉGER: *Three Musicians*. Collection, The Museum of Modern Art, New York.

white spaces devoid of depth. Respect for the vertical plane—thin, rigid, limiting. This is true purism: incorruptible. The tumult and the speed of modern life, which is dynamic and full of contrasts, beat furiously against this light and brittle construction as it emerges coldly from the chaos.

<div align="right">From The Writings of Fernand Léger</div>

Pablo Picasso

(1881–)

There are men who become legends in their life-time. Such is Picasso. His genius, his startling original-ity, his flamboyant disregard for convention, have made him the most talked about artist of our times.

ROLAND PENROSE

ABOUT PAINTING

. . . A picture used to be a sum of additions. In my case it is a sum of destructions. I do a picture—then I destroy it. In the end, though, nothing is lost: the red I took away from one place turns up somewhere else.

It would be very interesting to preserve photographically, not the stages, but the metamorphoses of a picture. Possibly one might then discover the path followed by the brain in materializing a dream. But there is one very odd thing—to notice that basically a picture doesn't change, that the first "vision" remains almost intact, in spite of appearances. I often ponder on a light and a dark when I have put them into a picture; I try hard to break them up by interpolating a color that will create a different effect. When the work is photographed, I note that what I put in to correct my first vision had disappeared, and that, after all, the photographic image corresponds with my first vision before the transformation I insisted on.

A picture is not thought out and settled beforehand. While it is being done it changes as one's thoughts change. And when it is finished, it still goes on changing, according to the state of mind of whoever is looking at it. A picture lives a life like a living creature, undergoing the changes imposed on us by our life from day to day. This is natural enough, as the picture lives only through the man who is looking at it.

At the actual time I am painting a picture I may think of white and put down white. But I can't go on all the time thinking of white and painting it. Colors, like features, follow the changes of the emotions. You've seen the sketch I did for a picture with all the colors indicated on it. What is left of them? Certainly the white I thought of and the green I thought of are there in the picture, but not in the places I intended, nor in the same quantities. Of course, you can paint pictures by matching up different parts of them so that they go quite nicely together, but they'll lack any drama.

I want to get to the stage where nobody can tell how a picture of

mine is done. What's the point of that? Simply that I want nothing but emotion to be given off by it.

Work is a necessity for man—A horse does not go between shafts of its own accord—Man invented the alarm clock.

When I begin a picture, there is somebody who works with me. Toward the end, I get the impression that I have been working alone—without a collaborator.

When you begin a picture, you often make some pretty discoveries. You must be on your guard against these. Destroy the thing, do it over several times. In each destroying of a beautiful discovery, the artist does not really suppress it, but rather transforms it, condenses it, makes it more substantial. What comes out in the end is the result of discarded finds. Otherwise, you become your own connoisseur. I sell myself nothing.

Actually, you work with few colors. But they seem like a lot more when each is in the right place.

Abstract is only painting. What about drama?

There is no abstract art. You must always start with something. Afterward you can remove all traces of reality. There's no danger then, anyway, because the idea of the object will have left an indelible mark. It is what started the artist off, excited his ideas, and stirred up his emotions. Ideas and emotions will in the end be prisoners in his work. . . . They can't escape from the picture. . . .

Nor is there any "figurative" and "non-figurative" art. Everything appears to us in the guise of a "figure." Even in metaphysics ideas are expressed by means of symbolic "figures." See how ridiculous it is to think of painting without "figuration." A person, an object, a circle are all "figures"; they react on us more or less intensely. . . .

I deal with painting as I deal with things, I paint a window just as I look out of a window. If an open window looks wrong in a picture, I draw the curtain and shut it, just as I would in my own room. In painting, as in life, you must act directly. Certainly, painting has its conventions, and it is essential to reckon with them. Indeed, you can't do anything else. And so you always ought to keep an eye on real life. . . .

When we invented cubism we had no intention whatever of inventing cubism. We wanted simply to express what was in us. Not one of us drew up a plan of campaign, and our friends, the poets, followed our efforts attentively, but they never dictated to us. Young painters today often draw up a program to follow, and apply themselves like diligent students to performing their tasks. . . .

With the exception of a few painters who are opening new horizons to painting, young painters today don't know which way to go.

Instead of taking up our researches in order to react clearly against us, they are absorbed with bringing the past back to life—when truly the whole world is open before us, everything waiting to be done, not just redone. Why cling desperately to everything that has already been fulfilled? There are miles of painting "in the manner of"; but it is rare to find a young man working in his own way.

Does he wish to believe that man can't repeat himself? To repeat is to run counter to spiritual laws; essentially escapism.

I'm no pessimist. I don't loathe art, because I couldn't live without devoting all my time to it. I love it as the only end of my life. Everything I do connected with it gives me intense pleasure. But still, I don't see why the whole world should be taken up with art, demand its credentials, and on that subject give free reign to its own stupidity. Museums are just a lot of lies, and the people who make art their business are mostly impostors. I can't understand why revolutionary countries should have more prejudices about art than out-of-date countries! We have infected the pictures in museums with all our stupidities, all our mistakes, all our poverty of spirit. We have turned them into petty and ridiculous things. We have been tied up to a fiction, instead of trying to sense what inner life there was in the men who painted them. . . .

From an interview with Picasso by Christian Zervos (1935)

PICASSO: *Guernica*. On extended loan from the artist

A STRUGGLE AGAINST REACTION

The Spanish struggle is the fight of reaction against the people, against freedom. My whole life as an artist has been nothing more than a continuous struggle against reaction and the death of art. How could anybody think for a moment that I could be in agreement with reaction and death? When the rebellion began, the legally elected and democratic republican government of Spain appointed me director of the Prado Museum, a post which I immediately accepted. On the panel on which I am working which I shall call *Guernica,* and in all my recent works of art, I clearly express my abhorrence of the military caste which has sunk Spain into an ocean of pain and death. . . .

Statement made in May 1937

ABOUT GUERNICA

No, the bull is not fascism, but it is brutality and darkness . . . the horse represents the people . . . the *Guernica* mural is symbolic . . . allegoric. That's the reason I used the horse, the bull, and so on. The mural is for the definite expression and solution of a problem and that is why I used symbolism.

From an interview with Picasso after World War II.

to The Museum of Modern Art, New York.

George Bellows

(1882–1925)

Bellows, who was influenced by Henri and The Eight although he did not participate in their famous group exhibition, was equally enthusiastic about depicting the American life around him.*

HELEN GARDNER

WHAT IS GOOD DRAWING?

This question depends upon the definition of what is a work of art. If we consider that a work of art is the finest, deepest, most significant expression of a rare personality, it follows that any plastic invention or creative molding of form which succeeds in giving life to this expression is good drawing. It may have the mechanical and spiritual shortcomings coincident with even the greatest of people but it will still remain good drawing.

OF WHAT IMPORTANCE IS ART TO SOCIETY?

All civilization and culture are the results of the creative imagination or artist quality in man. The artist is the man who makes life more interesting and beautiful, more understandable or mysterious, or, probably, in the best sense more wonderful. His trade is to deal in illimitable experience. It is therefore only of importance that the artist discover whether he be an artist, and it is for society to discover what return it can make to its artists.

HOW DOES SUBJECT MATTER RELATE TO ART?

A work of art is both independent of and dependent on a subject; independent in that all objective or subjective sensations, anything, in fact, which has the power to hold or receive human attention, may be the subject of a work of art; dependent, in the sense of the necessity, whether realized or not, of a point of departure, a kernel, a unit established, around which the creative imagination builds or weaves itself. The name given to a thing is *not* the subject; it is only a convenient label. Any subject is inexhaustible.

From *The Paintings of George Bellows*, by George Bellows

* Later known as the "Ash Can" school.

Umberto Boccioni

(1882–1916)

*The experience of continuous movement generated
by the painting finds eventually a kind of resolution.
The motion or interplay does not stop, yet at a given
point we feel that we have reached the climax, the mo-
ment of maximum concentration in the picture. This
is not the same as recognizing finally the architectural
stability underlying the dislocations of a Cubist paint-
ing; we do not leave the work with a new assurance of
formal law and order, first threatened and then re-
established. Instead we are boldly launched or cun-
ningly enticed to set out on an untrackable path that
fragments and expands to take us well beyond the
limits of our normal movement, and we are thus re-
leased into a realm of ideal motion that escapes the
checks and measures of our physical world. This re-
lease is the Futurist's moment of ecstasy, his contact
with the "universal rhythm" that grants him the free-
dom of the superman . . . "dans l'Infini libérateur."*

JOSHUA C. TAYLOR

EXTRACTS FROM THE
SECOND FUTURIST MANIFESTO*

WE DECLARE:

1) That all forms of imitation must be despised, all forms of
originality glorified.

2) That it is essential to rebel against the tyranny of the terms
"harmony" and "good taste" as being too elastic expressions, by the
help of which it is easy to demolish the works of Rembrandt, of
Goya, and of Rodin.

* Known as the Technical Manifesto and signed by Boccioni, Carrà, Russolo,
Balla, and Severini. The First Futurist Manifesto was published by *Le Figaro*,
on February 20, 1909. It was the work of the Italian poet F. T. Marinetti, who
was the only signer. The Second Futurist Manifesto appeared on April 11, 1910.
The Third Futurist Manifesto, entitled "The Exhibitors to the Public," ap-
peared on February 5, 1912, and it was signed by the same group that had signed
the Second. The Fourth Futurist Manifesto, which appeared on April 11, 1912,
was entitled "Technical Manifesto of Futurist Sculpture." It was signed only by
Boccioni.

3) That the art critics are useless or harmful.

4) That all subjects previously used must be swept aside in order to express our whirling life of steel, of pride, of fever, and of speed.

5) That the name of "madman" with which it is attempted to gag all innovators should be looked upon as a title of honor.

6) That innate complementariness is an absolute necessity in painting, just as free meter in poetry or polyphony in music.

7) That universal dynamism must be rendered in painting as a dynamic sensation.

8) That in the manner of rendering nature the first essential is in sincerity and purity.

9) That movement and light destroy the materiality of bodies.

WE FIGHT:

1) Against the bituminous tints by which it is attempted to obtain the patina of time upon modern pictures.

2) Against the superficial and elementary archaism founded upon flat tints, and which, by imitating the linear technique of the Egyptians, reduces painting to a powerless synthesis, both childish and grotesque.

3) Against the false claims to belong to the future put forward by the secessionists and independents, who have installed new academies no less trite and attached to routine than the preceding ones.

4) Against the nude in painting, as nauseous and as tedious as adultery in literature.

We wish to explain this last point. Nothing is *immoral* in our eyes; it is the monotony of the nude against which we fight. We are told that the subject is nothing and that everything lies in the manner of treating it. That is agreed; we, too, admit that. But this truism, unimpeachable and absolute fifty years ago, is no longer so today with regard to the nude, since artists obsessed with the desire to expose the bodies of their mistresses have transformed the Salons into arrays of unwholesome flesh!

*We demand, for ten years, the total suppression of the nude in painting.**

* In the publication of the collected manifestoes in 1914 these final two paragraphs were omitted. In their place was the following:

"You think us mad. We are, instead, the primitives of a new, completely transformed, sensibility.

"Outside the atmosphere in which we live are only shadows. We futurists ascend towards the highest and most radiant peak and proclaim ourselves Lords of Light, for already we drink from the live founts of the sun."

Georges Braque

(1882–1963)

His role was heroic. His art calm and splendid. He is a serious craftsman. He expresses a beauty full of tenderness, and the pearly lusters of his pictures play on our senses like a rainbow. This painter is angelic.
GUILLAUME APOLLINAIRE

Braque, in the great tradition of French painting, cultivated with increasing maturity a somberly lyrical style, always emphasizing texture. He refines an expressive design outlining simple flattened forms. Based on a subtle palette of rare sensitivity, Braque's still lifes are visual understatements that unfold their riches only gradually and only to the discerning eye.
PAUL ZUCKER

APHORISMS

One should not imitate what one wishes to create.

I would much rather put myself in unison with nature than copy it.

Nature does not give taste to perfection. One conceives of it as neither better nor worse.

The painter thinks in forms and colors. The object is his poetic aim.

The painter knows things from sight, the writer by name.

In art there is only one thing of value, that which cannot be explained (i.e., explained in words).

The painter does not attempt to restate an anecdote but to get at the essence of a pictorial fact.

Form and color do not mix.

Progress in art does not consist in extending one's limitations, but in knowing them better.

Impregnation is that which comes to us unconsciously, which is developed and retained by obsession and which is delivered up one day by creative hallucination.

Hallucination is the definitive realization of a long impregnation whose beginnings may go back to youth.

The age of impregnation is early youth. I find that I am painting today the most anonymous aspirations of my beginning, things that touched me at the time without my being aware of it and which have since pursued me until this final realization.

From *Aphorisms*, by Georges Braque

BRAQUE: *Woman with a Mandolin*. Collection, The Museum of Modern Art, New York (Mrs. Simon Guggenheim Fund).

IN PAINTING THERE MUST BE NO PRECONCEIVED IDEA

I could not do otherwise than I do. The picture makes itself under the brush. I insist on this point. There must be no preconceived idea. A picture is an adventure each time. When I tackle the white canvas I never know how it will come out. This is the risk you must take. I never visualize a picture in my mind before starting to paint. On the contrary, I believe that a picture is finished only after one has completely effaced the idea that was there at the start.

From a statement on painting by Braque (1949)

Max Beckmann

(1884–1950)

Between the two world wars he developed a strongly individual Expressionism which, as Hitler rose to power, seemed to be squeezed in upon itself in crowded, distorted forms by the unbearable pressure of Germany's anguished upheavals. As Hitler's power became stabilized, crushing Germany into a new order, Beckmann's canvases took on a stark calmness. No more crowding and distortion—just a methodically mad mutilation of limbs, a binding of body with body, like trussed fowls, a senseless torture.

SARAH NEWMEYER

ON MY PAINTING

I assume, though, that there are two worlds: the world of spiritual life and the world of political reality. Both are manifestations of life which may sometimes coincide but are very different in principle. I must leave it to you to decide which is the more important.

What I want to show in my work is the idea which hides itself behind so-called reality. I am seeking for the bridge which leads from the visible to the invisible, like the famous cabalist who once said: "If you wish to get hold of the invisible you must penetrate as deeply as possible into the visible." My aim is always to get hold of the magic reality and to transfer this reality into painting—to make the invisible visible through reality. It may sound paradoxical, but it is, in fact, reality which forms the mystery of our existence.

What helps me most in this task is the penetration of space. Height, width, depth are three phenomena which I must transfer into one place to form the abstract surface of the picture, and thus to protect myself from the infinite of space. My figures come and go, suggested by fortune or misfortune. I try to fix them divested of their apparent accidental quality.

One of my problems is to find the Ego which has only one form and is immortal—to find it in animals and men, in the heaven and in the hell which together form the world in which we live. Space, and space again, is the infinite deity which surrounds us and in which we are ourselves contained.

That is what I try to express through painting, a function different from poetry and music but, for me, predestined necessity.

When the spiritual, metaphysical, material or immaterial events come into my life, I can only fix them by the way of painting. It is not the subject which matters but the translation of the subject into the abstraction of the surface by means of painting. Therefore I hardly need to abstract things, for each object is unreal enough already, so unreal that I can only make it real by means of painting. . . .

Art is creative for the sake of realization, not for amusement; for transfiguration, not for the sake of play. It is the quest of our Ego that drives us along the eternal and never-ending journey we must all make.

My way of expressing my Ego is by painting; there are, of course, other means to this end, such as literature, philosophy, or music; but as a painter, cursed or blessed with a terrible and vital sensuousness, I must look for wisdom with my eyes. I repeat, with my eyes, for nothing could be more ridiculous or irrelevant than a "philosophical conception" painted purely intellectually without the terrible fury of the senses grasping each visible form of beauty and ugliness. . . .

Everything intellectual and transcendental is joined together in painting by the uninterrupted labor of the eyes. Each shade of a flower, a face, a tree, a fruit, a sea, a mountain, is noted eagerly by the intensity of the senses, to which is added, in a way of which we are not conscious, the work of the mind, and in the end the strength and weakness of the soul. . . .

The uniform application of a principle of form is what rules me in the imaginative alteration of an object. One thing is sure—we have to transform the three-dimensional world of objects into the two-dimensional world of the canvas.

If the canvas is only filled with a two-dimensional conception of space, we shall have applied art, or ornament. Certainly this may give us pleasure, though I myself find it boring, as it does not give me enough visual sensation. To transform three into two dimensions is for me an experience full of magic in which I glimpse for a moment that fourth dimension which my whole being is seeking.

<div align="right">From a lecture given by Beckmann at the New
Burlington Galleries, London, 1938</div>

Amadeo Modigliani

(1884–1920)

Modigliani's women are not the grown-up cherubs of which the eighteenth century was fond. They are adult, sinuous, carnal, and real. The final stage in the sequence leading from Giorgione's Concert champêtre *to Manet's* Déjeuner sur l'herbe *and on to Lautrec and his contemporaries. . . . His nudes are an emphatic answer to his Futurist countrymen who, infatuated with the machine, considered the subject outworn and urged its suppression for a period of ten years.*

JAMES THRALL SOBY

PAINTING LIPCHITZ

"I charge ten francs and a little alcohol for each sitting," said the painter. "He came the next day," recalls Lipchitz, "and made a lot of preliminary drawings, one right after the other with tremendous speed and precision. . . . Finally a pose was decided upon—a pose inspired by our wedding photograph.

"The following day at one o'clock, Modigliani came with an old canvas and his box of painting material, and we began to pose. I see him so clearly even now—sitting in front of his canvas, which he had put on a chair, working quietly, interrupting only now and then to take a gulp of alcohol from a bottle standing nearby. From time to time he would get up and glance critically over his work and look at his models. By the end of the day, he said, "Well, I guess it's finished."

From *The Memoirs of Jacques Lipchitz*

LETTER TO ZBOROWSKI

NICE, 1919

Dear Friend:

You are naïve and can't take a joke.* I haven't sold a thing. Tomorrow or the next day I'll send you the stuff.

Now for something that is *true* and very serious. My wallet with 600 francs has been stolen. This seems to be a specialty of Nice. You can imagine how upset I am.

* During the Christmas-New Year season, Modigliani, while drunk, had written his dealer and friend Zborowski that he had sold a number of paintings. From the tone of the letter it was obvious that he was just joking, but Zborowski took him seriously and wrote the painter a humorless, angry reply.

213

Naturally I am broke, or almost. It is all too stupid, but since it is neither in your interests nor in mine to have me stop working, here is what I suggest: wire me, care of Sturvage, 500 francs, if you can. And I'll repay you 100 francs a month; that is, for five months you can take 100 francs out of my allowance. At any rate, I shall keep the debt in mind. Apart from the money, losing the papers worries me immensely. That was all that was needed . . . and now, of all times, just when I thought that I had finally found a little peace. Please believe in my loyalty and friendship and give my best wishes to your wife.

Oskar Kokoschka

(1886–)

Certain characteristics are inherent in all of Koko-schka's works: the sensuality and the passion they express; their symbolism that has changed from personal allusions to general significance.

EDITH HOFFMANN

EXTRACT FROM A LETTER TO PROFESSOR TIETZE (1917–1918)

And so I now use as models the faces of people such as those who happen to have been holding out here with me for a long time and whom I know inside out, so that they torment me almost like night-mares, to build up compositions showing the struggle of man against man, their contrast of one with another, like the contrast of hate and love, and in each picture I search for the dramatic accent that will weld the individuals into a higher unity. Last year I did a picture, the *Exiles*, that would interest you: and this year the *Gamblers*, which I started five months ago and which I am only now slowly finishing. It represents my friends playing cards. Each terrifyingly naked in his passions, and all submerged by a color which binds them together just as light raises an object and its reflection into a higher category by revealing something of reality and something of its reflection, and therefore more of both.

SELF-PORTRAIT OF A DEGENERATE ARTIST*

This time I tried to combine two contrasting aspects, different from the psychological point of view and different in the structural ideas as well, similar to the use of counterpoint in musical composi-

* Hitler declared Expressionist art degenerate and forbade its being shown.

214

tion. That such processes are feasible in the arts which are non-sensically called "imitative" is manifest in the outstanding example of Michelangelo's late work, the *Pietà* in the Florence Duomo, where he combined three different actions and different ideas of form in one vision. This unfinished work opens in truth the period of art which we call the Baroque. If such terms as Cubism or Surrealism have any meaning, then here it can be found.

From a statement by Kokoschka (1937)

KOKOSCHKA: *Hans Tietze and Erica Tietze-Conrat.* Collection, The Museum of Modern Art, New York (Mrs. John D. Rockefeller, Jr. Fund).

Marc Chagall

(1887–)

Chagall never loses contact with reality, but it must be said that he eludes reality, the reality we are accustomed to think of as unalterable.

PHILIPPE SOUPAULT

ON MY PAINTING

I strive primarily to build up my picture architectonically, just as the Impressionists and the Cubists used to do in their day. The Impressionists covered their canvas with light and dark patches of color, the Cubists with square, triangular, and round shapes. In-

stead of this, I try to fill my canvas with objects and figures which I employ in place of such shapes, with ringing forms filled with passion that are to create an additional dimension such as cannot be attained with the pure geometry of Cubist lines or Impressionist dabs of color.

THE SYMBOLS IN MY PAINTING

That I have made cows, girls, cocks, and houses of provincial Russia my fundamental form is explained by the fact that they belong to the milieu from which I originated and they have undoubtedly left the deepest imprint on my visual memory. However vitally and variously a painter may react to the atmosphere and influences of his later surroundings, a certain "aroma" of his birthplace will always remain attached to his work. . . . Thus I hope I have preserved the influences of my childhood in more than merely their material aspect.

From *Reflections on My Work,* by Chagall

CHAGALL: *Birthday.* Collection, The Museum of Modern Art, New York (Acquired through the Lillie P. Bliss Bequest).

Juan Gris

(1887–1927)

Here is the man who has meditated on everything modern, here is the painter who wants to conceive only new structures, whose aim is to draw or paint nothing but materially pure forms.

GUILLAUME APOLLINAIRE

ON THE POSSIBILITIES OF PAINTING

In the so-called "decadent" periods of art, there is an over-development of technique to the detriment of the esthetic. There is no selection, and the most variegated elements jostle each other in contemporary works. *Pasticheurs* imitate the accepted appearance of works of the past without understanding either their esthetic or the higher laws by which they are ordered. For no work which is destined to become a classic can look like the classics which have preceded it. In art, as in biology, there is heredity but no identity with the ascendants. Painters inherit characteristics acquired by their forerunners; that is why no important work of art can belong to any period but its own, to the very moment of its creation. It is necessarily dated by its own appearance. The conscious will of the painter cannot intervene. An appearance which is deliberate and results from a desire for originality is sham; every deliberate manifestation of the personality is the very negation of personality. . . .

Certain issues still need to be defined after all that has been said. Painting for me is like a fabric, all of a piece and uniform, with one set of threads as the representational, esthetic element, and the cross-threads as the technical, architectural, or abstract element. These threads are interdependent and complementary, and if one set is lacking the fabric does not exist.

A picture with no representational purpose is to my mind always an incomplete technical exercise, for the only purpose of any picture is to achieve representation. Nor is a painting which is merely the faithful copy of an object a picture, for even supposing that it fulfills the conditions of colored architecture, it still has no esthetic, that is to say, no selection of the elements of the reality it expresses. It will only be the copy of an object and never the subject. . . . The essence of painting is the expression of certain relationships between the painter and the outside world, and that a picture is the intimate association of these relationships with the limited surface which contains them.

From *On the Possibilities of Painting*, by Juan Gris (1924)

Kurt Schwitters

(1887–1948)

Kurt Schwitters was called the master of collage. He was the master of collage. The heresy of giving a new value to odd and overlooked, downtrodden bits of reality—be they bits of wire or bits of words—by putting them together into some specific kind of relationship and creating thus a new entity, was . . . the essence of Schwitters' art.

STEFAN THEMERSON

HARD TIMES

I took a seat on the bench and looked all around me. I was not hungry, because I had been given three pieces of bread in the shop of an art dealer I know. Three pieces of bread, with white cheese. It was raining, a thunderstorm. So I interrupted my business of visiting one shop after another and trying to get commissions for portrait painting. There must be people who would like to have a good portrait of their nice head done by me, but I cannot find them. There was a thunderstorm, so I sat down on this bench, protected by an immense plane tree. Behind me there was lots of barbed wire, because there was a war on. I felt sad about the hopelessness of my situation, and this bench looked quite as hopeless as I was.

Life is sad. Why did the director of the National Gallery not even want to see me? He does not know that I belong to the avant-garde in art. That is my tragedy. Why did Mr. A. tell me that not even the really famous painter Lieutenant F. could get portrait commissions, and so I should be quite satisfied. Why did people tell me I should wait till after the war? I have already been waiting seven months for work, and my stomach cannot wait with eating.

From *The Notes of Kurt Schwitters* (World War II)

Marcel Duchamp

(1887–1968)

The thing that constitutes the strength of Marcel Duchamp, the thing to which he owes his escape alive from several perilous situations, is above all his disdain for the thesis *which will always astonish less favoured men.*

<div align="right">ANDRÉ BRETON</div>

ART IS A DRUG

. . . I'm not so interested in art per se. It's only one occupation, and it hasn't been my whole life, far from it. You see, I've decided that art is a habit forming drug. That's all it is, for the artist, for the collector, for anybody connected with it. Art has absolutely no existence as veracity, as truth. People always speak of it with this great religious reverence, but why should it be so revered? It's a drug, that's all. The more I go on, the more I'm convinced of it. The onlooker is as important as the artist. In spite of what the artist thinks he is doing, something stays on that is completely independent of what he intended, and that something is grabbed by society —if he's lucky.

The artist himself doesn't count. Society just takes what it wants. The work of art is always based on these two poles of the maker and the onlooker, and the spark that comes from this bi-polar action gives birth to something, like electricity. But the artist shouldn't concern himself with this because it has nothing to do with him— it's the onlooker who has the last word. Fifty years later there will be another generation and another critical language, an entirely different approach. No, the thing to do is try to make a painting that will be alive in your own lifetime. No painting has an active life of more than thirty or forty years—that's another little idea of mine. I don't care if it's true, it helps me to make that distinction between living art and art history. . . .

As a drug it's probably very useful for a number of people, very sedative, but as religion it's not even as good as God.

<div align="right">From *The Bride and the Bachelors* by Calvin Tomkins (1965)</div>

Giorgio de Chirico

(1888–)

He had no analytical intention and no logical apti-
tude: he used perspective, for example, not with a rep-
resentational purpose, but for its emotional effect. The
objects in his paintings are usually isolated, properties
of an imaginary stage, and they are so disposed that
they create a sense of expectancy, of drama. But there
is no sense of deliberation in his compositions, and
one must suppose that the images came into his inner
vision with a trance-like spontaneity.

<div align="right">

HERBERT READ

</div>

THE PAINTING OF THE FUTURE

To be really immortal a work of art must go completely beyond the limits of the human: good sense and logic will be missing from it.

In this way it will come close to the dream state, and also to the mentality of children.

What is needed above all, is to rid art of all that has been its familiar content until now; all subject, all idea, all thought, all symbol must be put aside. If I still accept something of Max Klinger, it is not as a thinker, a symbolist, or a scholar; it is because he *invented* something which had not previously existed, something that can be seen in fragments here and there. Only he did not have the force to *understand* the inner recesses of the heart; that corner which is the most profound, the most mysterious, and finally the truest, to look only into this corner, and to see only through this corner.

To have the courage to *give up* all the rest. There is the artist of the future: someone who renounces something every day, whose personality daily becomes purer and more innocent. For even without following in someone else's footsteps, as long as one is subject to the direct influence of something someone else *also knows,* something one might read in a book or come upon in a museum, one is not a creative artist as I understand the term. Above all, what is needed is great confidence in oneself. The revelation we have of a work of art, the conception of a picture *must* represent something which has sense in itself, has no subject, which from the point of view of human logic *means nothing at all.* I say that such a revela-

DE CHIRICO: *The Great Metaphysician*. Collection, The Museum of Modern Art, New York (The Philip L. Goodwin Collection).

tion (or, if you like, conception) must be felt so strongly, must give us such joy or pain, that we are obliged to paint, impelled by a force greater than the force which impels a starving man to bite like a wild beast into the piece of bread he happens to find.

That is what the painting of the future must be.

From *Notes on Painting*, by de Chirico (1911–15)

221

*Naum Gabo**

(1890–)

*Who has not stood speechless before the perfect plas-
tic beauty of certain plaster casts stored on the shelves
of the department of mathematics in some faculty of
sciences? Yet these objects are nothing else than straight
geometric models, unless they represent the concrete
development, in space, of some algebraic formula
whose intelligibility thus becomes perceptible to sense:
No wonder, then, that we can now see them, or very
similar ones, no longer as mathematical models, but as
works of art, in the* Development of the Column *of
Pevsner, in the* Spiral Theme *of Naum Gabo.*

<div align="right">

ÉTIENNE GILSON
</div>

ON CONSTRUCTIVE REALISM

I ascribe to art a function of a much higher value and put it on a
much broader plane than that somewhat loose and limited one we
are used to when we say: painting, sculpture, music, poetry, etc.

I hold that art has a supreme vitality, second only to the su-
premacy of life itself, and that it therefore reigns over all man's
creations.

I denominate by the word "art" the specific and exclusive faculty
of man's consciousness to conceive and represent the world external
to him and within him in form and by means of artfully constructed
images—conceptions.

Moreover, I maintain that this faculty predominates in all the
processes of our mental and physical orientation in this world of
ours; it being impossible for our consciousness to perceive or ar-
range or act upon our world and in our life in any other way but
through these constructions of an ever-changing yet coherent chain
of images—conceptions.

Furthermore, I maintain that these consciously constructed
images are the very essence of the reality of the world which we are
searching for.

Consequently, I go on to maintain that all the other constructions
of our consciousness, be they scientific, philosophical, or technical,
are but arts disguised in the specific forms of their peculiar disci-
plines.

<div align="center">

From the Trowbridge Lecture, by Naum Gabo (1948)
</div>

*Naum Pevsner changed his name to Naum Gabo in 1915 so as not to be con-
fused with his brother Nikolaus Pevsner. Together the two brothers issued the
Constructivist Manifesto, in Moscow, on August 5, 1920.

Mark Tobey

(1890–)

*Mark Tobey is much older than Pollock or de Koon-
ing but, like them, he first won general recognition
after World War II. He has studied Chinese art and,
living on the West Coast, looks across the Pacific to a
tradition of abstract calligraphy more subtle and an-
cient than the mysticism of color through which Kan-
dinsky strove for "spiritual harmony."*

ALFRED H. BARR, JR.

TODAY AMERICA MUST LOOK TOWARD ASIA

Our ground today is not so much the national or the regional
ground as it is the understanding of this single earth. The earth has
been round for some time now, but not in man's relations to man or
in the understanding of the arts of each as a part of the roundness.
As usual we have occupied ourselves too much with the outer, the ob-
jective, at the expense of the inner world wherein the true roundness
lies.

Naturally, there has been some consciousness of this for a very
long time, but only now does the challenge to make the earth one
place become so necessarily apparent. Ours is a universal time and
the significances of such a time all point to the need for the univer-
salizing of the conscious and the conscience of man. It is in the aware-
ness of this that our future depends unless we are to sink into a uni-
versal dark age.

America more than any other country is placed geographically to
lead in this understanding, and if from past methods of behavior
she has constantly looked toward Europe, today she must assume her
position, Janus-faced, toward Asia, for in not too long a time the
waves of the Orient shall wash heavily upon her shores.

All this is deeply related to her growth in the arts, particularly
upon the Pacific slopes. Of this I am aware. Naturally my work will
reflect such a condition and so it is not surprising to me when an
Oriental responds to a painting of mine as well as an American or a
European.

From a statement by Mark Tobey (1946)

223

Edwin Dickinson

(1891–)

A major American artist whose work is not widely known to the public, even though he has been painting steadily and masterfully for almost fifty years. . . . His art does not fit any of the easy categories. It is modern but grounded in tradition, representational but not realistic, and its subject matter, though always identifiable, is somehow mysterious.

Horizon

ON MY WAY OF PAINTING

I am a painter in oil. I have painted many landscapes *premier-coup* in America and Europe. These I either keep or destroy, but I never work on them more than once. Since 1915 I have painted large figure compositions, working on them from one hundred to four hundred sittings each. No preliminary drawings were made for these compositions, nor were objects to be represented planned before starting. It was always intended, however, that human models, as well as other things, were to be painted. Plans that preceded even the stretching of the canvases included predetermination of the keys, the stretch of values, the color schemes, the number and grouping of the spots, their sizes and their shapes and their variety. When any carefully painted passage was found to be hindering the development of a composition, it was removed and, in time, a better passage was painted in its place. This practice of eliminating and repainting accounted in part for the many sittings which were felt to be requisite. After working on a composition two years or more, my own development during that period made keeping the painting up to date, as it were, impossible. After years of work on it, a painting could not be quite completely reorganized, nor thrown away, so I often felt forced to stop work on it and to begin another. Very pleasing and exhilarating, too, was always the commencement of a new composition, unburdened with the dissatisfactions of the old one.

From a statement by Edwin Dickinson (1963)

George Grosz

(1893–1959)

The most devastatingly satirical artist of his era, he castigated unmercifully the evils left in Germany in the wake of the First World War.

ERWIN O. CHRISTENSEN

THE WORLD OF REALITY AND THE INNER VISION

Line does not exist in nature. Line is an invention of man; so, in fact, is all drawing. Line, drawing, and writing are interrelated. The signature and other descriptive material that often accompany the drawings of the old masters have no independent existence as writing, apart from the drawing itself; they form part of the whole conception. This idea is well illustrated in certain drawings of old masters like Dürer, Altdorfer, and Mantegna. It is illustrated even more strikingly in Oriental drawings, where line and writing blend to form an indissoluble whole.

There must have been a reason for the invention of line. Yes, it is a guide for those who would venture into the formlessness that surrounds us on every side; a guide that leads us to the recognition of form and dimension and inner meaning. It is like the thread Adriadrie gave Theseus before he ventured into the mysterious recesses of the Labyrinth. Line guides us when we would enter the Labyrinth of the countless millions of natural objects that surround us. Without line we would be soon lost: never would we be able to find our way again out of the maze.

Let us then follow line whithersoever it may go. It may lead to something quite definite and precise—a landscape, or a human face or figure. Or it may lead to the subconscious—the land of Fantasy, where fancy roams where it will.

Fanatasy may be uninhibited fancy, which has no contact with the world of reality. But it may also lurk beneath a simple object in nature, like a tree or a rock or a sand dune. In fact it is almost everywhere if you can penetrate deeply enough beneath the husk of things. For, after all, nature is not simply the sum total of animate and inanimate objects. There is more to a tree or a rock or a sand dune than the mere outer appearance of reality. After many a prayer the angel might appear and perhaps the everlasting mystical truth hidden beyond our catalogue-minded conception of nature. As the great Dürer once said: "Art is embedded in nature; he who can pluck it out possesses it."

GROSZ: *Metropolis*. Collection, The Museum of Modern Art, New York.

The last century laid a great deal of emphasis on the outer world of reality but neglected the inner world. And so it is that today, when the search for inner truth again possesses the soul of man, we feel spiritually more akin to the painters of the Middle Ages than to the realistic draftsmen who lived in the days of our grandfathers. A

drawing by Pisanello or Grünewald is not a mere blueprint; it may be either sketchy or complete, but it will always be a spiritual organism.

Now line, as I have pointed out, is an invention—a product of the brain and soul of man. It is perfectly logical and natural, then, that to the lines that we find in nature we should add other lines that are the product of our inner vision. Such drawing can present both the outer husk and the inner essence. It is infinitely superior to the machine that we call the camera. You cannot take a camera with you into your dream world. No camera has ever been invented —or will be invented—that can give a flawless mechanical record of your daydreams or your inner visions.

From my early childhood days I liked to draw. Where did I draw? What media did I use? It matters little that I made my first drawings with white chalk on a blackboard and that later I did charcoal sketches after plaster casts at the Academy. The entire artistic life of a painter is a story of steady growth—of constant curiosity, observation and research. In the story of growth everything is significant, even the first faltering steps of artistic childhood. An artist's mature work often displays a certain adult naïveté. . . .

You will note that, generally speaking, though I give free rein to my fancy, I have not neglected the outer shell of things. The utter rejection of reality is a perilous matter. Totally abstract fancy has a tendency to become stylized and conventional. Look, for example, at the drawings of Aubrey Beardsley, who had such a tremendous vogue around 1900, and you will see what I mean. Abstract fancy that becomes pure convention is as much to be shunned by the artist as the slavish copying of nature.

The searcher after Fantasy should not avoid reality; he should know how to present the outer appearance of things together with their inner content. The early Italian painters possessed this faculty to an exceptional degree. They created an inner world, yet left the exterior shell of reality intact.

I have always sought as models the various forms that nature takes; yet never did I approach the task with such zest and self-confidence as in America. . . . In former days, when I essayed political and social satire, I often felt its limitations. In portraying and satirizing the events of the day, the comedies and tragedies of the passing scene, the artist is like a fiddler scraping on too small a violin. There is only a small place in great art for the quips and digs and innuendo of the satirist. In all humility I offer you the evidence that I have outgrown the satirical phase of my artistic development.

From *George Grosz Drawings*, by George Grosz

Charles Burchfield

(1893–1967)

A painter of memories in an era of anticipation.
JAMES THRALL SOBY

No other American artist, since the mid-nineteenth century, has approached nature more closely, expressed her moods more imaginatively, or found in her presence a greater spiritual force.
JOHN I. BAUR

THE BARREN ROAD OF DECORATION

I would just as soon not comment on the arts of today other than to say that I think any comment is futile; when a decadence sets in, and really gets rolling, there is nothing that can stop it; it must run its course before a renaissance can begin.

I can't possibly see what a course in design would do for an artist if he did not also have *academic* training in life drawing, still life, and composition—in fact, the renaissance in the arts I mentioned will be impossible unless these subjects are restored to the artist's training. Otherwise we will continue on the barren road of decoration most artists are now traveling. Thank God there are a few individualists who refuse to conform.

AN ARTIST DOES NOT TRY TO BYPASS NATURE

An artist must paint, not what he sees in nature, but what is there. To do so he must invent symbols, which, if properly used, make his work seem even more real than what is in front of him. He does not try to bypass nature; his work is superior to nature's surface appearances, but not to its basic laws.

From two statements by Charles Burchfield (1959, 1963)

Joan Miró

(1893–)

The abstract paintings of Joan Miró incorporate aspects of biological imagery which lend them a weird and disturbing humor. Intensive work in collage in various mediums as a study in forms and textures led Miró to a greater simplification of shapes, with stress on the curved lines and amoeba-like organisms which seem to float in an immaterial space.

HELEN GARDNER

THE STATE OF PAINTING TODAY

Q. Who are your favorite old masters or schools of painting?

A. My favorite schools of painting are as far back as possible: the cave painters—the primitives. To me the Renaissance does not have the same interest. But I have a great respect for the Renaissance. In the work of Leonardo da Vinci I think of the *"esprit"* of painting. And in the work of Paolo Ucello, it is the plasticity and structure which interest me. This, I think, happens often in painting. Some painters are better for the spirit and the force they represent. And other painters one likes because they are better as painters. With me, I find that I like Odilon Redon, Paul Klee, and Kandinsky for their "esprit." As pure painting—from the point of view of plasticity—I like Picasso or Matisse. But both points of view are important.

Q. Today there are many kinds of painting. In the older epochs, the Egyptian, the Greek, the Renaissance, there was more or less one kind of painting in each period. Why is that?

A. There are always different kinds of painting in an epoch. What we see in the museums today is only the résumé of what has come through all the others.

In a period of transition (like the present), where there are many different efforts and views, one finds many trends in art. It is for this reason that I isolate myself from others in order to see clearly. I regard the past and I work with the future in mind as well.

Q. What do you think is the direction that painting ought to take?

A. To rediscover the sources of human feeling.

Q. Why is painting so esoteric today?

A. We live in a period of transition. It is necessary to make a revision of everything that has been done.

Q. How do you like the painting in America? I mean the younger, forward-looking painters?

A. Yes, I understand. I admire very much the energy and vitality of American painters. I especially like their enthusiasm and freshness. This I find inspiring. They would do well to free themselves from Europe's influence.

<div align="right">From an interview with Miró (1947)</div>

Stuart Davis

(1894–1964)

Davis uses scraps of lettering or abstract words and phrases to give an abrasive, contemporary quality to a painting, the shock of a suddenly evoked, everyday reality in the midst of an abstract pictorial scheme. At other times letters are identified with the individual and his emotions in an anonymous urban environment. . . .

Davis's art is one of the few links of continuity between America's first phase of advanced art and contemporary experiment. While his expression is no longer related in style or aims to present-day abstraction, in the thirties it provided a useful frame of reference and a point of support for many of the young artists who were beginning to move toward abstraction.

<div align="right">SAM HUNTER</div>

I ALWAYS THOUGHT A PAINTING WAS A "FIGURE"

I have always held that a painting has effective public currency as an independent object, not a subjective reflection of one. The *content* of the best *art* corresponds to the freshness of subjective experience that initiated it, but communicates in an objective visual grammar and syntax. Art of this kind doesn't wear out because it is based on the gift of pleasurable response to simple things in daily

life, a faculty shared by most people. These remarks constitute a fast run-down on an attitude, not a philosophical pretension. . . .

Recently voices have been raised in some quarters to the effect that there is a plethora of Abstract Art of all kinds. A call has been put out that "The Figure" should be returned to art. I will be frank in admitting that I never knew that it had been omitted. I always thought a painting was a "Figure." I can understand the possibility of a touch of ennui and irritability under the massive impact of current art exposure, but the suggested "cure" seems irrational. It appears rather as a prescription by a witch doctor with the talent and wit left out.

Actually, the weighty panorama of American painting today is the greatest in our history, qualitatively speaking. A collation of previous panoramas would make this apparent. Individual works of distinction remain just that and are the signs by which people are reminded to distinguish between statistical résumés and art.

From a statement by Stuart Davis (1961)

DAVIS: *Flying Carpet.* Collection, The Museum of Modern Art, New York.

Chaim Soutine

(1894–1943)

Everything dances around me as in a landscape by Soutine.

MODIGLIANI

It bends and shakes his figures as though they had St. Vitus's dance. Harmonious still lifes, flowers and fruits, it reduces to rags and tatters. Houses oscillate on their foundations and move ardently hither and thither in the landscape, turning it topsy-turvy as in a series of seismic shocks.

WALDEMAR GEORGE

LETTER TO ZBOROWSKI

1923

I have received the money order. I thank you. I am sorry not to have written you sooner about my work.

It is the first time in my life that I have not been able to do anything.

I am in a bad state of mind and I am demoralized, and that influences me.

I have only seven canvases. I am sorry. I wanted to leave Cagnes, this landscape that I cannot endure. I even went for a few days to Cap Martin, where I thought of settling down. It displeased me. I had to rub out the canvases I started.

I am in Cagnes again, against my will, where, instead of landscapes, I shall be forced to do some miserable still lifes. You will understand in what a state of indecision I am. Can't you suggest some place for me. Because, several times, I have had the intention of returning to Paris.

Yours,
SOUTINE

David Alfaro Siqueiros

(1898–)

*Siqueiros is the wonderful synthesis between mass
conception and the individually perceived representation of it.*

SERGE EISENSTEIN

If Orozco be the critical voice of this movement,
and Rivera its genial historical interpreters, Siqueiros
is the flame of enthusiasm, restless and turbulent,
which points out to posterity its obligation to continue
on in the direction indicated by the Mexican Revolution, but which he considers a stage rather than a goal.*

FERNANDO GAMBOA

ON ART WITHOUT AN IDEOLOGICAL FUNCTION

An art without an ideological function, in spite of the genius of
its creator—or more specifically its maker—changes the artist progressively and inevitably into a juggler for the society of "ladies
and gentlemen" . . . inasmuch as the generator governs the force
of the current.

ON THE PROFOUND SENTIMENT OF
THE PROFESSIONAL

We oppose the proverb "The painter is born, not made." In its
place we present the following: "The painter is born without any
doubt, inasmuch as his faculty is emotive . . . but it is later that he
is made or destroyed." Thus, we endeavor to put an end to instinctivism, to the somnambulistic method, as the exclusive motive for
the production of representative plastic arts . . . and for that we
do no more than return to the classics.

ON THE SIGNIFICANCE OF
MODERN MEXICAN PAINTING

Mexican painting is the only international impulse with a theory, though perhaps very juvenile, being the rudimentary theory of a
movement that is just beginning, but a theory and a vital theory
at all events. Further, it is the only international modern movement
that puts its theory into practice; a practice with all the contradic-

* The so-called "new realism."

tions that are inevitably found in periods of transition, still lacking forms and styles integrally its own, with everything mixed. But this is natural in such processes of development, before it reaches "its own Gothic cathedral." A movement, although still in the stammering stage, that has not yet developed its own eloquence and its own attitude, but one that undoubtedly has an open road ahead . . . the only road that functionally conveys at once the social equivalent of that which today we are able to call a new realism, the new humanism of the present and of the immediate future, and, as a later goal, of a new classicism.

<div align="right">From statements by Siqueiros (1951)</div>

Jean Dubuffet

(1901–)

Possibly the most original painter to have emerged in Paris since the war is not abstract in his art. A man of exceptional intelligence and maturity, Jean Dubuffet combines a childlike style with bold innovations in surface handling and a grotesque sense of humor.

ALFRED H. BARR, JR.

ON MY PAINTING

I believe more and more that my paintings of the previous years avoided in subject and execution specific human motivations. To paint the earth the painter tended to become the earth and to cease to be a man—that is, to be a painter. In reaction against this absenteeist tendency my paintings of this year put into play in all respects a very insistent *intervention*. The presence in them of the painter now is constant, even exaggerated. They are full of personages, and this time their role is played with spirit. It seems to me that in the whole development of my work there is a constant fluctuation between bias for personages and bias against them. Besides I should mention that the imitations, developments, and variations which have been made from my paintings of the "materiologic" type by so many painters in these last years have contributed, no doubt, to turning me from this path and sending me in the opposite direction. My *Hautes Pâtés* of 1945 and the following years, then my *Sols et Terrains* of 1951 and 1952, had at the time an

DUBUFFET: *Snack for Two*. Collection, The Museum of Modern Art, New York (Gift of Mrs. Saidie A. May).

extraordinary and supernatural character which enchanted me. However, they no longer have this power for me, now that one finds in the windows of all the art galleries of the world paintings stemming from the same spiritual positions, and which have more or less borrowed their themes, style, color, and composition. I feel a need that every work of art should in the highest degree lift one out of context, provoking a surprise and shock. A painting does not work for me if it is not completely unexpected. Hence my new concern, which at least gives me the satisfaction of being taken to territory where no one else has been.

From a statement by Dubuffet (1961)

Philip Evergood

(1901–)

Although every painting is representational, nothing is real. The weak are emaciated. The strong are bullies. His men have enormous biceps. His flowers are way out of proportion to the people around them. There is a deliberate distortion of perspective and exaggerated stylized treatment, both of which give his works a feeling of helpless innocence.

SAMUEL BEIZER

THE FINISHED PRODUCT SHOULD BE INVIGORATING

In my paintings I aim to be simple and clear. As to the meaning, it speaks rather bluntly. If the paint is handled as bluntly as the idea, one could be lacking in a plastic interest and pictorial mystery. When the idea and mood of a picture are conceived strongly, directly, this does not negate the use of understatement and even the presence of unexplained passages and the juxtaposing of elaborate minutiae with them, if that is deemed necessary.

The finished product should be invigorating in some way and unstaid as Nature is itself. A mountain holds great excitement for the eye and the senses because the simple magnitude and sheer blocks and masses run together with the myriad details of crumbling rock, crag, foliage, into a combination of broken passages over one monolithic shape.

It is the same variety which a forest has—a bird—any animal.

And Man has the same diversity of texture and form in his make-up as almost anything else, but here something indescribable has been added. One might call it inner energy which is reflected in the expression. Thus Man is a special challenge to the artist. I am predominantly interested in People.

REALISM OR REPRESENTATIONALISM WILL NEVER BE OUTMODED

We who deal with subject matter are expressing our personalities, our tastes, and our talents in that direction. Realism or representationalism will never be outmoded, nor does it ever deserve the epithet "archaic" with which it is labeled sometimes by the stupid and the ignorant.

Representations will never be replaced by something new because new minds add phases to it, just as the violin will always remain an instrument because it supplies a need—a special beauty—a quality in music which nothing else can replace. I think that people will always be eager to see art that deals with the forms of nature, with man, with animals, with trees, art which tries to express the varying moods of nature, the human values and emotions.

Let the theorists theorize and the avant-garde-ists "lead." Let the monuments grow to the most stupendous and awe-inspiring dimensions which money and power can produce, fancifully fulfilling the aggrandizements of this or that sect in art.

Any art which has imagination, has the "magic touch" and expresses universal truths which man can feel and understand, is valid—is Art. Only people and time will decide what is great. As far as being "lasting" in our present stage of the atomic age, only the diplomats and the military leaders will decide what is to last.

From two statements by Philip Evergood (1963, 1961)

Robert Gwathmey

(1903–)

Gwathmey's message is one of protest, social comment and indignation through the voice of art.
ROLAND F. PEASE, JR.

BEAUTY COMES FROM
STRUCTURAL COHERENCE

Art itself is produced, in part, from the compulsion to express, a unique attribute of man. It is a desire to find and separate truth from the complex of lies and evasions in which he lives. Something that the artist necessarily thinks worthy of recording. The artist, working free of compromise and out of his experience and philosophical convictions, dominates his subject. All of this promotes a sharing of valued emotional experiences and recalls man to his cultural ideals. The formal aspects, the conventions of the craft, as well as the history, are all essential to the understanding of art. This knowledge, if isolated, however, becomes static, and external pe-

culiarities assume exaggerated proportions. Time, place, origin, and rarity take precedence over depth of understanding. Within the narrow historical approach the intellectual and the esthetic are equated, taste becomes confused with fashion, and the whole becomes fragmented. To pretend to separate subject from artistic intention is to infringe upon the basic structure, to deny its anatomy.

Art is the conceptual solution of complicated forms, the perceptual fusion of personality, not humble ornamentation of surface pyrotechnics. Beauty never comes from decorative effects but from structural coherence. Art never grows out of the persuasion of polished eclecticism or the inviting momentum of the band wagon.

From a statement by Robert Gwathmey (1963)

GWATHMEY: *Clearing*. Collection of Mr. Armand G. Erpf.

Mark Rothko

(1903–1970)

Rothko's painting style has evolved from a realist mode in the thirties to the grave and monumental inventions of the present day. He showed his first original style in the early forties, under the influence of the international Surrealist movement. . . . Then in 1947 Rothko eliminated recognizable forms defined by lines, building up his surfaces with irregular color stains, high in key, which formed a complex of distinct, segmented areas.

SAM HUNTER

THE ROMANTICS WERE PROMPTED

I think of my pictures as dramas: the shapes in the pictures are the performers. They have been created from the need for a group of actors who are able to move dramatically without embarrassment and execute gestures without shame.

Neither the action nor the actors can be anticipated, or described in advance. They begin as an unknown adventure in an unknown space. It is at the moment of completion that in a flash of recognition they are seen to have the quantity and function which was intended. Ideas and plans that existed in the mind at the start were simply the doorway through which one left the world in which they occur.

The great cubist pictures thus transcend and belie the implications of the cubist program.

The most important tool the artist fashions through constant practice is faith in his ability to produce miracles when they are needed. Pictures must be miraculous: the instant one is completed, the intimacy between the creation and the creator is ended. He is an outsider. The picture must be for him, as for anyone experiencing it later, a revelation, an unexpected and unprecedented resolution of an eternally familiar need.

ON SHAPES

They are unique elements in a unique situation.

They are organisms with volition and a passion for self-assertion.

They move with internal freedom, and without need to conform with or to violate what is probable in the familiar world.

They have no direct association with any particular visible experience, but in them one recognizes the principle and passion of organisms.

From an article by Mark Rothko (1947)

Salvador Dali

(1904–)

*Dali has endowed surrealism with an instrument of
primary importance, in particular the paranoiac criti-
cal method, which has immediately shown itself capa-
ble of being applied with equal success to painting,
poetry, the cinema, to the construction of typical sur-
realist objects, to fashions, to sculpture and even, if
necessary, to all manner of exegesis.*

ANDRÉ BRETON

THE PARANOIAC CRITICAL METHOD

I believe the moment is at hand when, by a paranoiac and active
advance of the mind, it will be possible (simultaneously with auto-
matism and other passive states) to systematize confusion and thus
to help discredit completely the world of reality.

Paranoia uses the external world in order to assert its dominating
idea, and it has the disturbing characteristic of making others ac-
cept this idea's reality. The reality of the external world is used for
illustration and proof, and so comes to serve the reality of our
mind.

From a statement by Dali

DEFINITION OF SURREALISM*

Hand-done color "photography" of "concrete irrationality" and
of the imaginative world in general.

From *Philosophic Provocations,* by Dali

* At the last important Dada show in Paris, in June 1922, André Breton and the
Dadaist leader Tristan Tzara opposed each other. After Breton's victory, he suc-
ceeded in drawing important French, Swiss, and German Dadaists into his camp.
In 1924, the First Surrealist Manifesto was published. In the Manifesto, Breton
defined his belief: "I believe in the future transmutation of those two seemingly
contradictory states, dream and reality, into a sort of absolute reality, of sur-
reality, so to speak. I am looking forward to its consummation, certain that I
shall never share in it, but death would matter little to me could I but taste the
joy it will yield ultimately."
Because the surrealist movement concerned itself with literature and politics
as well as the arts (in 1925, Breton allied it with communism), there were numer-
ous intellectual disputes among the members of the new movement. One of the
major reasons why Surrealism collapsed, as a movement, in the thirties was be-
cause, ideologically, it could not align itself with Stalinist orthodoxy. However,
individual artists continued to work in the surrealist spirit.
Among the artists who were associated with the movement from its early years,
in one way or another, were: Tanguy, Ernst, Arp, Masson, Matta, Dali, Seligmann,
and others.

240

Willem de Kooning

(1904–)

Willem de Kooning's rise to his role as abstract ex-pressionism's most influential painter began immedi-ately after his first one-man exhibition in 1948. . . . De Kooning is an inventor. One line swirls and angu-lates, meets itself, interacts, forms shapes. Other lines join in. The shapes begin to relate and interact and, by 1959, are forgotten or converted to areas flooded with color; thin but rich hues and colors; color over color; color in color; color that expands space, defines areas.

DANIEL ABRAMSON

THERE IS NO STYLE OF PAINTING NOW

Spiritually I am wherever my spirit allows me to be, and that is not necessarily in the future. I have no nostalgia, however. If I am confronted with one of those small Mesopotamian figures, I have no nostalgia for it, but, instead, I may get into a state of anxiety. Art never seems to make me peaceful or pure. I always seem to be wrapped in the melodrama of vulgarity. I do not think of inside or outside—or of art in general—as a situation of comfort. I know there is a terrific idea there somewhere, but whenever I want to get into it, I get a feeling of apathy and want to lie down and go to sleep. Some painters, including myself, do not care what chair they are sitting on. It does not even have to be a comfortable one. They are too nervous to find out where they ought to sit. They do not want to "sit in style." Rather, they have found that painting—any kind of painting, any style of painting—to be painting at all, in fact—is a way of living today, a style of living, so to speak. That is where the form of it lies. It is exactly in its uselessness that it is free. Those art-ists do not want to conform. They only want to be inspired.

The group instinct could be a good idea, but there is always some little dictator who wants to make his instinct the group instinct. There *is* no style of painting now. There are as many naturalists among the abstract painters as there are abstract painters in the so-called subject-matter school.

From a statement by Willem de Kooning (1951)

SOMETIMES I GO THROUGH
PERIODS OF REAL DESPAIR

Whatever I see becomes my shapes and my condition. The recognizable forms people sometimes see in the pictures after they're painted, I see myself, but whether they got there accidentally or not, who knows? . . .

I will admit to you frankly that I want to be on the artistic band wagon. Sure, sometimes I go through periods of real despair, look at my picture, and say to myself, "What the hell am I doing?" But to go back to scratch—what scratch? As an artist I am what I am now, and couldn't possibly go back to representation, to the academy, which was where I started. In Holland I was a full-fledged member of the academy at twelve.

From an interview with Willem de Kooning by Selden Rodman (1956)

DE KOONING: *Woman II* (1952). Collection, The Museum of Modern Art, New York (Gift of Mrs. John D. Rockefeller, III).

Arshile Gorky

(1904–1948)

*When Jackson Pollock, Hans Hofmann, Arshile
Gorky and a number of their contemporaries sought
in the early years of World War II to emancipate
themselves both from the closed world of geometric
abstraction and from the image-suggestion of represen-
tational and Surrealist art, they suddenly found them-
selves in an unfamiliar territory, bereft of conven-
tional signposts or prescribed procedures. They had
arrived at the unknown somewhat in the spirit of
abnegation, but they conferred on their renunciation
of the past, positive values of freedom and spontaneity.
Free invention became its own justification and the
picture plane, the physical reality of surface in all its
concreteness, became its own mythology. The function
of the image was reversed; it was detached from all
objects in the external world, and became instead a
vital graph of the artist's own operations; it reflected
the self-sufficiency of the creative art.*

SAM HUNTER

PAINTING THE AIRPORT MURAL

The architectonic two-dimensional surface plane of wall must be
retained in mural painting. How was I to overcome this plastic
problem when the subject of my murals was that of the unbounded
space of the sky-world of aviation? . . . The problem resolved it-
self when I considered the new vision that flight has given to the
eyes of man. The Isle of Manhattan with all its skyscrapers from the
view of an airplane five miles up becomes but a geographical map, a
two-dimensional surface plane. This new perception simplifies the
forms and shapes of earth objects. The thickness of objects is lost
and only space occupied by the objects remains. Such simplifica-
tion removes all decorative details and leaves the artist with limita-
tions which become a style, a plastic invention, particular to our
time. How was I to utilize this new concept for my murals?

In the popular idea of art, an airplane is painted as it might
look in a photograph. But such a hackneyed concept has no archi-

GORKY: *Agony*. Collection, The Museum of Modern Art, New York
(A. Conger Goodyear Fund).

tectural unity in the space that it is to occupy nor does it truthfully represent an airplane with all its ramifications. An operation was imperative, and that is why in the first panel of "Activities on the Field" I had to dissect an airplane into its constituent parts. An airplane is composed of a variety of shapes and forms and I have used such elemental forms as a rudder, a wing, a wheel, a searchlight, etc., to create not only numerical interest, but also to include within a given wall space plastic symbols of aviation. These plastic symbols are the permanent elements of airplanes that will not change with the change of design. . . .

To add to the intensity of these shapes, I have used such local colors as are to be seen on the aviation field, red, blue, yellow, black, gray, brown, because these colors were used originally to sharpen the objects against neutral backgrounds so that they could be seen clearly and quickly.

From a statement by Arshile Gorky

244

Clyfford Still

(1904–)

*Shortly after World War II, Clyfford Still emerged
as the leader of that sudden, vital—and unprecedented
in this country—upsurging of exceptional creative
energy and productivity. His work and his influence
in this particular American revolution have been of
the utmost importance in art history since that time.*

GORDON M. SMITH

A STATEMENT

. . . Of course, trouble began when my paintings were first pub-
licly seen. The professionals complained that they were without
precedent; or that they gave evidence of traditional things misunder-
stood. Aesthetic, political, even religious offense was apparent! To
make assault plausible crypto–Christian moralities were applied to
me in terms brashly devised to misinterpret every facet of my life
and meaning. Judgment was given and published.

The compliment was returned. Because now I had proof that my
years of painting and deliberation had not been wasted. Only, the
work had to be carried on in aloneness and with ruthless purpose.
I had learned as a youth the price one pays for a father, a master, a
Yahweh, or his contemporary substitute—an Institutional Culture.
But the crime was compounded. To sin against the *Order* in the
lighted arena was no deep offense; one could be dealt with—analyzed,
neutralized, or encysted. But for one to defy the laws of Control, in
the silence of the catacombs, with the canon instrument of aggran-
dizement—for this more than correction was needed—this was treason!

Here was I free and here was I betrayed by my failure to with-
draw completely from those who knew me. Surely that which they
found of interest should be shared with others. That the "others"
responded with resentment or fear only stimulated their desire to
justify their interest. Always in terms that would convince. Rational,
artistically adequate, socially acceptable terms. Reminding my de-
fenders that their efforts bore the germs of negation of all that gave

those canvases meaning and purpose for me, I was made aware that the professionals had caught the odor of a latent power, smelled qualities that could be exploited.

For these conceptions could be perverted into pretentious exercises in design, parodied as socio-aesthetic devotions, or mauled into psychotic alibis expedient for ambition or intellectual impotence. The elements of my paintings, ineluctably co-ordinated, confirmed for me the liberation of the spirit. In the hands of unscrupulous and calculating men it was readily apparent that these elements could be segregated and evacuated to intimidate the mind, blast the eyes with hatred, or seduce with insipid deceit.

Meanwhile, literary frustrates, and political aficionados posing as painters, leapt forth to affirm their dedication to Progress, People, Peace, Purity, Love, or the *avant-garde*. Examples purporting to be my antecedents were hauled out and indiscriminately compared with my work. Fatuous generalizations obscured every particular. Thus the genesis of a liberating absolute was buried under a blanket of historical inanities.

I have been told, to my considerable amusement, that my personal departure from New York City was hailed by many remaining there as "a victory for their Establishment." Certainly, acquiescent replacements from coast to coast—ex-students and perennial imitators alike—were happily hustled forth to deny that I had ever existed. So was authority restored to the institution of Art; and the crafting of histories resumed by those who would starve should their hoax be exposed. A Pyrrhic charade.

Let it be clearly understood that my relation to that contemporary Moloch, the Culture State, has not been altered. In its smothering omnipresence there is no *place*, ideologically or practically, for anyone who assumes the aspiration by which birth was given to the paintings reproduced in this catalogue.

From *Clyfford Still*, The Buffalo Fine Arts Academy, Buffalo, N.Y. (1966)

STILL: *1946-E,* Courtesy of the Marlborough Gallery, New York.

Peter Blume

(1906–)

The American artist literally closest to Surrealism has been Peter Blume. His earliest paintings . . . combined free association, fantastic imagery, and the precisionist surfaces of Sheeler and the "Immaculates." * *. . . He paints with the scrupulous care of a fifteenth-century craftsman, and he is an astonishing technician.*

<div align="right">SAM HUNTER</div>

TELLING STORIES IS A PRIMARY FUNCTION OF THE PLASTIC ARTS

Since I am concerned with the communication of ideas, I am not at all ashamed of "telling stories" in my paintings, because I consider this to be one of the primary functions of the plastic arts. Visual or pictorial images are as much a part of the material of a painter as the color, shapes, and forms he uses. They have, moreover, a unique quality which is as distinct from verbal language as the senses are from one another. They must be used plastically in order to evoke the "total image" which a painting is capable of.

Modern esthetics has stripped painting of this quality almost with repugnance. Any sophisticate now knows that there is no more devastating criticism of a picture than "illustrative" or "literary." Personally, I believe in expanding the range of experience in art rather than contracting it. I would like to see the quality of light, now almost lost, as Caravaggio developed it, integrated once more in painting. I would like to see illusion, illusion of space, texture, and reality, restored again as another one of the mysteries in the art of painting, which makes it really unique. On the critical level I would like to see a general reappraisal of values which would reduce the cult of primitivism and "innocence" to its proper perspective. Finally, I would like to see a fresh interest in the human gesture, with all its infinite variations and subtlety. This offers the most challenging material for the artist. Why not use it?

<div align="right">From a statement by Peter Blume (1963)</div>

* Sometimes called "Precisionists," a number of artists just before and after 1920 began to apply the principles of abstract design and a feeling for mechanical functionalism to the subject matter of the American industrial scene (Sam Hunter).

Balthus (Baltusz Klossowski)

(1908–)

For over thirty years he has worked in a style that is in direct opposition to contemporary trends. . . . For him the important thing is to rediscover the lost means which enables the painter to transpose his inner vision directly onto the canvas. A simple return to tradition is not enough.

<div style="text-align: right">GEORGES BERNIER</div>

REFLECTIONS ON PAINTING

Balthus says that for him "a landscape must be literal; the more depersonalized the artist becomes, the better he can arrive at that stage of knowledge and understanding which was the province of the painters of ancient China."

Sometimes his conversation expresses discouragement. He is inclined to say that "it is impossible to paint a good portrait today, that the last great portraits were made by Renoir and Bonnard."

BALTHUS: *Joan Miró and His Daughter Dolores.* Collection, The Museum of Modern Art, New York (Mrs John D. Rockefeller, Jr. Fund).

Courbet's statement: "to create a suggestive magic that contains both the object and the subject, the world outside the artist, and the artist himself" is close to Balthus' beliefs. For Balthus believes that "in the past painters were able to create this magic because they worked in a pictorial language perfect enough not to conflict with thought."

From *A Talk with Balthus,* by Georges Bernier (1956)*

* Note: In the words of Georges Bernier, "Balthus is fanatically discreet; detesting confidences, he believes that the artist can only work anonymously. He refuses to give interviews or be photographed."

It is for this reason that Balthus' statement necessarily has to be based on the account of an intermediary, Georges Bernier, an editor of *L'Oeil* and a friend of Balthus'.

Francis Bacon

(1910–)

Our historical catagories break down, and Surrealism becomes but one term to characterize one aspect of the complex phenomena of the modern movement. That aspect is still in evidence, not only in the work of those artists like Max Ernst, Miró, Matta, Magritte, Delvaux and Lam, but also in the work of younger artists like Francis Bacon and Heinz Troekes, whose work is as "paranoiacally critical" as any Surrealist could desire.

HERBERT READ

ON PAINTING

I'm trying to paint the track left by human beings—like the slime left by snails.

I usually like a canvas when I finish it. But the more I look at it, the more dissatisfied I become. If somebody doesn't take it away from me within a few days, I will probably destroy it.

(The whole purpose) is to distort into reality. I distort to bring the reality of the object violently forward.

ABOUT ABSTRACT ART

Man gets tired of decoration. Man is obsessed with himself. I would like some day to trap a moment of life in its full violence, its full beauty. That would be the ultimate painting.

From a statement by Francis Bacon (1962)

Franz Kline

(1910–1962)

A new spatial dynamism declared itself quite mirac-
ulously without the resource of color, depending solely
on the weighted brush stroke, the thick or thin, shiny
or matte streaks of black and white pigment. With
Philip Guston's show of the same year, Kline's exhi-*
bition announced the last significant new *extension of*
the radical abstract styles of the decade.

SAM HUNTER

ON MY WORK IN BLACK AND WHITE

Since 1949 I've been working mainly in black and white paint
or ink on paper. Previous to this I planned painting compositions
with brush and ink using figurative forms and actual objects with
color. The first work in only black and white seemed related to fig-
ures, and I titled them as such. Later the results seemed to signify
something—but difficult to give subject [or] name to, and at present
I find it impossible to make a direct verbal statement about the
paintings in black and white.

From a statement by Franz Kline (1955)

DOES THE PAINTER'S EMOTION COME ACROSS?

People have the crazy idea that an abstract painter doesn't like
realism. I like Hyman Bloom's work and going back further, Ry-
der's, and even Eakins'. But the thing is that painters like Daumier
and Ryder don't ever really paint things the way they look. Nobody
can ever look at a boat by Ryder—like a hunk of black tar—and
say to me that a boat ever looked like that! Or one of Daumier's
faces, composed of slabs of paint, deliberately crude! The final test
of painting, theirs, mine, any other, is: does the painter's emotion
come across? . . .

I think it's wonderful that an artist like Jack Levine can go on con-
cerning himself with representational images and illustrative texts.
If he can make great emotional impact, *painting,* out of that ap-
proach, more power to him. I happen to admire the work of Ever-
good and Tamayo, too.

* 1950.

251

KLINE: *Chief.* Collection, The Museum of Modern Art, New York (Gift of Mr. and Mrs. David M. Solinger).

FREE ASSOCIATION FROM THE START TO THE FINISHED STATE

Procedure is the key word. The difference is that we don't begin with a definite sense of procedure. It's free association from the start to the finished state. The old idea was to make use of your talent. This, we feel, is often to take the line of least resistance. Even a painter like Larry Rivers uses his creative gift in the old way—which is O.K.; I'm not criticizing him or saying that for him it may not be the right way—but painters like Rothko, Pollock, Still, perhaps in reaction to the tendency to *analyze* which has dominated painting from Seurat to Albers, *associate*, with very little analysis. A new form of expressionism inevitably followed. With de Kooning, the procedure is continual change, and the immediacy of the change. With Pollock, it's the confidence you feel from the concentration of his energy in a given picture.

CALLIGRAPHY

Everybody likes calligraphy. You don't have to be an artist to like it, or go to Japan. Mine came out of drawing, and light. When I look out the window—I've always lived in the city—I don't see trees in bloom or mountain laurel. What I do see—or rather, not what I see but the feelings aroused in me by that looking—is what I paint.

From an interview with Franz Kline by Selden Rodman (1956)

Jackson Pollock

(1912–1956)

*Although Pollock and a number of his American
contemporaries had been drawn to Surrealism, be-
cause its exasperations and climate of crisis seemed to
jibe with their own violently rebellious feelings, they
were not driven into an art of fantasy or chimerical
vision primarily, but one of immediate concrete pic-
torial sensations.*

SAM HUNTER

HOW I PAINT

My painting does not come from the easel. I hardly ever stretch my
canvas before painting. I prefer to tack the unstretched canvas to
the hard wall or the floor. I need the resistance of a hard surface. On
the floor I am more at ease. I feel nearer, more a part of the painting,
since this way I can walk around it, work from the four sides and
literally be *in* the painting. This is akin to the method of the Indian
sand painters of the West.

I continue to get further away from the usual painter's tools such
as easel, palette, brushes, etc. I prefer sticks, trowels, knives, and
dripping fluid paint or a heavy impasto with sand, broken glass,
and other foreign matter added.

When I am *in* my painting, I'm not aware of what I am doing. It is
only after a sort of "get acquainted" period that I see what I have
been about. I have no fears about making changes, destroying the
image, etc., because the painting has a life of its own. I try to let
it come through. It is only when I lose contact with the painting that
the result is a mess. Otherwise there is pure harmony, an easy give
and take, and the painting comes out well.

From an article by Jackson Pollock (1947)

Ad Reinhardt

(1913–1967)

In his search for an absolute, Reinhardt wished to arrive at an invisible image and a single color. . . . His relentless polemicizing for a mystically pure art-for-art's sake (embodied, it would appear, only in his own work) made him a thorn in the side of his contemporaries, who called him the "black monk."

BARBARA ROSE

INGREDIENTS FOR A PAINTING

A square (neutral, shapeless) canvas, five feet wide, five feet high, as high as a man, as wide as a man's outstretched arms (not large, not small, sizeless), trisected (no composition), one horizontal form negating one vertical form (formless, no top, no bottom, directionless), three (more or less) dark (lightless) non-contrasting (colorless) colors, brushwork brushed out to remove brushwork, a mat, flat, free-hand-painted surface (glossless, textureless, non-linear, no hard edge, no soft edge) which does not reflect its surroundings—a pure, abstract, non-objective, timeless, spaceless, changeless, relationless, disinterested painting—an object that is self conscious (no unconsciousness), ideal, transcendent, aware of no thing but Art (absolutely no anti-art).

From *Art, USA, Now*

Edward Dugmore

(1915–)

ON PAINTING

Most that can be said about one's work, lies more directly and clearly in the mind of the painter.

254

To me, any aspirations to verbal enlightenment seem somewhat inadequate and illusionary. And, over a period of time one becomes more and more constructive in an attempt to verbalize and crystallize —to clarify and simplify that kind of imagery that fits into the pattern or direction of one's work. But inevitably, the wish to verbalize diminishes as the work is in constant change. And to explain a painting would be defeating its purpose as a visual image that has no boundaries.

Any validity is in the act itself and in the finished works.

From a statement by Edward Dugmore (1970)

DUGMORE: *Series X-6-1970*. Medium oil on canvas. Collection, the Artist.

Robert Motherwell

(1915–)

Robert Motherwell is distinguished for his extraordinary inventiveness in the creation of highly personal shapes, which project and recede in space and shift in scale with ambiguous results.

ALLEN S. WELLER

A PAINTING MUST MAKE HUMAN CONTACT

I never think of my pictures as "abstract," nor do those who live with them day by day—my wife and children, for example, or the profound and indomitable old French lady whose exile in New York has been enhanced by a miniature collection of them. I happen to think primarily in paint—this is the nature of a painter—just as musicians think in music. And nothing can be more concrete to a man than his own felt thought, his own thought feeling. I feel most real to myself in the studio, and resent any description of what transpires there as "abstract"—which nowadays no longer signifies "to select," but, instead, something remote from reality. From whose reality? And on what level?

If a painting does not make a human contact, it is nothing. But the audience is also responsible. I adore the old French lady because among my works she chooses those that specifically move *her*. Through pictures, our passions touch. Pictures are vehicles of passion, of all kinds and orders, not pretty luxuries like sports cars. In our society, the capacity to give and to receive passion is limited. For this reason, the act of painting is a deep human necessity, not the production of a hand-made commodity.

I respect a collector who returned one of my "abstract" pictures to the gallery, saying it was too tragic in feeling for her to be able to look at it every day. But somewhere there is a man with a tragic sense of life who loves that same picture, and I think he will find one day a way to have it. These are real human contacts, and I love painting that it can be a vehicle for human intercourse. In this solitary and apathetic society, the rituals are so often obsolete and corrupt, out of accord with what we really know and feel. . . . True painting is a lot more than "picture-making." A man is neither a decoration nor an anecdote.

From a statement by Robert Motherwell (1955)

256

Jack Levine

(1915–)

*Jack Levine finds dramatic situations and characters
in the American city environment. His early works
were heavily but effectively satirical, often with bitter
undercurrents; today they tend to be more urbane in
their social comment. He retains a brilliant pseudo-
impressionistic style and has enlarged the concept of
illustrational painting to monumental proportions.*

ALLEN S. WELLER

DISTORTION AND EXPRESSIONISM
ARE NOT THE SAME THING

Distortion and Expressionism are not the same thing. Clouet,
Corneille de Lyon distort. You distort for empathy. You give some-
thing a larger area because it is more important. And a madonna is
more important than an apple, every time. You distort for editorial
reasons—a dignified way of saying caricature—that has always
been, and that isn't Expressionism. I would smooth out every brush
stroke in favor of the structure of the head. . . .

I have always distorted for satire or pathos or one thing or an-
other, but never just to express myself. Distortion is always a drama-
tic vehicle. Drama is an external sense. The world is certain, and
figures have a certain height proportionally. Sure, I distort them. It
is a distortion, but it also relates . . . it *does* relate. . . .

Maybe I have an idea about a norm which I don't intend to fol-
low. I don't intend to lose sight of it either. To lose sight of it is to
lose everything.

From a statement by Jack Levine (1952)

257

Andrew Wyeth

(1917–)

Many of the paintings utilize unexpected angles and points of view of the simplest occurrences in nature. The minute and careful detail could almost be called photographic realism, except that no camera has yet been invented which would bring everything into such consistently sharp focus. Color seems subordinated to his awareness of textures of his subject matter.

<div align="right">

LYDIA K. GRIMES

</div>

MY AIM IS TO ESCAPE FROM THE MEDIUM WITH WHICH I WORK

My inherent desire to draw and paint was whipped into action by many youthful adventures in my father's studio, where at the age of fourteen I started a long period of instruction. This training consisted of incessant drilling in drawing and construction from cast,

WYETH: *A Crow Flew By*. Tempera. The Metropolitan Museum of Art (Arthur H. Hearn Fund, 1950).

from life, and from landscape, "and so," my father often said, "to understand nature objectively and thus be soundly prepared for later excursion into subjective moods and the high spirit of personal and emotional expression."

My aim is to escape from the medium with which I work. To leave no residue of technical mannerisms to stand between my expression and the observer. To seek freedom through significant form and design rather than through the diversion of so-called free and accidental brush handling. In short, to dissolve into clear air all impediments that might interrupt the flow of pure enjoyment. Not to exhibit craft, but rather to submerge it, and make it rightfully the handmaiden of beauty, power, and emotional content.

<div align="right">From a statement by Andrew Wyeth (1943)</div>

Alan Davie

(1920–)

He knew what he had to reject (1947), and any sense he himself had of a "natural affinity" with the Americans arose from the fact that they were rejecting the art of painting in terms of a tremendous zest for the act of painting.

<div align="right">ROBERT MELVILLE</div>

PAINTINGS WITHOUT SUBJECT OR FORM

At an early stage it was my ambition to set myself free from the conventions of picture making, to produce paintings without subject or form. However, I found that I had tied myself to a dogmatic and narrow concept of being without idea. I began to grasp an idea of the role of destruction and realized that an important factor in creation was the "breaking down of ideas" rather than their absence.

PAINTING AND ZEN ARCHERY

The more obstinately one tries to learn how to shoot for the sake of hitting the target, the less one will succeed. In the same way, as long as I am aware of my inability to paint exactly as I desire, I am paralyzed by that very desire and only when I succeed in abolishing completely that desire can I create anything.

<div align="right">From an interview with Alan Davie (1961)</div>

<div align="center">259</div>

Karel Appel

(1921–)

Along with Corneille and Constant, Appel is one of the founders of the Dutch "experimental group."
EXPRESSIONISM 1900-1955

ON PAINTING

Painting is a tangible, sensory experience, an intense "being stirred" by the joy and the tragedy of man.

A spatial experience which, nourished by instinct, becomes a living form. I try to capture this tangible reality in paint and in so doing give expression to my times.

From a statement by Karel Appel

Burt Hasen

(1921–)

Composed of strongly massed substance and concern with the space element in abstract art, Hasen's pictures do not represent but symbolize experience.
CARLYLE BURROWS

MULTIPLE IMAGES

I am interested in multiple images and unbridled imagination. Living is wonder and surprise before nature, that inexhaustible enigma. The external and internal—a fan opening and closing. A conglomeration of beings; mythical life colliding with real life to create ever changing relationships. The mystery of forms touching the meaning of things; impossible dreams, and what I can find within them.

Very, very early we conceive a way of seeing. Living fossils, we store up impressions, signs, and symbols. We accumulate nourishment underground for future use. Then, one day, these signs, im-

pressions, and symbols fling themselves before us, transformed al-
most magically by time and memory. At last we have a place to
put all this sundry bric-a-brac. Years of impatient and difficult ap-
prenticeship were not in vain. I seek the meaning of my past and
the many instances in which I live. They represent the two poles
between which I might discover myself.

<div align="right">From a statement by Burt Hasen (1963)</div>

John Hultberg

(1922–)

A WAY TO CREATE MY OWN EARTH

If my painting appears repetitive, lacking in inventive variations
or wide connotations, perhaps this is because I want some kind of
icon-like stability instead. As the plague of despair and dishonor
spreads I find it necessary to retrench instead of seeking new escapes.
Standing in the midst of this sickness I hold onto painting. It's too
late to expect solace from the conceits of the surrealists or the labora-
tory work of the abstractionists. In this grim time of transition,
when we are balanced between destruction and hope we deserve that
which can comfort and warm us, make us whole again. I want to
gather together those scattered insights that modern art has un-
covered and burn them in an eclectic bonfire in this frozen desert.
In these somber embers perhaps I may be allowed to glimpse once
more the poetry and romance I felt as a child. Now that the values
of the outside world have become meaningless for me I rejoice that
I find in painting a way to create my own earth.

<div align="right">From a statement by John Hultberg 1966</div>

HULTBERG: *Toward the New Planet*. Oil on canvas.
Courtesy of the Martha Jackson Gallery, Inc., New York

Roy Lichtenstein

(1923–)

Roy Lichtenstein, James Rosenquist, and Tom Wesselmann work as the young abstract painters do, bringing up their images close to the surface in imitation of the movie close-up, using brilliant color, and stressing surface tension.

BARBARA ROSE

WHAT IS POP ART?

I don't know—the use of commercial art as subject matter in painting, I suppose. It was hard to get a painting despicable enough so that no one would hang it—everybody was hanging everything. It was almost acceptable to hang a dripping paint rag, everybody was accustomed to this. The one thing everybody hated was commercial art; apparently they didn't hate that enough either.

IS POP ART DESPICABLE?

That doesn't sound so good, does it? Well, it *is* an involvement with what I think to be the most brazen and threatening characteristics of our culture, things we hate, but which are also so powerful in their impingement on us. I think art since Cézanne has become extremely romantic and unrealistic, feeding on art; it is utopian. It has had less and less to do with the world, it looks inward—neo-Zen and all that. This is not so much a criticism as an obvious observation. Outside is the world; it's there. Pop Art looks out into the world; it appears to accept its environment, which is not good or bad, but different—another state of mind.

"How can you like exploitation?" "How can you like the complete mechanization of work? How can you like bad art?" I have to answer that I accept it as being there, in the world.

ARE YOU ANTI-EXPERIMENTAL?

I think so, and anti-contemplative, anti-nuance, anti-getting–away–from–the–tyranny–of–the–rectangle, anti-movement-and–light, anti-mystery, anti-paint–quality, anti-Zen, and anti all of

those brilliant ideas of preceding movements which everyone understands so thoroughly.

We like to think of industrialization as being despicable. I don't really know what to make of it. There's something terribly brittle about it. I suppose I would still prefer to sit under a tree with a picnic basket rather than under a gas pump, but signs and comic strips are interesting as subject matter. There are certain things that are usable, forceful and vital about commercial art. We're using those things—but we're not really advocating stupidity, international teenagerism and terrorism.

From an interview with G. R. Swenson (1963)

LICHTENSTEIN: *Study for Modern Painting of New York State 1968.*
Collection of Mr. and Mrs. M. Riklis

Paul Georges

(1923–)

Anti-minimal and not influenced at all by the art scene of the 'Sixties, Georges paints his world with vigor and expansiveness; very much in the classical mainstream of painting.

HENRI PICARD

TO FILL A VOID

Art is contextual. If there are three filling stations on a corner, should you put up a fourth? Put another way, I work out of need (an absence) and I try to fill a void. At the moment, in art, the fashionable thing is the void. I am *un-minimal*. In art, the word is simultaneous that things must exist at once. Ideal and real completely meshed objects: geometry, color, identities made to exist at once.

Paraphrasing Einstein in his description of relativity: if a man sits on a hot stove, a minute seems like an hour; but if you sit next to a pretty girl an hour seems like a minute. This is an example of object relations changing time. In the 19th century realistic artists tried to fix time. In our century, we try to change it in order to make it exist, i.e., what happens if a pretty girl sits on a hot stove?

The more finite the thing you want to relate, the more secure the relationship. For example, if you take identity away from either party in a relationship, it ceases to exist. (Two centers are needed to relate. Identity depends on more than the parts put together; rather it requires the whole functioning of the parts.)

265

The reason I use objects is because they are the closest thing to relativity outside of pure time. I consider Noland or Stella to be examples of that. There are two ways to go directly to infinity in a more limited but more pure way, or to go to infinity by making an example of how a relationship changes a thing, and therefore time.

From a statement by Paul Georges (1970)

GEORGES: *Return of the Muse,* 10 ft. x 20 ft., Collection, the Artist.

266

Herbert Katzman

(1923–)

The earlier phases of Katzman's work and the later ones are united by a continuous all-pervading mood which one critic described as both romantic and Germanic. The Homage to Ensor, *which Katzman painted several years ago, was actually homage to all painting of the deep spirit: from Munch to Soutine, and from Ryder to Kokoschka. These are, however, not necessarily Katzman's principal influences, for he is more a painter of a certain tradition than a member of a school.*

RANDOLPH BARR

ON PAINTING

Since life defies formula, so does painting if its meaning lies in its truest reflection of life. Therefore for some painters the fulfillment in their art will not come simply from the proper juxtaposition of color with color or form with form. In their painting, as in life, there is struggle and disappointment before realization, and

KATZMAN: *Duny and Annie.* Courtesy of Mr. and Mrs. A. M. Fiering.

267

their first approach to realization is their doorway to a new labyrinth of obstacles and problems.

I find that I am one of that number, from the family of expressionist painters, occupied in an ongoing experience in which the seeking of new values is the fulfillment.

ART EXPERTS, ACADEMIES,
ART PHILOSOPHERS, AND ART COLUMNISTS

Art experts, academies of one sort or another, art philosophers, and art columnists have no meaningful relation to painting and can be considered unimportant to the work of the painter. They cannot, however, be ignored as peripheral to the life of art as they do have considerable power in the pantry.

From a statement by Herbert Katzman (1963)

Robert Rauschenberg

(1925–)

Together with Jasper Johns, who is five years younger, Rauschenberg has often been referred to as the co-founder (or co-perpetrator, depending on one's point of view) of the Pop Art School.

BARBARA ROSE

BECAUSE I WANT TO

It has never bothered me a bit when people say that what I'm doing is not art. I don't think of myself as making art. I do what I do because I want to, because painting is the best way I've found to get along with myself. And it's always the moment of doing it that counts. When a painting is finished it's already something I've done, and no longer something I'm doing, and it's not so interesting anymore. I think I can keep on playing this game indefinitely. And it *is* a game—everything I do seems to have some of that in it. The point is, I just paint in *order* to learn something about painting, and everything I learn always resolves itself into two or three pictures.

I really feel sorry for people who think things like soap dishes or

mirrors or Coke bottles are ugly, because they're surrounded by things like that all day long, and it must make them miserable.

From: *The Bride and the Bachelors* by Calvin Tomkins (1965)

RAUSCHENBERG: *Buffalo II*. From the collection of Mr. and Mrs. Robert B. Mayer.

George Rhoads

(1926–)

George Rhoads is a "visionary" painter. He uses images not to tell us something about his visual sensations, about the way his eye responds to seen objects, or to tell us something exclusively about himself, about his personality, as the "action painters" seem to do; he presents us with a way of viewing and of imagining, that is, of thinking about and of dealing emotionally with "reality." . . . I think it is art of a high order.

WILLIAM STEIG

I HAVE TO WORK WITH JOY

I have to work with joy. For me there is no other way. When I see ugly things I am miserable until I can redeem them by painting them into my own world. That is the joy.

Our world is ugly because people are afraid to see. The clear sight an artist enjoys, and must have to be an artist, puts him forever beyond the reach of the comforting popular delusions. People close their eyes on the ugliness around them and listen to the lullaby of the mass madness that sings of safety, power, and superiority. The ones who shout the loudest for realism are the ones lost deepest in dreams. These are the pragmatists, the doers, the empire builders. In their blindness they are creating a chaos of ugliness.

But in the worst of this junkpile of buildings, cars, tortured landscape, and brutalized people, there is spontaneous life germinating. This what I attempt to paint. I have ironic purpose, but my first aim is to transform the ugliness to fit into my world, which is the real world.

ON CRITICISM

Not long ago a painter told me, with no shame, that when he was on a jury to choose paintings for a show he let in a painting he didn't like because a critic on whom he doted had praised the artist. When I asked him why he didn't use his own judgment he said that the painting was "important" and his own humble feelings about it were worthless. By "important" he said he meant "significant in the development of art." He didn't realize that whatever "develops" in art is insignificant.

RHOADS: *Green Truck Missing a Pedestrian*. Courtesy of Terry Dintenfass
Gallery.

Claptrap criticism thrives in this world where everybody is won-
dering what everybody else thinks about everything so they will
not have to decide for themselves.

ON "FASHIONABLE" ART

A word about Pop art, found objects, abstract expressionism, and
such clique fashions: Most of these artists are wasting their imagi-
nation cooking up ugliness, nonsense, and insults to feed to the
snobs. Some of them believe the myth the snobs have created for
them, and some are laughing up their sleeves; either way they are
pathetic.

From a statement by George Rhoads (1963)

Nathan Oliveira

(1928–)

It is always the essential gesture with which Oliveira is concerned. Oliveira's paint surface bears the scars of his fury to capture the truth of a gesture. Scratches, splatters, areas of thickly applied paint and thin washes combine, all rapidly placed. The colors he uses are as soft and neutral, and as contradictory as his space.

KIM LEVIN

THE HUMAN FIGURE

Every artist deals with his sense of reality. This reality is for him to determine, and involves a broad and varied range of expressive symbols. The image of the human figure is the vehicle with which I can most positively relate. My concern for the figure is primarily a formal one, growing out of the problems of painting itself. The implications are unconscious, for I have no desire to illustrate stories.

From *The New Images of Man*

Painting is my work. I have constructed my life around it. There is little more to say. Whatever else could be stated, would do nothing more than distract from the essential realities that the work may, or may not contain.

I do not pretend, through painting, to defend popular or unpopular attitudes, but rather hope that my efforts are true to myself alone.

From *Art USA Now*

An artist is an instinctive person. To intellectualize is stupid. To make a conscious art is stupid.

In growing up as an artist you're defeated continuously.

Being an artist is a kind of luxury and you take it as a luxury. First of all it's a privilege. You don't expect anything, unless you go and seek it. And the very god-damn thing you think is so important today, you'll be stomping on all over tomorrow! But that's the way life is! That's why I can't really detach myself—art from living. And

that is why I don't like to be esthetic and talk about art. What makes the quality of life? I have to bring the quality to it: and that's what we seem to have forgotten today.

The consciousness, the liveness is the important thing right now. Staying right on top of being alive.

Everything in life can occur in a painting, spontaneously in the work.

From a statement by Nathan Oliveira (1969)

OLIVEIRA: *Standing Man with Hands in Belt.*
Collection, Walker Art Center, Minneapolis, Minnesota.

Robert D'Arista

(1929–)

He is now experimenting lyrically with traditions of Cézanne and Seurat and his new still lifes of fruit and flowers, as well as figurative studies, point to a new direction singing diminutively with a lightened heart.
ROLAND F. PEASE, JR.

REFLECTIONS ON PAINTING

There is, perhaps, in painting, more than in most art forms, an intrusion of public events and postures, seemingly only indirectly related or pertinent to the process of painting itself and, occasionally, quite at odds with it. Despite the latter-day insistence on the esthetics of the personal, the idiosyncratic, and the exclusive, the artist persists in institutionalizing himself, in running in schools, in creating amorphous public edifices with dogmas and hierarchies, in a more than passing concern for the artistic heresy. In the past, this behavior's resultant uniformity of effort and attitude was rewarded with a commensurate product and achievement. But this dovetailed logically with the ethos of, for example (an especially pertinent one), French Impressionism, with its mainsprings in a new and scientifically orientated realism. One would presume that a repesentation of the real, under a stable theory of analysis, should perforce be anonymous, and that stylistic differences could almost be dismissed as residual effect.

274

D'ARISTA: *Nude.* Charcoal drawing. Courtesy of Lee Nordness Gallery.

Perhaps because we count the days of art as "modern" from the advent of Impressionism, the course of its history has taken on the proportions of a myth which we insist on repeating as a precondition for the validity of our own art as "historic" and "modern." In any event, Impressionism's emergence as a movement and theory which naturally accommodated a collective effort and result, may have gone far toward accounting for its historic course in a pattern not unlike the pseudo-eschatology of a triumphant political or religious movement. In this connection, one finds Mary Cassatt's comment on Pissarro—"He could teach a stone to draw"—an intriguing one. Presumably, for a movement to extend itself, a man with this peculiar talent is invaluable.

I am quite certain he could do nearly that. On the other hand, if a theory of art insists on denying the validity of any real ethos, one is puzzled by the uniformity of results, the pattern of group effort, the meaning of heresy, and, not least of all, the interesting work produced. Differing perhaps in all other respects, the various contemporary movements seem to agree only on an allegiance to the expressive, the personal, and the unique effort—and proceed then to proliferate arbiters, exegetes, claques, cliques, and cabals that must be a source of wonder to the participants most of all. Seeming to obey every known law of the few attempting to manage the many, they proceed from virtuous evangelism to Bonapartist activism, aggrandizement, and so on. We speak of the end result as an academy, invidiously—hopefully, a school.

Being a painter, I do not deny at least a passive participation in this type of event and, perhaps, am quite ambivalent, as is, I believe, the case with most people. It is possible, moreover, that most of the art which has permanent value has emerged from such a process. Needless to say, the final corrupt stage is repugnant to everyone, but—with the telescoping of events which seems to characterize the era—this can be mercifully short. I would argue that in the contradiction between the theory and the event, the painter might well examine his ideas as to the validity of the values in his painting which are exclusive and personal, and seek to isolate some possibly more universal elements which may, after all, be truly operative. Further, one might examine the real implications of an artistic colloquy of any sort, with or without its attendant hazards.

From a statement by Robert D'Arista (1963)

Jasper Johns

(1930–)

Like Duchamp, Johns has devoted himself to challenging some of our most cherished preconceptions about aesthetics and perception. Because of his play with the theme of illusion versus reality, his work is one of the most important sources for pop imagery.

BARBARA ROSE

RANDOM THOUGHTS

Make something, a kind of object, which as it changes or falls apart (dies as it were) or increases in its parts (grows as it were) offers no clue as to what its state or form or nature was at any previous time.

Physical or metaphysical obstinacy. Could this be a useful object?

. . . Sometimes I see it and then paint it. Other times I paint it and then see it. Both are impure situations, and I prefer neither.

. . . At every point in nature there is something to see. My work contains similar possibilities for the changing focus of the eye.

THREE IDEAS

. . . Three academic ideas which have been of interest to me are what a teacher of mine (speaking of Cézanne and cubism) called "the rotating point of view." (Larry Rivers recently painted a black rectangle, two or three feet away from where he had been looking in a painting and said ". . . like there's something happening over there too.")

Marcel Duchamp's suggestion "to reach the impossibility of suffi-
cient visual memory to transfer from one object to another memory
imprint," and Leonardo's idea . . . that the boundary of a body is
neither a part of the enclosed body nor a part of the surrounding
atmosphere.

From *Catalogue on Jasper Johns,* by Alan R. Solomon and John Cage

JOHNS: *Flags* (1965) . Collection, the Artist.

Bibliography

ALBERTI, LEONE BATTISTA, *De pictura* (tr. Giac. Leoni), London, 1726.
APOLLINAIRE, GUILLAUME, *The Cubist Painters* (tr. Lione Abel), New York, 1944.

BARR, ALFRED H., JR., *Cubism and Abstract Art*, New York, 1936.
———, *Picasso, Fifty Years of His Art*, New York, 1946.
———, *Matisse, His Art and His Public*, New York, 1952.
BAUDELAIRE, CHARLES, *The Mirror of Art*, New York, 1956.
BAUR, JOHN I. H., *The New Decade, 35 American Painters and Sculptors*, New York, 1955.
BAZAINE, JEAN, *Notes sur la peinture d'aujourd'hui*, Paris, 1953.
BECKMANN, MAX, *On My Painting*, New York, 1941.
BELLOWS, GEORGE, *The Paintings of George Bellows*, New York, 1929.
BENESCH, OTTO, *Edvard Munch* (tr. Joan Spencer), London, 1960.
BERENSON, BERNARD, *The Drawings of the Florentine Painters*, Chicago, 1938.
———, *Italian Painters of the Renaissance*, London, 1952.
———, *Aesthetics and History*, New York, 1954.
BERNIER, GEORGES, "On Balthus," *The Selective Eye* (New York), 1956-57.
BOAS, GEORGE, *Courbet and the Naturalist Movement*, Baltimore, 1938.
BODE, W. VON, *Great Masters of Dutch and Flemish Painting* (tr. M. L. Clarke), London, 1909.
———, *Die Kunst der Frührenaissance in Italien*, Berlin, 1926.
BRANDES, GEORG, *Michelangelo: His Life, His Times, His Era* (tr. Heinz Norden), New York, 1963.
BRAQUE, GEORGES, *Le Jour et la nuit: Cahiers, 1917-1952*, Paris, 1952.
BRETON, ANDRÉ, *What Is Surrealism?* (tr. David Gascoyne), London, 1936.
BRONSTEIN, LEO, *El Greco*, New York, 1950.
BUCHER, FRANÇOIS, *Despite Straight Lines*, New Haven, 1961.

CAILLER and COURTHION, *Portrait of Manet, by Himself and His Contemporaries* (tr. Michael Ross), London, 1960.
CALIERI, PIETRO, *Paolo Veronese, sua vite e sue opere*, Rome, 1888.
CALVERT, ALBERT F., *Goya*, London, 1908.
CASSOU, JEAN, *Situation de l'art moderne*, Paris, 1950.
CENNINI, CENNINO, *The Book of the Arts* (tr. Christiana J. Herringham), London, 1899.
———, *The Craftsman's Handbook (Il Libro dell'arte)* (tr. Daniel V. Thompson, Jr.), New Haven, 1933.

CHRISTENSEN, ERWIN O., *The History of Western Art*, New York, 1962.
CLARK, KENNETH, *Leon Battista Alberti on Painting*, London, 1944.
———, *Piero della Francesca*, London, 1951.
———, *The Nude*, New York, 1959.
———, *Landscape into Art*, Boston, 1961.
CLEMENCEAU, GEORGES, *The Water Lilies* (tr. George Boas), New York, 1930.
COOPER, DOUGLAS, *Fernand Léger et le nouvel espace*, Geneva, 1949.
Contemporary American Painting and Sculpture, Urbana, Ill., 1959, 1961.
CONWAY, WILLIAM MARTIN, *Literary Remains of Albrecht Dürer*, Cambridge, England, 1889.
———, *The Van Eycks and Their Followers*, London, 1922.
COROT, JEAN BAPTISTE CAMILLE, *Corot, raconté par lui-même et par ses amis*, Geneva, 1946.
COURTHION. *See* Cailler.

DAVID, JACQUES LOUIS, *Le Peintre Louis David, souvenirs et documents inédits*, Paris, 1880.
DE GROOT, C. HOFSTEDE, *Die Urkunden über Rembrandt*, The Hague, 1906.
DE KOONING, WILLEM, "What Abstract Art Means to Me," *Bulletin of the Museum of Modern Art*, Vol. XVIII, No. 3 (New York, 1951).
DELACROIX, EUGÈNE, *The Journal of Eugène Delacroix* (tr. Walter Pach), New York, 1948.
DENIO, ELIZABETH H., *Nicolas Poussin, His Life and Work*, London, 1899.
DE VRIES, A. B., *Jan Vermeer van Delft* (tr. Robert Allen), London, n.d.
DEWEY, JOHN, *Art as Experience*, New York, 1934.
DOERNER, MAX, *The Materials of the Artist*, New York, 1949.
DOUGLAS, LANGSTON, *Fra Angelico*, London, 1902.
———, *Leonardo da Vinci, His Life and Pictures*, Chicago, 1944.
DOWNES, WILLIAM HOWE, *The Life and Work of Winslow Homer*, Cambridge, Mass., 1911.
DURET, T., *Manet and the French Impressionists*, London, 1910.
DUTHUIT, GEORGES, *The Fauvist Painters* (tr. Ralph Manheim), New York, 1930.

EASTLAKE, CHARLES, *Materials for a History of Oil Painting*, London, 1847.
EEGHEN, ISABELLA H. VAN, *Seven Letters from Rembrandt* (tr. Ida D. Ovink), The Hague, 1961.
ERBEN, WALTER, *Marc Chagall* (tr. Michael Bullock), London, 1957.
ESCHOLIER, RAYMOND, *Matisse*, New York, 1960.

FEININGER, LYONEL, *Excerpts*, New York, 1941.
FERNANDEZ, JUSTINO, *El arte moderno en México*, Mexico City, 1944.
FINBERG, A. J., *The Life of J. M. W. Turner*, New York, 1961.
FLEXNER, JAMES T., *America's Old Masters*, New York, 1939.
FRIEDLANDER, MAX J., *Early Netherlandish Painting from Van Eyck to Bruegel*, London, 1956.

FRIEDLANDER, W., *Mannerism and Anti-Mannerism in Italian Painting*, New York, 1957.
FROMENTIN, EUGÈNE, *The Masters of Past Time* (tr. Andrew Boyle), London, 1913.
FRY, ROGER, *Reflections on British Painting*, New York, 1934.

GABO, NAUM, *Of Divers Arts*, New York, 1962.
GARDNER, HELEN, *Art Through the Ages*, New York, 1959.
GEORGE, WALDEMAR, *Giorgio de Chirico*, Paris, 1928.
GILCHRIST, ALEXANDER, *Life of William Blake*, New York, 1880.
GILSON, ETIENNE, *Painting and Reality*, New York, 1959.
GOETHE, JOHANN WOLFGANG VON, *Theory of Colors* (tr. Charles Eastlake), London, 1840.
GOGH, VINCENT VAN, *The Complete Letters of Vincent Van Gogh*, Greenwich, Conn., 1959.
GOLDSCHEIDER, LUDWIG, *El Greco*, New York, 1938.
GOLDWATER, ROBERT, *Primitivism in Modern Painting*, New York, 1938.
—— and MARCO TREVES, *Artists on Art*, New York, 1958.
GOLZIO, V., *Raffaelo, nei documenti e nelle testimonianze dei contemporanei e nelle letteratura del suo secolo*, Vatican City, 1936.
GONCOURT, EDMUND and JULES, *French Eighteenth Century Painters* (tr. Robert Ironside), London, 1948.
GOODRICH, LLOYD, *Thomas Eakins, His Life and Work*, New York, 1933.
GORKY, ARSHILE, *Aviation: Evolution of Forms under Aerodynamic Limitations*, New York, 1957.
GRIS, JUAN, "On the Possibilities of Painting," *Transatlantic Review*, Vol. I, No. 6 (Paris, June 1924); Vol. II, No. 1 (Paris, July 1924).
GROHMANN, WILL, *Paul Klee*, New York, 1954.
GROSZ, GEORGE, *George Grosz Drawings*, New York, 1944.
GUÉRIN, MARCEL, *The Degas Letters* (tr. Marguerite Kay), Oxford, n.d.

HAUSER, ARNOLD, *The Social History of Art*, 4 vols., New York, 1957-59.
HENRI, ROBERT, *The Art Spirit*, Philadelphia, 1951.
HODLER, FERDINAND, "The Mission of the Artist," *Liberté de Fribourg*, March 1897.
HOGARTH, WILLIAM, *The Analysis of Beauty*, London, 1753.
HOLT, ELIZABETH, *A Documentary History of Art*, Princeton, 1957.
HUNTER, SAM, *Modern American Painting and Sculpture*, New York, 1962.
HUYGHE, RENÉ, *Art Treasures of the Louvre*, New York, 1962.

IDEVILLE, H. D'., *Gustave Courbet, Notes et documents sur sa vie et son oeuvre*, Paris, 1878.
INNESS, GEORGE, JR., *Life, Art, and Letters of George Inness*, New York, 1917.

JANSON, H. W. and DORA JANE, *The Picture History of Painting*, New York, 1961.
JOYANT, MAURICE, *Henri de Toulouse-Lautrec*, 2 vols., Paris, 1926.
JUSTI, CARL, *Diego Velazquez and His Times*, London, 1889.

KAHNWEILER, DANIEL-HENRY, *Juan Gris: His Life and Work* (tr. Douglas Cooper), London, 1947.
KANDINSKY, WASSILY, *Concerning the Spiritual in Art,* New York, 1947.
KLEE, FELIX, *Paul Klee* (tr. Richard and Clara Winston), New York, 1962.
KUH, KATHARINE, *Léger,* Chicago and New York, 1953.

LEONARDO DA VINCI, *A Treatise on Painting* (tr. J. F. Rigaud), London, 1835.
———, *The Notebooks of Leonardo da Vinci* (tr. E. MacCurdy), New York, 1938.
LE ROY, GRÉGOIRE, *James Ensor,* Brussels, 1922.
LEŚLIE, C. R., *Memoirs of John Constable,* London, 1845.
LOMAZZO, GIOVANNI PAOLO, *A Tracte Containing the Arts of Curious Painting* (tr. Richard Haydock), Oxford, 1598.
LONGHI, R., *Piero della Francesca,* London, 1930.

MACK, GERSTLE, *Toulouse-Lautrec,* New York, 1938.
———, *Gustave Courbet,* New York, 1951.
MALEVICH, KASIMIR, "Die gegenstandlose Welt," *Bauhausbücher 11,* (Munich, 1927).
MALINGUE, MAURICE, *Paul Gauguin, Letters to His Wife and Friends* (tr. Henry J. Stenning), London, n.d.
MALONE, EDMOND, *The Works of Sir Joshua Reynolds,* London, 1797.
MALRAUX, ANDRÉ, *The Voices of Silence* (tr. Stuart Gilbert), New York, 1953.
MANDER, CAREL VAN, *Dutch and Flemish Painters* (tr. Constant van de Wall), New York, 1936.
MARIN, JOHN, Editorial, *The Palisadian* (Cliffside Park, N.J.), Nov. 15, 1940.
MATHEY, FRANÇOIS, *The Impressionists* (tr. Jean Steinberg), New York, 1961.
MILLER, DOROTHY C., *Fourteen Americans,* New York, 1946.
MIRÓ, JOAN, Interview in *Possibilities 1* (New York), Winter 1947-48.
MONDRIAN, PIET, *Plastic Art and Pure Plastic Art,* New York, 1945.
MUNTZ, EUGENE, *Raphael,* London, 1896.

NEWMEYER, SARAH, *Enjoying Modern Art,* New York, 1962.
NOLDE, EMIL, *Das eigene Leben,* Berlin, 1913.
NORDNESS, LEE, *Art, USA, Now,* Lucerne, 1962.
NORMAN, DOROTHY, *John Marin,* New York, 1949.

PACH, WALTER, *Queer Thing, Painting: Forty Years in the World of Art,* New York, 1938.
———, *Ingres,* New York, 1939.
———, *Renoir,* New York, 1950.
PACHECO, FRANCISCO, *Discursos practicables del mobilismo arte de la pintura,* Madrid, 1866.
PANOFSKY, ERWIN, *The Early Netherlands Painting,* Cambridge, Mass., 1953.
———, *Meaning in the Visual Arts,* New York, 1955.

PATER, WALTER, *The Renaissance: Studies in Art and Poetry,* London, 1919.

PENROSE, ROLAND, *Picasso, His Life and Work,* New York, 1962.

PERRUCHOT, HENRI, *Toulouse-Lautrec* (tr. Humphrey Ware), New York, 1962.

PETRUS, PICTOR BURGENSIS, *De prospectiva pigendi,* Strasbourg, 1899.

POLLOCK, JACKSON, "My Painting," *Possibilities 1* (New York), Winter 1947-48.

POST, C. R., *History of Spanish Painting,* 12 vols., Cambridge, Mass., 1930-58.

READ, HERBERT, *The Meaning of Art,* Baltimore, 1951.

――――, *The Philosophy of Modern Art,* New York, 1955.

――――, *A Concise History of Modern Painting,* New York, 1962.

REDON, ODILON, "An Artist's Journal" (tr. Hyman Swetzoff), *Tricolor,* Vol. XI, No. 11 (New York, 1945).

――――, *Bresdin Lithography and the Nature of Black* (tr. Hyman Swetzoff), Northampton, Mass., 1959.

REWALD, JOHN, *Paul Cézanne Letters* (tr. Marguerite Kay), London, 1941.

――――, *Camille Pissarro, Letters to His son Lucien,* New York, 1943.

――――, *The History of Impressionism,* New York, 1946.

――――, *Georges Seurat* (tr. Lionel Abel), New York, 1946.

――――, *Pierre Bonnard,* New York, 1948.

――――, *Post Impressionism from Van Gogh to Gauguin,* New York, 1956.

REYNOLDS, JOSHUA, *The Discourses of Sir Joshua Reynolds,* London, 1842.

RICCI, CORRADO, *Correggio: His Life, His Friends, and His Time* (tr. Florence Simonds), London, 1897.

RICHTER, JEAN PAUL, *Literary Works of Leonardo da Vinci,* London, 1883.

RIDOLFI, CARLO, *Delle maraviglie dell'Arte,* Venice, 1648.

RITCHIE, ANDREW CARNDUFF, *Abstract Painting and Sculpture in America,* New York, 1951.

――――, *Edouard Vuillard,* New York, 1954.

――――, *The New Decade,* New York, 1955.

RODMAN, SELDEN, *Conversations with Artists,* New York, 1957.

ROSENBERG, J., *Rembrandt,* Cambridge, Mass., 1948.

ROTHKO, MARK, "The Romantics Were Prompted," *Possibilities 1* (New York), Winter 1947-48.

ROUSSEAU, HENRI, "Letter to André Dupont," *Le Soirées de Paris,* Vol. III, No. 20. (Jan. 1933).

RUELANS, *Correspondance de Pierre-Paul Rubens,* Antwerp, 1887.

RUSKIN, JOHN, *Works,* London, 1903-12.

SACHS, PAUL J., *The Pocket Book of Great Drawings,* New York, 1961.

SAINSBURY, W. NOEL, *Originally Unpublished Papers Illustrative of the Life of Sir Peter Paul Rubens,* London, 1859.

SAMSON, ADELAIDE, "Paragraphs from the Studio of a Recluse," *The Broadway Magazine* (New York), Sept. 1905.

SANDRART, JOACHIM VON, *Teutsche Academie der Edlen Bau-, Bild-, und Mahlerey-Künste,* Munich, 1675.

SAUNDERS, RUTH, *The Letters of Peter Paul Rubens*, Cambridge, Mass., 1955.
SCHLOSSER, J. VON, *Lorenzo Ghiberti's Denkwürdigkeiten*, Berlin, 1912.
SELZ, PETER, *German Expressionist Painters*, Berkeley, 1957.
———, *The Work of Jean Dubuffet*, New York, 1962.
SEUPHOR, MICHEL, *Piet Mondrian, Life and Work*, London, 1957.
SIQUEIROS, DAVID ALFARO, *Through the Road of a Neo-Realism or Modern Social Realistic Painting in Mexico*, Mexico City, 1951.
SLOANE, JOSEPH C., *French Painting between the Past and the Present*, Princeton, 1951.
SOBY, JAMES THRALL, *George Rouault*, New York, 1947.
———, *Giorgio de Chirico*, New York, 1955.
SPENCER, JOHN R., *Alberti on Painting*, New Haven, 1956.
STONE, IRVING and JEAN, *I, Michelangelo, Sculptor* (tr. Charles Speroni), New York, 1962.
SWEENEY, J. J., *Marc Chagall*, New York, 1946.
SWENSON, G. R., "What is Pop Art?" *Art News*, Vol. 62, No. 7 (New York), Nov. 1963.
SWILLENS, P. T. A., *Johannes Vermeer, Painter of Delft, 1632-1675* (tr. C. M. Breuning-Williamson), Utrecht, 1950.
SYMONDS, JOHN ADDINGTON, *The Life of Michel-Angelo Buonarroti*, London, 1893.

TAINE, HIPPOLYTE, *Philosophie de l'art*, Paris, 1918.
TAYLOR, JOSHUA C., *Futurism*, New York, 1961.
THEMERSON, STEFAN, *Kurt Schwitters in England*, London, 1958.
THORNBURY, WALTER, *Life of J. M. W. Turner*, London, 1877.
TIETZE, HANS, *Titian Paintings and Drawings*, Vienna, 1937.
———, *Tintoretto*, New York, 1948.
TOMKINS, CALVIN, *The Bride and the Bachelors*, New York, 1965.

VASARI, GIORGIO, *Lives of the Most Eminent Painters, Sculptors, and Architects* (tr. Mrs. Jonathan Foster), London, 1892.
———, *The Lives of Painters, Sculptors and Architects*, New York, 1959.
———, *Vasari on Technique* (tr. Louisa S. Maclehouse), London, 1907.
VENTURI, LIONELLO, *Italian Painting* (tr. Stuart Gilbert), Geneva, 1950.
VILLON, JACQUES, *Reflections on Painting*, Boston, 1950.
VOLLARD, AMBROISE, *Renoir, An Intimate Record* (tr. Harold L. Van Doren and Randolph T. Weaver), New York, 1925.

WHEELER, MONROE, *Soutine*, New York, 1950.
WHISTLER, JAMES ABBOT McNEILL, *The Gentle Art of Making Enemies*, New York, 1893.
WILENSKI, R. H., *Modern French Painters*, London, 1954.
WOLFFLIN, HEINRICH, *The Art of the Italian Renaissance*, New York, 1913.
———, *Principles of Art History*, New York, 1950.
WORRINGER, WILHELM, *Form in Gothic*, London, 1927.

ZUCKER, PAUL, *Styles in Painting*, New York, 1963.

ACKNOWLEDGMENTS

THE editor and the publishers wish to thank the following for their courtesy in granting permission to reprint from copyrighted material.

DOUBLEDAY & COMPANY, INC.: from *I, Michelangelo, Sculptor*, edited by Irving and Jean Stone. Copyright © 1962 by Doubleday & Co., Inc.

HARVARD UNIVERSITY PRESS: from *The Letters of Peter Paul Rubens*, edited and translated by Ruth Saunders Magurn. Cambridge, Mass.: Harvard University Press, Copyright 1955 by the President and Fellows of Harvard College.

PHAIDON PRESS LTD.: from *French XVIII Century Painters*, by E. and J. Goncourt, translated by Robin Ironside.

————: from *The Journal of Eugène Delacroix*, edited and with an introduction by Hubert Wellington, translated by Lucy Norton.

————: from *Munch*, by Otto Benesch.

Published by Phaidon Press Ltd., London. Distributed in the USA by New York Graphic Society Publishers Ltd., Greenwich, Connecticut.

HARPER & ROW: from *Ingres*, by Walter Pach. Copyright 1939 by Harper & Brothers. Reprinted with permission of Harper & Row, Publishers Incorporated.

PIERRE CAILLER: from *Corot, raconte par lui-même et par ses amis*.

MEREDITH PRESS: from *Life, Art, and Letters of George Inness*, by George Inness, Jr.

PANTHEON BOOKS: from *Pissarro, Letters to His Son Lucien*.

CASSELL & CO. LTD.: from *Portrait of Manet by Himself and His Contemporaries*, edited by Pierre Courthion and Pierre Cailler, translated by M. Ross. Copyright © 1960 by Cassell & Company Limited, London.

HARRY N. ABRAMS, INC., NEW YORK: from *Renoir*, by Walter Pach.

WHITNEY MUSEUM OF AMERICAN ART: from *Eakins*, by Lloyd Goodrich.

————: from *The New Decade*, edited by John I. H. Baur (Franz Kline, Robert Motherwell). New York: The Macmillan Company, 1955.

G. A. CRAMP & SONS LTD.: from *Paul Gauguin, Letters to His Wife and Friends*, edited by M. Malingue, translated by H. J. Stenning.

BERNARD GRASSET: from *Paul Gauguin, Letters to His Wife and Friends*.

GEORGE WITTENBORN, INC: from *Georges Seurat*, by John Rewald.

————: from *Concerning the Spiritual in Art*, by Wassily Kandinsky.

————: from *Possibilities I, Winter 1947/48* (Miró, Pollock, Rothko).

J. B. LIPPINCOTT COMPANY: from *The Art Spirit*, by Robert Henri. Copyright 1923 by J. B. Lippincott Company, 1951 by Violet Organ. Published by J. B. Lippincott Company.

THE PALISADIAN: from the *Guest Editorial*, by John Marin (Nov. 15, 1940).

HARRY HOLTZMAN: from *Plastic Art and Pure Plastic Art*, by Piet Mondrian.

GEORGE BRAZILLER, INC.: from *Paul Klee*, by Felix Klee, translated by Richard and Clara Winston. Copyright English translation 1962 by George Braziller, Inc.

UNIVERSITY OF ILLINOIS PRESS: from *Catalogues of 1959, 1961 Art Shows*.

EDITIONS DES TROIS COLLINES: from *Fernand Leger et le nouvel espace*, by Douglas Cooper.

THE ORION PRESS, INC.: from *Modigliani: Man and Myth*, by Jeanne Modigliani. Copyright 1958 by The Orion Press, Inc.

❧ INDEX ❧

INDEX

Page references to the principal section on a painter are in italics.

A CATALOG OF SELECTED
DOVER BOOKS
IN ALL FIELDS OF INTEREST

A CATALOG OF SELECTED DOVER
BOOKS IN ALL FIELDS OF INTEREST

CONCERNING THE SPIRITUAL IN ART, Wassily Kandinsky. Pioneering work by father of abstract art. Thoughts on color theory, nature of art. Analysis of earlier masters. 12 illustrations. 80pp. of text. 5⅜ x 8½. 23411-8 Pa. $4.95

ANIMALS: 1,419 Copyright-Free Illustrations of Mammals, Birds, Fish, Insects, etc., Jim Harter (ed.). Clear wood engravings present, in extremely lifelike poses, over 1,000 species of animals. One of the most extensive pictorial sourcebooks of its kind. Captions. Index. 284pp. 9 x 12. 23766-4 Pa. $14.95

CELTIC ART: The Methods of Construction, George Bain. Simple geometric techniques for making Celtic interlacements, spirals, Kells-type initials, animals, humans, etc. Over 500 illustrations. 160pp. 9 x 12. (USO) 22923-8 Pa. $9.95

AN ATLAS OF ANATOMY FOR ARTISTS, Fritz Schider. Most thorough reference work on art anatomy in the world. Hundreds of illustrations, including selections from works by Vesalius, Leonardo, Goya, Ingres, Michelangelo, others. 593 illustrations. 192pp. 7⅛ x 10¼. 20241-0 Pa. $9.95

CELTIC HAND STROKE-BY-STROKE (Irish Half-Uncial from "The Book of Kells"): An Arthur Baker Calligraphy Manual, Arthur Baker. Complete guide to creating each letter of the alphabet in distinctive Celtic manner. Covers hand position, strokes, pens, inks, paper, more. Illustrated. 48pp. 8¼ x 11. 24336-2 Pa. $3.95

EASY ORIGAMI, John Montroll. Charming collection of 32 projects (hat, cup, pelican, piano, swan, many more) specially designed for the novice origami hobbyist. Clearly illustrated easy-to-follow instructions insure that even beginning papercrafters will achieve successful results. 48pp. 8¼ x 11. 27298-2 Pa. $3.50

THE COMPLETE BOOK OF BIRDHOUSE CONSTRUCTION FOR WOOD-WORKERS, Scott D. Campbell. Detailed instructions, illustrations, tables. Also data on bird habitat and instinct patterns. Bibliography. 3 tables. 63 illustrations in 15 figures. 48pp. 5¼ x 8½. 24407-5 Pa. $2.50

BLOOMINGDALE'S ILLUSTRATED 1886 CATALOG: Fashions, Dry Goods and Housewares, Bloomingdale Brothers. Famed merchants' extremely rare catalog depicting about 1,700 products: clothing, housewares, firearms, dry goods, jewelry, more. Invaluable for dating, identifying vintage items. Also, copyright-free graphics for artists, designers. Co-published with Henry Ford Museum & Greenfield Village. 160pp. 8¼ x 11. 25780-0 Pa. $10.95

HISTORIC COSTUME IN PICTURES, Braun & Schneider. Over 1,450 costumed figures in clearly detailed engravings–from dawn of civilization to end of 19th century. Captions. Many folk costumes. 256pp. 8⅜ x 11¾. 23150-X Pa. $12.95

EARLY NINETEENTH-CENTURY CRAFTS AND TRADES, Peter Stockham (ed.). Extremely rare 1807 volume describes to youngsters the crafts and trades of the day: brickmaker, weaver, dressmaker, bookbinder, ropemaker, saddler, many more. Quaint prose, charming illustrations for each craft. 20 black-and-white line illustrations. 192pp. 4⅝ x 6. 27293-1 Pa. $4.95

VICTORIAN FASHIONS AND COSTUMES FROM HARPER'S BAZAR, 1867–1898, Stella Blum (ed.). Day costumes, evening wear, sports clothes, shoes, hats, other accessories in over 1,000 detailed engravings. 320pp. 9⅜ x 12¼.
22990-4 Pa. $15.95

GUSTAV STICKLEY, THE CRAFTSMAN, Mary Ann Smith. Superb study surveys broad scope of Stickley's achievement, especially in architecture. Design philosophy, rise and fall of the Craftsman empire, descriptions and floor plans for many Craftsman houses, more. 86 black-and-white halftones. 31 line illustrations. Introduction 208pp. 6½ x 9¼. 27210-9 Pa. $9.95

THE LONG ISLAND RAIL ROAD IN EARLY PHOTOGRAPHS, Ron Ziel. Over 220 rare photos, informative text document origin (1844) and development of rail service on Long Island. Vintage views of early trains, locomotives, stations, passengers, crews, much more. Captions. 8⅞ x 11¾. 26301-0 Pa. $13.95

THE BOOK OF OLD SHIPS: From Egyptian Galleys to Clipper Ships, Henry B. Culver. Superb, authoritative history of sailing vessels, with 80 magnificent line illustrations. Galley, bark, caravel, longship, whaler, many more. Detailed, informative text on each vessel by noted naval historian. Introduction. 256pp. 5⅜ x 8½.
27332-6 Pa. $7.95

TEN BOOKS ON ARCHITECTURE, Vitruvius. The most important book ever written on architecture. Early Roman aesthetics, technology, classical orders, site selection, all other aspects. Morgan translation. 331pp. 5⅜ x 8½. 20645-9 Pa. $8.95

THE HUMAN FIGURE IN MOTION, Eadweard Muybridge. More than 4,500 stopped-action photos, in action series, showing undraped men, women, children jumping, lying down, throwing, sitting, wrestling, carrying, etc. 390pp. 7⅞ x 10⅝.
20204-6 Clothbd. $27.95

TREES OF THE EASTERN AND CENTRAL UNITED STATES AND CANADA, William M. Harlow. Best one-volume guide to 140 trees. Full descriptions, woodlore, range, etc. Over 600 illustrations. Handy size. 288pp. 4½ x 6⅜.
20395-6 Pa. $6.95

SONGS OF WESTERN BIRDS, Dr. Donald J. Borror. Complete song and call repertoire of 60 western species, including flycatchers, juncoes, cactus wrens, many more–includes fully illustrated booklet. Cassette and manual 99913-0 $8.95

GROWING AND USING HERBS AND SPICES, Milo Miloradovich. Versatile handbook provides all the information needed for cultivation and use of all the herbs and spices available in North America. 4 illustrations. Index. Glossary. 236pp. 5⅜ x 8½.
25058-X Pa. $7.95

BIG BOOK OF MAZES AND LABYRINTHS, Walter Shepherd. 50 mazes and labyrinths in all–classical, solid, ripple, and more–in one great volume. Perfect inexpensive puzzler for clever youngsters. Full solutions. 112pp. 8⅛ x 11.
22951-3 Pa. $4.95

PIANO TUNING, J. Cree Fischer. Clearest, best book for beginner, amateur. Simple repairs, raising dropped notes, tuning by easy method of flattened fifths. No previous skills needed. 4 illustrations. 201pp. 5⅜ x 8½. 23267-0 Pa. $6.95

A SOURCE BOOK IN THEATRICAL HISTORY, A. M. Nagler. Contemporary observers on acting, directing, make-up, costuming, stage props, machinery, scene design, from Ancient Greece to Chekhov. 611pp. 5⅜ x 8½. 20515-0 Pa. $12.95

THE COMPLETE NONSENSE OF EDWARD LEAR, Edward Lear. All nonsense limericks, zany alphabets, Owl and Pussycat, songs, nonsense botany, etc., illustrated by Lear. Total of 320pp. 5⅜ x 8½. (USO) 20167-8 Pa. $7.95

VICTORIAN PARLOUR POETRY: An Annotated Anthology, Michael R. Turner. 117 gems by Longfellow, Tennyson, Browning, many lesser-known poets. "The Village Blacksmith," "Curfew Must Not Ring Tonight," "Only a Baby Small," dozens more, often difficult to find elsewhere. Index of poets, titles, first lines. xxiii + 325pp. 5⅜ x 8¼. 27044-0 Pa. $8.95

DUBLINERS, James Joyce. Fifteen stories offer vivid, tightly focused observations of the lives of Dublin's poorer classes. At least one, "The Dead," is considered a masterpiece. Reprinted complete and unabridged from standard edition. 160pp. 5³⁄₁₆ x 8¼. 26870-5 Pa. $1.00

THE HAUNTED MONASTERY and THE CHINESE MAZE MURDERS, Robert van Gulik. Two full novels by van Gulik, set in 7th-century China, continue adventures of Judge Dee and his companions. An evil Taoist monastery, seemingly supernatural events; overgrown topiary maze hides strange crimes. 27 illustrations. 328pp. 5⅜ x 8½. 23502-5 Pa. $8.95

THE BOOK OF THE SACRED MAGIC OF ABRAMELIN THE MAGE, translated by S. MacGregor Mathers. Medieval manuscript of ceremonial magic. Basic document in Aleister Crowley, Golden Dawn groups. 268pp. 5⅜ x 8½. 23211-5 Pa. $9.95

NEW RUSSIAN-ENGLISH AND ENGLISH-RUSSIAN DICTIONARY, M. A. O'Brien. This is a remarkably handy Russian dictionary, containing a surprising amount of information, including over 70,000 entries. 366pp. 4½ x 6⅛. 20208-9 Pa. $10.95

HISTORIC HOMES OF THE AMERICAN PRESIDENTS, Second, Revised Edition, Irvin Haas. A traveler's guide to American Presidential homes, most open to the public, depicting and describing homes occupied by every American President from George Washington to George Bush. With visiting hours, admission charges, travel routes. 175 photographs. Index. 160pp. 8¼ x 11. 26751-2 Pa. $11.95

NEW YORK IN THE FORTIES, Andreas Feininger. 162 brilliant photographs by the well-known photographer, formerly with *Life* magazine. Commuters, shoppers, Times Square at night, much else from city at its peak. Captions by John von Hartz. 181pp. 9¼ x 10¾. 23585-8 Pa. $13.95

INDIAN SIGN LANGUAGE, William Tomkins. Over 525 signs developed by Sioux and other tribes. Written instructions and diagrams. Also 290 pictographs. 111pp. 6⅛ x 9¼. 22029-X Pa. $3.95

THE WIT AND HUMOR OF OSCAR WILDE, Alvin Redman (ed.). More than 1,000 ripostes, paradoxes, wisecracks: Work is the curse of the drinking classes; I can resist everything except temptation; etc. 258pp. 5⅜ x 8½. 20602-5 Pa. $6.95

SHAKESPEARE LEXICON AND QUOTATION DICTIONARY, Alexander Schmidt. Full definitions, locations, shades of meaning in every word in plays and poems. More than 50,000 exact quotations. 1,485pp. 6½ x 9¼. 2-vol. set.
Vol. 1: 22726-X Pa. $17.95
Vol. 2: 22727-8 Pa. $17.95

SELECTED POEMS, Emily Dickinson. Over 100 best-known, best-loved poems by one of America's foremost poets, reprinted from authoritative early editions. No comparable edition at this price. Index of first lines. 64pp. 5¾₆ x 8¼.
26466-1 Pa. $1.00

CELEBRATED CASES OF JUDGE DEE (DEE GOONG AN), translated by Robert van Gulik. Authentic 18th-century Chinese detective novel; Dee and associates solve three interlocked cases. Led to van Gulik's own stories with same characters. Extensive introduction. 9 illustrations. 237pp. 5⅜ x 8½. 23337-5 Pa. $7.95

THE MALLEUS MALEFICARUM OF KRAMER AND SPRENGER, translated by Montague Summers. Full text of most important witchhunter's "bible," used by both Catholics and Protestants. 278pp. 6⅝ x 10. 22802-9 Pa. $12.95

SPANISH STORIES/CUENTOS ESPAÑOLES: A Dual-Language Book, Angel Flores (ed.). Unique format offers 13 great stories in Spanish by Cervantes, Borges, others. Faithful English translations on facing pages. 352pp. 5⅜ x 8½.
25399-6 Pa. $8.95

THE CHICAGO WORLD'S FAIR OF 1893: A Photographic Record, Stanley Appelbaum (ed.). 128 rare photos show 200 buildings, Beaux-Arts architecture, Midway, original Ferris Wheel, Edison's kinetoscope, more. Architectural emphasis; full text. 116pp. 8¼ x 11. 23990-X Pa. $9.95

OLD QUEENS, N.Y., IN EARLY PHOTOGRAPHS, Vincent F. Seyfried and William Asadorian. Over 160 rare photographs of Maspeth, Jamaica, Jackson Heights, and other areas. Vintage views of DeWitt Clinton mansion, 1939 World's Fair and more. Captions. 192pp. 8⅞ x 11. 26358-4 Pa. $12.95

CAPTURED BY THE INDIANS: 15 Firsthand Accounts, 1750-1870, Frederick Drimmer. Astounding true historical accounts of grisly torture, bloody conflicts, relentless pursuits, miraculous escapes and more, by people who lived to tell the tale. 384pp. 5⅜ x 8½. 24901-8 Pa. $8.95

THE WORLD'S GREAT SPEECHES, Lewis Copeland and Lawrence W. Lamm (eds.). Vast collection of 278 speeches of Greeks to 1970. Powerful and effective models; unique look at history. 842pp. 5⅜ x 8½. 20468-5 Pa. $14.95

THE BOOK OF THE SWORD, Sir Richard F. Burton. Great Victorian scholar/adventurer's eloquent, erudite history of the "queen of weapons"–from prehistory to early Roman Empire. Evolution and development of early swords, variations (sabre, broadsword, cutlass, scimitar, etc.), much more. 336pp. 6½ x 9¼.
25434-8 Pa. $9.95

THE INFLUENCE OF SEA POWER UPON HISTORY, 1660–1783, A. T. Mahan. Influential classic of naval history and tactics still used as text in war colleges. First paperback edition. 4 maps. 24 battle plans. 640pp. 5⅜ x 8½. 25509-3 Pa. $14.95

THE STORY OF THE TITANIC AS TOLD BY ITS SURVIVORS, Jack Winocour (ed.). What it was really like. Panic, despair, shocking inefficiency, and a little hero-ism. More thrilling than any fictional account. 26 illustrations. 320pp. 5⅜ x 8½. 20610-6 Pa. $8.95

FAIRY AND FOLK TALES OF THE IRISH PEASANTRY, William Butler Yeats (ed.). Treasury of 64 tales from the twilight world of Celtic myth and legend: "The Soul Cages," "The Kildare Pooka," "King O'Toole and his Goose," many more. Introduction and Notes by W. B. Yeats. 352pp. 5⅜ x 8½. 26941-8 Pa. $8.95

BUDDHIST MAHAYANA TEXTS, E. B. Cowell and Others (eds.). Superb, accu-rate translations of basic documents in Mahayana Buddhism, highly important in his-tory of religions. The Buddha-karita of Asvaghosha, Larger Sukhavativyuha, more. 448pp. 5⅜ x 8½. 25552-2 Pa. $12.95

ONE TWO THREE . . . INFINITY: Facts and Speculations of Science, George Gamow. Great physicist's fascinating, readable overview of contemporary science: number theory, relativity, fourth dimension, entropy, genes, atomic structure, much more. 128 illustrations. Index. 352pp. 5⅜ x 8½. 25664-2 Pa. $8.95

ENGINEERING IN HISTORY, Richard Shelton Kirby, et al. Broad, nontechnical survey of history's major technological advances: birth of Greek science, industrial revolution, electricity and applied science, 20th-century automation, much more. 181 illustrations. ". . . excellent . . ."–*Isis*. Bibliography. vii + 530pp. 5⅜ x 8¼. 26412-2 Pa. $14.95

DALÍ ON MODERN ART: The Cuckolds of Antiquated Modern Art, Salvador Dalí. Influential painter skewers modern art and its practitioners. Outrageous evalu-ations of Picasso, Cézanne, Turner, more. 15 renderings of paintings discussed. 44 calligraphic decorations by Dalí. 96pp. 5⅜ x 8½. (USO) 29220-7 Pa. $4.95

ANTIQUE PLAYING CARDS: A Pictorial History, Henry René D'Allemagne. Over 900 elaborate, decorative images from rare playing cards (14th–20th centuries): Bacchus, death, dancing dogs, hunting scenes, royal coats of arms, players cheating, much more. 96pp. 9¼ x 12¼. 29265-7 Pa. $12.95

MAKING FURNITURE MASTERPIECES: 30 Projects with Measured Drawings, Franklin H. Gottshall. Step-by-step instructions, illustrations for constructing hand-some, useful pieces, among them a Sheraton desk, Chippendale chair, Spanish desk, Queen Anne table and a William and Mary dressing mirror. 224pp. 8⅛ x 11¼. 29338-6 Pa. $13.95

THE FOSSIL BOOK: A Record of Prehistoric Life, Patricia V. Rich et al. Profusely illustrated definitive guide covers everything from single-celled organisms and dinosaurs to birds and mammals and the interplay between climate and man. Over 1,500 illustrations. 760pp. 7½ x 10¼. 29371-8 Pa. $29.95

Prices subject to change without notice.

Available at your book dealer or write for free catalog to Dept. GI, Dover Publications, Inc., 31 East 2nd St., Mineola, N.Y. 11501. Dover publishes more than 500 books each year on science, elementary and advanced mathematics, biology, music, art, literary history, social sciences and other areas.